CONTENT

*An exhibition celebrating
the tenth anniversary of
the Hirshhorn Museum and
Sculpture Garden*

CONTENT

A Contemporary Focus

1974–1984

Howard N. Fox

Miranda McClintic

Phyllis Rosenzweig

*Published for the Hirshhorn Museum
and Sculpture Garden
by the Smithsonian Institution Press
Washington, D.C. 1984*

Dates of the exhibition: October 4, 1984–January 6, 1985

Designed by Polly Sexton
Type set by EPS Group Inc., Baltimore, Maryland
Printed by Stevenson, Inc., Alexandria, Virginia

The paper in this book meets the guidelines for permanence and durability of the
Committee on Production Guidelines for Book Longevity of the Council on Library
Resources.

Library of Congress Cataloging-in-Publication Data
Fox, Howard N.
 Content: a contemporary focus, 1974–1984.
 "An exhibition celebrating the tenth anniversary of the Hirshhorn Museum and Sculpture
Garden"—Opposite t.p.
 Bibliography: p.
 1. Avant-garde (Aesthetics)—History—20th century—Exhibitions. 2. Social problems in
art—Exhibitions. 3. Visual perception—Psychological aspects—Exhibitions. I. McClintic,
Miranda. II. Rosenzweig, Phyllis. III. Hirshhorn Museum and Sculpture Garden. IV. Title.
N6487.W3H574 1984 709'.04'70740153 84-10624
ISBN 0-87474-436-9 0-87474-437-7 (pbk.)

Contents

6 Lenders to the Exhibition

9 Foreword by Abram Lerner

11 Acknowledgments

13 Preface

14 The Will to Meaning
Howard N. Fox

25 Content: Making Meaning and Referentiality
Miranda McClintic

39 Catalog of the Exhibition

164 Chronology
Phyllis Rosenzweig

181 Bibliography

LENDERS TO THE EXHIBITION

Vito Acconci, New York
Terry Allen, Fresno, California
Ara Arslanian, New York
Robert Barry, Teaneck, New Jersey
Jonathan Borofsky, Venice, California
Robert and Maryse Boxer, London, England
Eli and Edythe L. Broad, Los Angeles, California
Joan Brown, San Francisco, California
Roger Brown, Chicago, Illinois
Gilda and Henry Buchbinder, Chicago, Illinois
Scott Burton, New York
Farideh Cadot, Paris, France
Donna Dennis, New York
Don and Nancy Eiler, Madison, Wisconsin
Suzanne and Howard Feldman, New York
Sandy and Jim Fitzpatrick, Washington, D.C.
Hamish Fulton, Canterbury, England
John Gibson, New York
Barbara Gladstone, New York
Arthur and Carol Goldberg, New York
Gary Goodwin, Chicago, Illinois
Doris and Robert Hillman, New York
Mick Jagger, New York
Neil Jenney, New York
J. U. Johnson, Jacksonville, Florida
Edward Kienholz and Nancy Reddin Kienholz, Hope, Idaho
Alain Kirili, New York
Robert Lehrman, Washington, D.C.
Sherrie Levine, New York
Sydney and Frances Lewis, Richmond, Virginia
Harry H. Lunn, Jr., Washington, D.C.
Joshua Mack, Byram, Connecticut
Donald B. Marron, New York
Metzger Collection, Essen, West Germany
Byron Meyer, San Francisco, California
Estate of Ree Morton, New York
Dolores and Hubert Neumann, New York
Hermann Nitsch, Prinzendorf, Austria
Dennis Oppenheim, New York
Esther Parada, Oak Park, Illinois
Walter Pichler, Vienna, Austria
William H. Plummer, Chicago, Illinois
Norma and William Roth, Winter Haven, Florida
Doris and Charles Saatchi, London, England
Italo Scanga, La Jolla, California
Barbara and Eugene Schwartz, New York
Michael H. Schwartz, Philadelphia, Pennsylvania
Gregory T. Semler, Hanover, Massachusetts
Holly and Horace Solomon, New York
Speyer Family Collection, New York

Emily and Jerry Spiegel, Kings Point, New York
Michael Tracy, San Ygnacio, Texas
Lori and Ira Young, West Vancouver, British Columbia
Eight anonymous lenders

Albright-Knox Art Gallery, Buffalo, New York
Brooklyn Museum, New York
Chase Manhattan Bank, New York
Dia Art Foundation, New York
Edward R. Broida Trust, New York
Holt, Rinehart and Winston, New York
Isamu Noguchi Foundation, Inc., Long Island City, New York
Los Angeles County Museum of Art, Los Angeles, California
Louisiana Museum, Humlebaek, Denmark
Lowe Art Museum, University of Miami, Florida
Moderna Museet, Stockholm, Sweden
Musée d'art contemporain, Montreal, Canada
Museum Folkwang, Essen, West Germany
Muzeum Sztuki, Lódź, Poland
Myers/Kent Galleries, Center for Art, Music and Theater, State University
 College, Plattsburgh, New York
Stedelijk Museum, Amsterdam, Holland
Stedelijk Van Abbemuseum, Eindhoven, Holland
Storm King Art Center, Mountainville, New York
Sydney and Frances Lewis Foundation, Richmond, Virginia
Tate Gallery, London, England
Thames and Hudson, London, England
University Gallery, University of Massachusetts at Amherst

Anthony d'Offay Gallery, London, England
Barbara Gladstone Gallery, New York
Blum/Helman Gallery, New York
Bonnier Gallery, New York
Brooke Alexander, Inc., New York
Castelli Graphics, New York
Delahunty Gallery, Dallas, Texas, and New York
Diane Brown Gallery, New York
Emilio Mazzol, Galleria d'Arte Contemporanea, Modena, Italy
Fraenkel Gallery, San Francisco, California
Fuller Goldeen Gallery, San Francisco, California
Fun Gallery, New York
G. Ray Hawkins Gallery, Los Angeles, California
Galerie Farideh Cadot, Paris, France
Galerie Ulysses, Vienna, Austria
H. F. Manès Gallery, New York
Hadler/Rodriquez Gallery, Houston, Texas, and New York
Hirschl and Adler Modern, New York
Holly Solomon Gallery, New York
John Weber Gallery, New York
L. A. Louver Gallery, Venice, California

Larry Gagosian Gallery, Los Angeles, California
Leo Castelli Gallery, New York
Mary Boone Gallery, New York
Mary Boone/Michael Werner Gallery, New York
Max Protetch Gallery, New York
Michael Klein, Inc., New York
Middendorf Gallery, Washington, D.C.
Morgan Art Gallery, Kansas City, Kansas
Nicola Jacobs Gallery, London, England
Pace Gallery, New York
Pace-MacGill Gallery, New York
Paula Cooper Gallery, New York
Ralph G. Mendez, Locus Gallery, San Antonio, Texas
Robert Miller Gallery, New York
Ronald Feldman Fine Arts, Inc., New York
Sidney Janis Gallery, New York
Sonnabend Gallery, New York
Sperone Westwater, New York
Susan Caldwell, Inc., New York
Ted Greenwald, Inc., New York
Texas Gallery, Houston, Texas
Waddington Galleries, London, England
Willard Gallery, New York

FOREWORD

Ten years in the life of a museum may be, to quote from Isaiah, "as a drop of a bucket." Nevertheless, a museum's first decade is significant as the nucleus from which subsequent developments are generated.

This exhibition celebrates the first ten years of the Hirshhorn Museum's existence, a period that has seen the Museum's transformation from a private collection to a national institution. Although Joseph H. Hirshhorn made his gift in 1966, the Museum did not open its doors until 1974 when the building was completed. The ambitions and hopes expressed during the opening ceremonies reflected the seriousness of purpose, the aspirations, and the high principles that guided everyone connected with this enterprise, from the optimism expressed by S. Dillon Ripley, Secretary of the Smithsonian, to the Chairman of the Museum's Board of Trustees, the Honorable Daniel Patrick Moynihan, to the members of the staff.

The creation of a museum of modern art offers an enormous challenge. By its very nature contemporary art is controversial, and the mission of a modern museum is in a sense propagandistic, intended not only to inform the public of developments in the visual arts, but to proselytize as well, or at the least, create a degree of intelligent curiosity. The challenge is therefore not a simple one for a museum such as ours, with an audience consisting largely of temporary visitors to the nation's capital, many of whom have little or no previous experience with the visual arts, and particularly with modern art. To create interest where skepticism exists is as important as to provide the more sophisticated visitors with an increased aesthetic capability. As Dr. Ripley stated at the inaugural ceremony, "The purpose of the Hirshhorn is to remind us all that life is more than the usual, that the human mind in its relentless diversity is capable of seeing life subjectively, and being stirred by objects into new and positive ways of thought, thus escaping from the numbing penumbra of the ritual known as everyday."

In celebration of our tenth year we are presenting this exhibition, which, while it does not pretend to represent the entire panorama of the past decade in art, focuses on an aspect that seems to best express the underlying aesthetic motivation of that period: the reaction to the formalist art of the previous decade. While we may be tempted to see only diversity in the work of artists during this current period, what they all share, more or less, is a return to, or exploration of, extra-formal content dealing with subjective ideas, social themes, and use of metaphor, which would have been considered non-art elements only ten years previously. It has been

noted that the generation of the seventies withdrew from the activism of its counterpart in the sixties. How interesting then that the artists of the seventies (and into the eighties) have returned to the realm of ideas, cultural commentary, and morality.

Such speculations aside, it is the art itself we must consider. Surely the diversity of means is stimulating and the union of form and content felicitous. Here is an aspect of the art of the past decade that once more (if indeed we ever doubted it) reaffirms one's faith in its regenerative nature, its spontaneous combustibility, and its power to help us escape "from the numbing penumbra of the ritual known as everyday."

Abram Lerner
Director
Hirshhorn Museum and Sculpture Garden

ACKNOWLEDGMENTS

If there is any aspect of the realization of this exhibition that surpasses our own enthusiasm and commitment, it is the involvement of a small legion of individuals upon whose expertise, generosity, and effort this project has been founded. To begin at the beginning, we extend our heartfelt thanks to Hirshhorn Museum Director Abram Lerner for his support and encouragement of this ambitious undertaking; his guidance and good will have been a sustenance, as they have always been over the years.

We are grateful to John F. Jameson, Assistant Secretary for Administration at the Smithsonian, and Dean Anderson, Special Assistant to the Assistant Secretary for History and Art, for their support of the exhibition since its inception.

The informed interest and astute critiques of Hirshhorn Museum Deputy Director Stephen E. Weil have contributed invaluably to our own thoughts, as has his technical advice on a host of matters. Chief Curator Charles W. Millard was vigilant in his support of curatorial discretion and encouraged us from the start. Executive Officer Nancy Kirkpatrick, with eloquence and know-how, secured funding for and managed the myriad administrative details of this exhibition.

Many others within the Museum contributed to the production of this exhibition. Our thanks are due to Joseph Shannon, Chief of Exhibits and Design, who was ably assisted by Edward Schiesser, Arthur Courtemanche, Robert Allen, and others who designed, built, and installed this exceptionally complex exhibition. Registrar Douglas Robinson oversaw the safe and efficient transport of the works borrowed for this show, and Photographer Lee Stalsworth fulfilled many of the exhibition's photographic needs.

No less formidable than the task of assembling the exhibition was the production of this catalog. We wish to thank Librarian Anna Brooke, who helped develop the bibliography. We are pleased to salute Jill Gollner for her excellent spirit and unfailing ability to coordinate the work of three curators and for endless hours of typing letters, loan forms, checklists, and manuscripts. Early drafts of our respective manuscripts were improved by the many insightful suggestions of freelance editor Carole Jacobs. Museum Editor Virginia Wageman and Smithsonian Press Editor Ruth Spiegel attended to the countless details of a complex manuscript. Designer Polly Sexton brought to this catalog a thoughtful and handsome format.

Special thanks must go to volunteers and interns: Sophie Orloff, who, two years ago, began initial research on some of the artists; Sarah Tanguy and Eve McIntyre, for their good research and practical assistance; Eden Rafshoon, for coordinating research on the special video program that accompanies this exhibition; Karen Siatras, for preparing the exhibition handout and labels; and especially Regina Hablützel, for her thorough detective work on countless aspects of the artists' biographies, the chronology, and the bibliography, and for her very sensitive translations. Without the dedicated efforts of these individuals, the exhibition would have been diminished.

Acknowledgments

As with any exhibition of this size and scope, many people have been extraordinarily helpful in providing information, facilitating introductions, securing loans, and generally furthering the show along its course. We would like to thank, collectively and individually, the following: In New York, Theodore Bonin, Brooke Alexander, Inc.; Mame Kennedy and Tom Pelham, Leo Castelli Gallery; Douglas Baxter, Paula Cooper Gallery; Karen Amiel, Delahunty Gallery; Donna M. De Salvo, Dia Art Foundation; Lynn Cassaniti, Ronald Feldman, and Barbara Goldner, Ronald Feldman Fine Arts; Richard Flood and Barbara Gladstone, Barbara Gladstone Gallery; John Cheim, Robert Miller Gallery; Cheryl Bishop Wolf, Paine Webber, Inc.; Alexandra Sutherland, Tony Shafrazi Gallery; Anita Grossman, Holly Solomon Gallery; Antonia Homen and David Nolen, Sonnabend Gallery; Angela Westwater, Sperone Westwater; Edward Thorpe, Edward Thorpe Gallery; Mary Boone, Stephen Frailey, and Michael Werner, Mary Boone/Michael Werner Gallery. In Houston, Neil Printz, De Menil Collection. In Los Angeles, Lynn Kienholz, California International Arts Foundation; Peter Goulds and John McCarron, L. A. Louver Gallery. In San Francisco, Wanda Hansen.

In Europe, we enjoyed the assistance of the following individuals and their organizations: Judy Adam, Anthony d'Offay Gallery, London; Judith Aminoff, Paris; René Block, Berlin; Wieslaw Borowski, Galerie Foksal, Warsaw; Andreas Breuning and Monika Schmela, Düsseldorf; Marie-Puck Broodthaers, Galerie Michael Werner, Cologne; Ursula Czartoryska and Ewa Mikina, Muzeum Sztuki, Lódź; Julia Ernst, Saatchi and Saatchi Company, London; Douglas Feuk, Stockholm; Richard Francis and Richard Morphet, Tate Gallery, London; Claude Gintz, Paris; Margaret Harrison, London; Fulvio Irache, Milan; Nicola Jacobs, Nicola Jacobs Gallery, London; Ulrich Krempel, Stadtische Kunsthalle, Düsseldorf; Paul Maenz, Cologne; Sandy Nairne, Institute of Contemporary Arts, London; Claes Nordenhake, Malmö; Suzanne Pagé, Paris; Giancarlo Politi, Milan; Anda Rottenberg, Warsaw; John Sailer and Gabriele Wimmer, Galerie Ulysses, Vienna; Bjorn Springfelt, Moderna Museet, Stockholm; Daniel Templon, Paris; Anders Tornberg, Lund; Antje van Gravenitz, Amsterdam; Tijmen van Grootheest, Museum Fodor, Amsterdam; Caren Faure Walker, Gimpel Fils, London; and Evelyn Weiss, Museum Ludwig, Cologne.

Finally, we extend our thanks to all the lenders for their generosity, which makes this exhibition possible, and to all the artists, who have supplied all the reasons, and then some, for this exhibition.

H.N.F.
M.McC.
P.R.

PREFACE

This is an exhibition about the art of our time—specifically the art of the last decade. It is a period acknowledged by its advocates and critics alike to be a critical juncture in twentieth-century art, identified with a climate of new ideas about art and its place in human culture.

Central to any understanding of the artistic thought that has spanned the past ten years is the recognition of a purposeful departure from certain formalist orthodoxies which posit that the actual nature of art objects is the embodiment of material and formal decisions that are also the only appropriate subjects of the artist. Great numbers of contemporary artists, rejecting such precepts and relegating material and formal aspects of their work to secondary importance, have reasserted the traditional role of art in the Western world as a means to reveal and interpret non-art experience. The central artistic issues thus have shifted from such concerns as how an object is made and perceived, or what defines its style, to considerations of why art is made and experienced, and what a work of art means or signifies beyond the experience of its formal and stylistic ingredients. Content, in a word, has emerged as the central issue of the international avant-garde.

This exhibition, the first historical investigation of the period 1974 to 1984, takes the issue of content as its conceptual focus. It has been organized to suggest a unified overview of the decade. By considering the central issue of content as it is manifested in a broad spectrum of contemporary art, we hope to reveal an underlying philosophical continuity among what heretofore has been diagnosed as merely a plurality of forms and styles.

To the extent that this exhibition embodies an analytical approach to the art of the period, it is not organized about a principle or standard of curatorial taste per se. Indeed, not every artist represented is a personal favorite of one or another of us; conversely, a number of artists deeply admired by all of us are simply not appropriate to the focus of this exhibition and therefore are not represented. Rather, our principle in selecting the artists and objects included here has been to present works that we believe to be exemplary of a historical and philosophical continuity characteristic of the art of the decade.

H.N.F.
M.McC.
P.R.

The Will to Meaning

Howard N. Fox

The American and European art of the past decade is among the liveliest and most challenging of the twentieth century. Even for an age conditioned to the radical experimentation and abrupt stylistic shifts of Modern art, developments in very recent art have seemed inordinately heterogeneous—and ultimately resistant to analysis by any Modern methodology. Under superficial scrutiny, the collective art of the period since the mid-1970s appears anomalous, contradictory, and at times even retrogressive; it seems to reflect no distinct consensus in the present and no clear direction for the future.

However, by looking closely and with a synthesizing habit of mind (one that is somewhat antithetical to the more delimiting methods of Modernist criticism, but closely parallel to the generative impulse of so much very recent art), it is possible to discern certain underlying continuities within the apparently protean art of the past ten years and to posit some conclusions about its foundations, its present state, and its continuing evolution. This much is certain: taken as a whole, contemporary art marks a major transition away from the Modernist values that had served so well for so many artistic generations of the past century.

Essential to any appreciation of the art of the past ten years is a recognition that, like the earlier avant-garde developments of the Modern age, it is self-consciously progressive and reflects a skepticism, if not precisely a rejection, of the art and artistic values that immediately preceded it. In particular, what has been challenged by so many of the most progressive artists during the past decade are certain implications, harbored in all Modernist art, about the proper concerns of the artist and the function of art in contemporary society and in the larger ongoing culture. Whereas for their Modern predecessors, the investigation of formal and material aspects of object-making came to be the highest pursuit of art, contemporary artists, operating in what may best be described as a post-Modern context,[1] are inclined to value art not exclusively (or even primarily) as a means to its own expression, but more as a vehicle to interpret other, "non-art" experience.

It was a sense of needing to "get beyond" Modernist thought that provided the catalyst for contemporary post-Modern art. But what might such Modernist principles be? The history of Modern art is so variegated, and its related ideas so complex, that discussing "Modernism" as if it were a single philosophy or a set attitude hardly seems plausible. For present purposes, however, it is possible to identify certain recurring traits and manifest ideas that by the mid-1960s had come to be described as distinctly, definitively "Modern." By then, a highly distilled and somewhat doctrinaire notion of the "Modern" object (especially as articulated more than a decade earlier in the influential writings of Clement Greenberg and reflected in the pages of *Artforum* magazine and elsewhere) had so ingrained itself in the collective imagination of the American and European art world, that it is safe to say that "Modernism" had come to be perceived, during those late days of the Modern age, as an integrated set of codified presumptions and values about art and object-making.

According to that distilled vision of it, the Modern enterprise had evolved as a revolutionary inquiry into the essential nature of visual art. Its history is a decades-long attempt to clarify and delimit the concerns appropriate to art in the twentieth century. Each of its landmark movements, from analytical Cubism and the much more radical Russian abstract movement early in the century to Minimalist art of the 1960s and early 1970s, reiterated the commitment to isolate the unique essentials of visual art and to redefine art according to its own immutable "natural" laws. In undertaking these efforts, Modernist sensibility stressed the primacy of form, fidelity to what was perceived as the "intrinsic" properties of materials, and the assertion of art as a modality apart from and indifferent to "natural" appearance and the objects of the daily world.

The Modern idea, as described here, was perhaps most fully expressed in the notion, advanced by Clement Greenberg, that the goal of Modern art was to render the modality of art "entirely optical."[2] For the Moderns, every conceivable element of art theoretically could be made knowable and visible in the physical *form* of the art object; any aspect that could not be rendered formally as a result of the manipulation of materials was a "non-art" aspect, extraneous to the proper condition of the art object. This complex of ideas, which prevailed throughout the many revolutions of Modern art, is the one that most distinctly characterizes the Modern sensibility.

As early as the 1960s, the authority—in fact, the philosophical foundations—of Modernism began to erode, so that by the mid-1970s there was general agreement among artists and critics in the United States and Europe that a major change was taking place or was about to occur. Indeed, as viewed with the advantage of hindsight, the past decade has proven to be a period of profound changes—not only of shifts in the vagabond procession of styles, movements, and personalities that constitute the "art scene" of any given season, but also of a fundamental rethinking of all the "traditional" Modern canons about art and its function in society.

The most profound artistic development of the last decade or so has been a marked shift in mainstream art from a primary concern with material and formal elements of the art object to a focus on the extra-formal content of the work of art. The term "extra-formal content" as used here refers to content in its traditional sense, denoting something that is signified, some idea to be conveyed, something intended to be interpreted, including any aspect that might come under the broad label of "subject matter": language and concept; narrative; social, political, or cultural relevance; moral issues; psychological and metaphysical concerns—in short, all those aspects traditional to visual art in the Western world that the Modernists discredited as "literary" or "thematic" values. Indeed, the central issue of post-Modernism *is* the issue of content.

At the heart of this development was the philosophical exhaustion of Modernism. Through the century, the practice of Modern art was restricted increasingly to basic material manipulations, so that by the mid-1960s the

only philosophical option left was to eliminate the object itself from the notion of art (which is precisely what happened in Conceptual art). The Modernist enterprise had depleted its potential for further significant development. It was as if certain irreducible tenets of Modern art— especially the value ascribed to the object's insularity from the non-art world in which it existed—simply became insupportable as viable artistic goals. In Minimal art such as the cubes and elemental geometric forms of Donald Judd, the black paintings of Frank Stella, and the systemic drawings of Sol LeWitt that play out basic permutations of a few simple geometric elements, the *idea* of Modernism (which is not to say its practice) reached its logical terminus; all that remained to subtract from the art object was its own material existence.

With only information left to work with, Conceptual art was born. Thus Conceptual and information-oriented art occupy a pivotal position in the decline of Modernism and what followed, assuming a dual role as both the logical finale of Modernism's reductive experiment and the nascent form of a *post*-Modern, content-oriented art. For the ironic consequence of this ultimate subtraction, which removed even the material barrier that separated the essence of art from its realization, was that it added—or, more accurately, restored—to Modern art what its reductive tendency had succeeded in taking away: the direct engagement of the intellect as an integral, even primary, component of artistic experience.

Fine art, however stylized or aestheticized, traditionally had been put at the service of moral, spiritual, and social values—in short, at the service of the mind. Indeed, despite the prophetic nonobjective experiments of the early-twentieth-century avant-garde, it was not until the late Modern period, during the 1960s, that visual art came to define its aesthetic success in terms of wholly sensate experience. Conceptual art undercut that anti-intellectual bias and restored to mainstream twentieth-century art the intellectual function that Modernism had succeeded in eroding. We can now conclude that the lasting significance of Conceptual art lies not in its radical, nonmaterial methodology of investigating the nature of art, but rather in its establishment of a new attitude—or at least one antithetical to the Modern idea—that suggested basic conceptualization as the primary substance of art. Thus, while Conceptual art may have been the inevitable outcome of Modernist practice and methodology, it was also the inception of post-Modern thought. At root, Conceptual art was forged by a defining post-Modern value: the will to meaning.

• • •

It is useful to consider here the remarkable breadth of concerns upon which contemporary artists have trained this animating force, this will to meaning, in their work. By the mid-1970s, there had already been significant innovation in the areas of language- and concept-oriented art, land projects, and physically confrontational structures by artists who turned

away from the context of the self-reflexive art object and the process of its manufacture, discovering through their art a means instead to engage and comprehend the world external to it, the world we live in. Nancy Holt's *Sun Tunnels*, for example, are not merely huge elemental forms of cast concrete, but are instruments, so to speak, that depend for their artistic lives on the entire celestial universe beyond their concrete hollowness. To properly experience them, one would have to live in them every day and night for a year; only on the solstices would their precise alignment to the sun's rising and setting be apparent. Like Stonehenge, the *Sun Tunnels* focus the viewer's attention on the heavens; the pipes are aligned to the solstices, and the precisely positioned holes in their surfaces, which formally are negative spaces, are intended as windows to particular constellations; thus the *Tunnels*, far from being merely the self-reflexive "primary structures" that they might have been described as a decade earlier, are extraordinary sculptural conduits to everything that lies outside of themselves.

Thus, with his diagnosis of an "emotional weariness" with its underlying issues, Morris implies an ethical malaise as well as a logical exhaustion with the Modern formalism. Moreover, given the disturbing conditions of contemporary existence—the moral enigma of the Viet Nam war, the revelations of Watergate, the recognition of man's often devastating encroachments upon nature, worldwide energy shortages, the emergence of new world powers, shifts in the international political order, and the threat of complete annihilation by nuclear warfare—it is inconceivable that artists would not respond through their work. Indeed, the period of the last ten years is notable for the pronounced resurgence of politically and socially oriented art, with many of the most influential artists addressing issues ranging from modern urban experience to international political harmony. Laurie Anderson's art in all its forms—objects, installations, synthesized music, and multimedia performances—characteristically has dealt with individual response to the daily tragicomedy of contemporary American experience. Vito Acconci uses language, visual symbols, logos, and other signage appropriated from popular culture to confront viewers, usually by surprise, with their own ideological presumptions and beliefs. And Joseph Beuys, with an almost prophetic tone, seeks to establish through his objects, his public dialogues, and the forum of the Free International University for Creativity and Interdisciplinary Research, which he founded in Düsseldorf in the early 1970s, a universal community of ideas within a world of flux.

Just as larger world events have precipitated a critical rethinking of art's social function, so too have changing notions of the artist's relationship to the past brought about a reconsideration of the position of contemporary art within the time line of art history and in Western culture generally. Whereas the Modern avant-garde, wary of the tyranny of the past, emphasized rebelliousness and the discontinuity of human culture, many contemporary artists seem more impelled to associate their art with relevant art from other periods and to affirm the value of an ongoing culture. This desire to establish connections of the present with the past is not a question of mere stylistic affinities, but—once again—an ethical issue,

in which the Modern insistence on stylistic and material innovation is of secondary importance to the identification, interpretation, and critique of larger cultural values.

Although this tendency has been criticized by some as retrogressive and counter to cultural evolution, the embracing of the past in the 1970s and 1980s tends far less toward outright imitation than toward inquiry and adaptation. Even when recent art does copy the past—as in Vitaly Komar and Alesander Melamid's satirical depictions of Joseph Stalin painted in a pastiche of archaic grand styles, or in Carlo Maria Mariani's imitations of academic neoclassical painting that challenge fashion, taste, and the Modern predilection for originality, especially in matters of style—the implications for content are often apparently deliberate. But generally, contemporary art's echoes of the past are no more retrograde than the Renaissance's probing of antiquity or of Modern primitivism's discovery of tribal art; indeed, many contemporary artists have found new sources of expression in areas where it was previously proscribed by conventions of taste and progressive thinking.

Following a period philosophically so disposed to the exclusion of all reference or recourse to the external world from its art objects, this shift was radical indeed. And once this sort of subject matter—nothing less than the process of thought itself and its operation on how we perceive and order the world—was introduced into art, it was inevitable that other extra-formal subject matter would follow.

This inevitability is clearly played out in the example of Robert Morris, whose cubes and other geometric solids of the 1960s ultimately gave way to highly political art—ruminations on death and nuclear destruction—in the 1980s. Reflecting on the decline of Modernism and its devolution into what he described as "decorative" elements and "a gigantic failure of imagination," Robert Morris has asked,

Have we become less concerned with absolutes, with our place in the universe and with our own individual mortality? In some sense I believe we have. It has not been just a matter of the exhaustion of modernist forms. An emotional weariness with what underlies them has occurred. I would suggest that the shift has occurred with the growing awareness of the more global threats to the existence of life itself.[3]

Beyond the indifferent physical world and beyond man's social and cultural world is what might be called the transrational world of dreams, personal vision, and metaphysical concerns. While Surrealism, Fauvism, and other Symbolist-derived art in the twentieth century have certainly been rooted in the expression of spiritual and psychological subjects, such art historically has been regarded as somehow *un*-Modern and of secondary importance to more formally oriented movements such as analytical Cubism, the Russian avant-garde, the innovations of Bauhaus and de Stijl, and so on. But in post-Modern art, those transrational subject areas are of cardinal importance, inspiring art of the richest visual and spiritual grandeur.

Building on signs and symbols, archetypes, myth, metaphor, and allegory, many contemporary artists have sought to render the intangible world of the mind or the soul accessible through art. For instance, Jonathan Borofsky's often congested installations—consisting of drawings made directly on the wall, kinetic statues, and a glut of other clutter that might range from litter, to ping-pong tables, to handwritten pages of counting, numbering from one to infinity—originate as dream- or trance-induced images to which the artist gives incarnate form. The vast paintings of Julian Schnabel, as heroic in scale as in conception, are usually abstract and gestural but with a heavy dose of traditional iconography and religious imagery and suggest interpretations dealing with the eternal struggle to comprehend life and death forces. More overtly mystical in spirit are the paintings and mosaics of Mimmo Paladino, which, drawing heavily upon sources in Etruscan art, depict a mysterious world, somewhere between the physical and the metaphysical, of animals and humans, bodies and souls, all animated by an ineffable primal force. And Alice Aycock's elegant yet dangerous-looking machines are an attempt to represent the very force of consciousness and life itself as an impersonal, quasimechanistic force that pulses through all being, energizing and giving it purpose.

●　●　●

All of this interest in overt subject matter in such diverse kinds of art suggests some broader considerations about the deeper nature of contemporary art. Of all the attributes that characterize Modern art, none is so distinguishing as its inherent empiricism. All of its particular qualities— its self-referentiality, its freedom from "literary" ideas, its primary focus on style and form—reduce themselves to a literalist habit of mind that is nowhere more cogently summed up than in the famous dictum of one of late Modernism's masters, Frank Stella: "What you see is what you see."[4] The Modern idea, expressed in its fullest theoretical development (as it was by artists from Kasimir Malevich to Brice Marden) was that every artistic aspect of the work be discernable (knowable) in the inherent physical and formal properties of the art object and that the viewer be able to experience the art object entirely by looking at it. Any response other than one visually induced by what was said to inhere specifically in the object simply was not part of its program; indeed, *seeing* was what Modernism came to be all about.

Surely that is a plausible goal for the visual arts. But for many artists, seeing eventually came to represent a certain kind of intellectual and moral blindness. Visual response, whatever it may consist of, is essentially a private, sensate experience. As a phenomenon, it is independent of the communication of shared values and the propagation of a culture. The disparity between private experience and shared values reflects the antipodal relationship between progressive contemporary art and what it

departs from. Post-Modern art, however eccentric and personal it may appear, is given to the expression and exploration of shareable experience and values. Emotional and intellectual "values" are precisely the cultural elements that Modernism tried to distill out in its quest for an autonomous art; such values are assigned and perceived or imagined by the audience in complicity with the artist's intention. The communication of such information involves a subtle transaction, a tacit engagement between artist and viewer that nowhere is to be found "in" the object. And that transaction is a kind of pretense, a kind of willing suspension of disbelief, a kind of theater.

Theatricality can be described as one of the defining properties of post-Modern art. "Theatrical" implies many qualities, an obvious one being the proclivity for exaggerated expression or extravagant gesture—stylistic qualities often attributed to contemporary "neo-expressionism." But there is a more profound idea of theatricality to be considered here. The term describes the basic operational structure of much contemporary art in which one reality is revealed or implied in terms of another. Theatricality may be defined in a post-Modern context as the propensity of a work of art to reveal itself in the mind of the viewer as something other than what it is known empirically to be.

Here, then, is the key to post-Modern response: Rather than to see the object for what it is, as the Modern aesthetic would require ("what you see is what you see"), the post-Modern response is to see the object for something that it is *not*—that is, to seek in the object something that is implied, or suggested, but that empirically is not "there."

The post-Modern art object is *not* a complete manifestation in and of itself, but rather is evidence, signification, news of something other than itself. In Hanne Darboven's drawings, for example, we look not for a drawing with certain qualities of line, texture, or other formal properties, but rather for an existential expression of the inner desire to know, to comprehend. To appreciate Darboven's work as she intends, we must seek in it not what is formally manifested and rendered "entirely optical," as Clement Greenberg would have asserted, but something that is in fact not there. Her works are overwhelming accumulations of page after page of carefully controlled, systematized scribbling that implies a content by its very appeal to the intellect. Resembling writing but signifying nothing that is directly intelligible, her endless scrawling in highly structured formats—charts, tables, calendars—implies a compulsion to signify almost anything at all. In Darboven's art, specific meaning plays no role; rather, her works are monumental manifestations of the pure desire for meaning. Her statement that "going on is the enormous thing I do"[5] is a sublime, existential expression that reflects not so much the artist's endurance in the endless Sisyphean task of filling empty pages with empty writing as it does the boundless will of the artist to mean, to communicate, to convey. It is a statement of desire, rather than of mere survival.

The post-Modern art object corresponds to ideas, conditions, experiences that it does not contain but rather that it describes by analogy, metaphor, symbol, or allegory. It demands that the viewer seek and find in it correspondences or restatements of all that exists outside it. Post-Modern art aspires to the condition of non-art, and is an interpretation of the non-art universe. Post-Modern art entails not just seeing, but thinking; it addresses not just the eye, but the mind's eye.

The post-Modern aesthetic restores to contemporary art in its many guises the Aristotelian dual function of art, which was both to delight (through its form) and to instruct or reveal (through its content). It also supports the notion of art's function as a moral agent, and, indirectly, of the artist's obligation to something beyond the aesthetics of the object. By contrast, the Modern aesthetic seems to harbor a fundamental mistrust of art itself. This mistrust can be traced beyond Aristotle to the judgment of his teacher Plato, who reasoned that the content or idea in art—what he described as Truth—was divisible from physical form, and that the art object itself was therefore a deception, a mere imitation of Truth. In Plato's reasoning, it followed that such a deception perpetuated false knowledge—*unreality*—and impaired reason, which was man's highest faculty to discern Truth. For Plato, art was a betrayal of Truth.

The Modern idea, like Platonic thought, represented a search for certainty. Over the decades its quest—and its objects—became fixated on the demonstration of particulars. Sharing Plato's mistrust of art, Modern aesthetics "reconciled" the Platonic dissociation of content and physical manifestation by re-defining, or de-defining, content *as* form. Modernism's contribution, so revolutionary in the history of art, was the premise that physical forms ought exist *not* as the carriers of ideas, but exclusive of them, as absolute entities to be experienced for their own attributes. In asserting its value as amoral, the Moderns thus had succeeded in reversing the traditional Western idea of art as a moral agent.

The post-Modern aesthetic more closely follows the Aristotelian argument (traditionally understood to be the protégé's answer to his mentor), asserting the moral value of art in its capacity both to delight the senses and to reveal Truth through its (extra-formal) content. Such traditional ideas hardly seem revolutionary in the history of Western thought, but within a post-Modern context that moral aspiration represents a revolutionary break with the dominant artistic thought of our century.

How curious it is, then, to encounter the widespread misreading, especially among admirers of the Modern avant-garde, that contemporary art is anarchic, indulgent, and reflective of a retreat from the rigors of Modernist idealism. As early as 1974, Harold Rosenberg was lamenting what he saw as a post-Modern malaise:

People speak of "post-modern." They have in mind not a more advanced position

than modernism, but on the contrary, a relaxation, a stopping short, or even a return to a state preceding the modernist excitement. Post-modernism is the epoch of worn out ideologies. ... No more vanguards, systems, dreams. No more radical tradition. Yet post-modernism is not a "return to solid principles." It is innovation without aim, a policy of eccentricity—the mental habits of modernism but lacking its expectations.[6]

Rosenberg's lament is still being heard from a variety of sources. "Ours is now a culture without a focus or a center," wrote Hilton Kramer in 1980, wondering aloud whether we are "condemned ... in the art of the '80s to remain in a perpetual whirl of countervailing and contradictory styles and attitudes"; he concluded that the "eager embrace of art of every persuasion ... satisfies our hearty new appetite for esthetic experience while requiring nothing from us in the way of commitment or belief."[7] Two years later, Kramer amplified his disapprobation of contemporary art and culture: at stake in the widespread "defections from modernist orthodoxy," as he aptly described it, is nothing less than "the concept of seriousness," for it is facing an insidious challenge by a pervasive attitude of cultural facetiousness— which Kramer identified as "Camp"—that has signaled "the decline of the modernist outlook and its absorption into the looser, less stringent, and more avowedly hedonistic and opportunistic standards of postmodernist culture. ... [It is] a betrayal of the high purposes and moral grandeur of modernism in its heyday."[8]

The proliferation of post-Modern styles has also troubled Hal Foster:

We exist, we say, in a state of pluralism: no style or even mode of art is dominant and no critical position is orthodox. Yet this state is also a position, and this position, it is now clear, is also an excuse—an excuse for art *and* criticism that are more indulgent than free. ... For in a pluralist state, art tends to be dispersed and so rendered impotent.[9]

Significantly, all of these critiques of contemporary culture turn on the issue of "pluralism"—that is, on the perception, all but impossible to avoid, of the unprecedented diversity of artistic styles that seemed to sprout and flourish simultaneously in the mid-1970s. But although it was much touted and debated, pluralism now appears to have been an apocryphal issue.

The very term "pluralism" is, to begin with, not a particularly useful one. Lacking any analytical significance, it was merely a rubric conjured up to denote a condition, a general circumstance, in which art found itself at the time; it does not address any of the properties of that art. As a concept, pluralism is misleading, for it is not properly an "ism," and its invocation betrays a superficial reading of contemporary art.

Furthermore, no stylistic or formalist account of contemporary art—and the pluralist argument is just that—could adequately explain the art of the last decade, whose continuing evolution resists stylistic categorization and whose most ambitious work is not generated by formal concerns in any case. Perhaps all the false attention devoted to the stylistic pluralism of the 1970s and 1980s has obscured a much more significant and deeply ingrained philosophical continuity that informs a broad diversity of forms

and fashions in contemporary art. The flaw in the critical concept of pluralism is the error of too much *looking* at objects; pluralism is at heart a Modernist issue, a stylistically and formally oriented one, that quite simply does not comport with the art it attempts to critique.

The genius of contemporary art is to be sought not in new stylistic inventions—to the contrary, current art derives many of its stylistic conventions from Modern and traditional art sources—but rather in its creators' intentionality, the decidedly post-Modern way in which they conceive art and art-making as establishing ties, not breaking them, between their art and the larger cultural and physical world surrounding it. If there is a unifying element that can be discerned among the diverse strains of contemporary art, it is in the establishment of such ties, which are its content, its purpose, its idealism and progressive spirit. What is generic to the contemporary avant-garde is the way it departs, as an inevitable evolutional process, from the anti-intellectualism of an academicized Modernism that has fulfilled its natural history.

In post-Modern culture, a work of art is successful not to the degree that it violates or refutes Modern values, but to the degree that, as a historical process, it moves beyond them, synthesizing and integrating artistic form with non-art content. The revelation and exploration of such content, and the furthering of shareable experience and values are the purpose of contemporary art. And far from "requiring nothing from us in the way of commitment or belief,"[10] post-Modern contemporary art requires everything from us in the way of commitment and belief. Post-Modern art is *about* believing and the will to meaning—that is, the aspiration that the content of the art object correspond to both the real world and the world of ideas, and the faith that it may mediate between them.

If the "high purposes and moral grandeur"[11] of all this have gone unrecognized in some quarters, it may well be that the evaluation of post-Modern culture is being subjected to Modern ideals and a nostalgia for them. One of the most persistent and, by contemporary values, errant of Modern notions is the presumption that progressive artistic activity must adopt an adversary posture to the larger culture; Modernism defined the avant-garde as hostile to the bourgeois parent culture. If that potent hostility is not so much in evidence in contemporary art, it does not necessarily follow that there is no longer a progressive avant-garde. Rather, it suggests that as part of the critical conscience of the age there has been a redefinition of the role of art and artists.

Thus there is much to consider in a statement such as Robert Longo's, which might be that of any number of contemporary artists, that "artists are like the guardians of culture. I'm totally obsessed with the idea of human value. I feel like I'm contributing to my culture, posing certain questions about living and the pressures of living today."[12] The humanism implied in Longo's statement reflects the artistic temper of the current decade and suggests that taken collectively, contemporary art represents a thoughtful and often daring attempt, motivated by the liveliest idealism, not to provoke an indifferent culture but to create a new one.

NOTES

1. The nomenclature of "post-Modern," sometimes written "Postmodern" or "Post-Modern," has been the subject of much critical debate in the past decade. Eluding a universally agreed upon meaning, it seems to be defined anew by each critic using the term. The word "post-Modern" is used in this essay not as a critical terminology that denotes an "ism" or particular system of thought or a style, but rather as a descriptive term that refers to works of art which, for the most part, have been produced in the past decade and which, taken collectively, evince an aesthetic outlook that, as described in the text, departs from certain Modern orthodoxies.

2. Clement Greenberg, "The New Sculpture," in idem, *Art and Culture* (Boston: Beacon Press, 1961), p. 144.

3. Robert Morris, "American Quartet," *Art in America* 69 (December 1981): 104.

4. Frank Stella, in William S. Rubin, *Frank Stella* (New York: Museum of Modern Art, 1970), p. 42.

5. Hanne Darboven, in Lucy R. Lippard, "Hanne Darboven: Deep in Numbers," *Artforum* 12 (October 1973): 37.

6. Harold Rosenberg, "Art and Politics (from the Note Book)," *Partisan Review* 41, no. 3 (1974): 383–84.

7. Hilton Kramer, "Today's Avant-Garde Artists Have Lost the Power to Shock," *New York Times*, November 16, 1980, sec. 2, p. 27.

8. Hilton Kramer, "Postmodern: Art and Culture in the 1980s," *The New Criterion* 1 (September 1982): 36–42.

9. Hal Foster, "The Problem of Pluralism," *Art in America* 70 (January 1982): 9.

10. See note 7, above.

11. See note 8, above.

12. Robert Longo, in Michael Brenson, "Artists Grapple with New Realities," *New York Times*, May 15, 1983, sec. 2, p. 30.

CONTENT: MAKING MEANING AND REFERENTIALITY

Miranda McClintic

Content—rather than form—has become the central concern of much of the best art produced during the past ten years. A prominent characteristic of artistic and critical attention during this decade has been a turning away from a focus on art that defined itself as a discrete object separated from the world by unique and specific material properties toward an art that involves itself with the "life-world" in which it evolves.[1] Questions of meaning, referentiality, signification, and intention have become crucial considerations for artist, critic, and viewer. Much work today refutes the ideal of art as a contemplative, specialized experience that is removed from everyday life, self-referential and valuable only in aesthetic terms. Rather, it is engaged, provocative, dependent on mundane association, and demanding of interpretation. The art under discussion here is no longer limited to "what you see is what you see."[2] In adopting a contextual approach in which referents external to the art object are essential to its meaning, art now demands to be considered on more than its face value.

The content of any work of art has to do with what is of greatest, most essential significance to it. Works of art generate particular meanings that have to do with the artist's intention, the over-all cultural context, and the relation of the viewer to the work of art. The shared assumption of the works selected for inclusion in this exhibition is that the work of art signifies something beyond itself and makes that intention explicit. That "something" can fall anywhere in the entire gamut of human experience, from the most objective and commonplace denominators of reality as reflected by mass media to archetypal images belonging to the universal unconscious.

Referentiality has replaced innovation as the primary concern of many artists in the last ten years. There has been a shift in emphasis away from definition by medium to definition by content. This can be seen as the most recent stage in an ongoing self-conscious examination of the essential properties of "Art" that began in the sixties. During much of that decade the serious business of art was to reduce the formal and material properties of painting and sculpture to their most potent fundamentals, on the assumption that the great purpose of each art form could be realized only by expressing the physical qualities inherent in and unique to a particular medium. This kind of concentration produces powerful, though highly specialized, works of art; yet, such self-reflexive statements no longer constitute the most "advanced" art practiced today.

Another approach, represented by Pop art and New Image painting, moved away from the integrity of artistic statement toward the creation of imagery that was strong in impact. The appeal of much of this work was, like that of Minimal art, primarily visual, but in adapting images and techniques from the world of popular culture, Pop and New Image referred art to the everyday world. This mundane focus was also central to the artists who in the late sixties and early seventies turned their backs on the commercial, high-technology world and moved their bodies and their works out into nature. The raison d'être of Conceptual art separated it from all the preceding strategies by promoting the importance of idea over sensation. In this kind of work the physical realization of intellectual and

philosophical premises related to art was regarded as incidental to its essential meaning.

All of these pursuits or foci of attention had been assimilated, mastered, or taken for granted by the most adventurous artists of the early seventies. By 1974, when the period covered by this exhibition began, a new interest developed in the world of contemporary art: a concern for content that is not strictly inherent in the art object but refers outward from it. Such works of art constitute a dialogue between the artists and the most powerful forces that determine contemporary experience. The dialogue and the points of reference are the content of the work. Many artists see and assert themselves as witnesses to our time; their work has an "I was there" quality by which the artists effect a transition from personal to universal themes and through which we, the viewers, become involved and implicated in the situations that these artists present.

The interests of contemporary artists are wide ranging, and their approaches can be emotionally expressive or documentarily analytic with equal validity. No matter how intensely personal in point of view or mode of address (the works of Louisa Chase and Jonathan Borofsky are exemplary in this regard), the references are recognizable. On the other hand, even with the most public form of address—such as that used by Lawrence Weiner or Jenny Holzer—the idiosyncratic quality of their messages separates the works decisively from the commercial announcements whose form they adopt. Focusing on particular circumstances, these artists seek to establish or reveal the relationships of particular incidents to universal conditions. As one critic notes, there is much evidence of artists "recovering themes which belong to the whole social community rather than to the individual artist"[3] through the associations made in their work. They assertively deny the existence of the gap that Robert Rauschenberg once said separates art and life.[4] Such artists show us how they see the world, even as they direct our attention to certain aspects of it. By representing natural, cultural, or metaphysical phenomena with reference to the context in which they personally experience them, these artists go beyond purely subjective expression toward collective content.

Any work of art necessarily depends on form as well as content. These components are interdependent, and neither the artist nor the critic can avoid attending to both. In the past ten years, however, the prevailing emphasis in criticism as well as in the making of art has been on content rather than form—a marked contrast with the decade before. A selection of titles of recent articles and exhibitions indicates both the specificity and the broad range of what is currently considered significant in art: Transcendent Anti-Fetishism; Allegorical Procedures: Appropriation and Montage in Contemporary Art; About Pictures; Zeitgeist; Social Commentary; The Expressive Fallacy; The Uses of Representation; Epistemological T.V.; The Allegorical Impulse; and The Private and the Public: Feminist Art in California. The reasons for this shift of critical concern, which both parallels and reflects the accent in art-making activity,

have been presented by Thomas McEvilley who succinctly enumerated what the writing of many critics now presumes:

(1) That there are serious omissions in formalist theory in the areas of content and intentionality, and that these omissions result from illogical assumptions at the very root of the theory; (2) that these illogical assumptions are specific to our culture in the postwar period and are not confirmed by the practice of other cultures and times; (3) that the "purely optical" theory is inadequate to account for the art experience; (4) that elements from outside the physical world cannot be excluded from any human mode of relating to the work, and that this is not a matter of personal decision but an outright impossibility; (5) that there is no apparent justification for denying that an artwork's conceptual resonances are as much a part of it as its esthetic resonances; (6) that the artist's intentions, when they are known or recoverable, cannot be neglected and in fact never are, though the critic might pretend that they are; (7) that the artwork exists in a context of both the viewer's and the artist's sensibilities with all the conditioning and acculturation involved in them—it exists, in other words, not as an isolated absolute or an end in itself, but as a rounded cultural object which relates to philosophy, politics, psychology, religion, and so forth; and (8) that the ultimate criticism of an artwork would be a multileveled complex of interpenetrated semantic realms which would virtually contain the cultural universe in miniature, and that since the same is true of any cultural object, the artwork has no privileged status outside the affections of its devotees.[5]

Instead of being self-referential, today's most characteristic works refer outward from themselves toward a larger context, proclaiming their relationship to life and drawing upon and addressing realms of experience that have been the province of art throughout history until the recent past. The freedom of access to the art of all times and places that is enjoyed by artists, critics, and viewers has made everyone aware of the many different ways art has been practiced, and has allowed artists to choose their precedents to suit their personal predilections. Most of the best artists look to the past as well as the present for ways to express a unique point of view about the world from which they come and in which they live.

The wider intellectual milieu that informs contemporary art is dominated by the philosophies of Roland Barthes, Jacques Lacan, Jacques Derrida, Edmund Husserl, and the observations of Claude Lévi-Strauss, Walter Benjamin, and John Cage. The conceptional and methodological premises of structuralism, semiotics, transactional analysis, Marxism, and cultural anthropology have all been incorporated into the way art is made as well as seen. The artwork is neither neutral nor objective, but incorporates value systems, fundamental assumptions, and points of reference characteristic of the world in which it is made.

Other crucial influences on the content of recent art have to do with fundamental redeterminations of the place of art in today's world, both theoretically and literally. The critic David Ross points out that much contemporary work "tends to blur the distinctions between art and reality, and even proposes the two are the same or should be. Artists ... are exploring the perceptual and conceptual implications of [their working] process in a manner that is specifically directed toward the breaking down of the specialized and categorical nature of the art experience and to the

creation of a holistic view of art activity as a generalized case of communication."[6] Allegorical, philosophical, and political concerns are as important as formal considerations. Data and methodologies from advertising, anthropology, archaeology, architecture, film, linguistics, literature, popular television, and experimental science—areas previously considered extrinsic to art—are often central to it. In this exhibition we have focused our attention on work whose raison d'être is meaning that refers to or derives from the world at large.

During the past decade, art has been informed by and has addressed all realms of intellectual, cultural, natural, and metaphysical experience. Artists have had encyclopedic access to information, so their references to these realms are limited by neither time nor space. Variously familiar or exotic, and variously different in value, innumerable aspects of human experience have been treated as equally appropriate to art. These have been used freely, with regard for original significance but with the intention of reassigning, realigning, or layering meaning to create something that is expressive of the ideas and feelings of a particular human being operating under particular circumstances.

The intellectual and emotional shift from an aesthetic realm to the real world corresponds to the physical shifting of art into mundane settings. The increased functioning of art outside the gallery and museum context—in alternate spaces, the streets, subways, night clubs, and remote landscapes—permits and necessitates different means of expression. Place becomes part of the content of the work in installations and performances. In a broader context, art has become decentralized during the past decade from a concentration on making, showing, and telling in New York City to centers of production and exhibition throughout the United States and western Europe. Further, the prevailing direction of cultural, economic, and political influence has shifted from the dominance of the United States to a more dynamic balance, further opening up art to new influences and possibilities. There seems to be an ever-expanding audience and market for many different kinds of art. The fact that there are now considerably more ways art can function in the world—as well as more ways that the world is incorporated into art—than there were ten years ago is central to any discussion of content in art.

Of the many kinds of content that have been important to art during the past decade, the most significant in terms of both volume and quality of work are structures of conception and perception, autobiography and persona, "high" and popular culture, social (sexual, communal, political) content, the natural world, and psychological, spiritual, and metaphysical content.

MAKING MEANING

The content of much contemporary art is the investigation of meaning itself, extending a Dada/Duchampian approach to reality from the realm of objects to that of ideas. Such content has to do with the means of reference, the methods used to communicate experience and

understanding, signs and structures of thought. Meaning is created, not assumed; inherited but not inherent.

During the seventies, Conceptual artists called into question the fundamental principles of art. What is the subject of art? What is its proper purpose, definition, and content? The consensus reached by Conceptual artists through a wide variety of investigations—some of which are represented by works in this exhibition—was that art could be anything that it said it was (just as Duchamp had proven sixty years before) and that art need not be a hand-crafted object.

Since the seventies, many artists have explored the meaning of art through the use of language and constructed a critique of language through its visualizations. Metaphor and allegory; sign and symbol; appropriation; narrative; diaristic recording; displacement, disjunction, and dislocation; re-presentation and replication; and visual and verbal punning are all structures of conception and perception. They are all strategies for seeing and interpreting the world. As photography has repeatedly demonstrated in the last decade, there is no such thing as objective reality. It is an imaginative construct. In works of art that are about the language of understanding, all meanings—and meaning itself—are shown to be assigned, assumed, or assimilated. They are not absolutes. Context must be taken into account as a critical component of any image or situation. Lest this sound too doctrinaire, much of this kind of art also provides evidence that humor is, as Freud once suggested, indicative of intellectual substance.

Language-related works are all predicated on the assumption that art, like language, is one of the fundamental cultural determinants of the way we perceive and conceive reality. Art that is conceptual sets forth and clearly proves this belief before our eyes. It is didactic in its demonstration of the arbitrary character of the words and symbols by which we define our life-world and of our power to make our own meanings out of anything. Art that is primarily conceptual in content is also generally analytical, wordy, and ambiguous. It is existential as well as structural philosophically. To establish an "objective" image against which these associative issues are played off, such work is often photographically or otherwise mechanically produced or rendered.

The principal ways of working within this genre communicate meaning in a forthright manner. The most primitive forms of language—archaic signs and symbols endowed with magical powers and universal meaning—are recalled in the hieroglyphic forms used by Keith Haring, A. R. Penck, and Susan Rothenberg. Fundamental questions of identity constitute the central issues raised in works by John Baldessari, Marcel Broodthaers, and Joseph Kosuth. Structural questions of syntax and context are addressed by Robert Barry, Jo Ann Callis, Vernon Fisher, Denise Green, and Douglas Heubler.

Dealing in different terms and systems derived from sources as diverse as primitive art and television, contemporary artists have conducted linguistic investigations into the nature of thought and perception. At the two

extremes of conceptual re-presentation are Lawrence Weiner, whose works consist entirely of words, and Jo Ann Callis, whose works involve only images, but in all cases such art shows us that meaning is assigned through structure, context, and accustomed usage.

AUTOBIOGRAPHY AND PERSONA

Works that declare the artists' personal experiences—in the form of either autobiography or persona—have appeared throughout the decade in numbers unprecedented in the history of art. Autobiography and the adoption of a persona are literary re-presentations that maximize the presence of the artist in the work and ensure the inclusion of a wide range of real life-world issues. Presented in the first person, this art is similar in many ways to performance art, in which the artist is actually indistinguishable from the work. It is immediate in character, possessed of an aura of authenticity, and revealing of a particular personality (real or assumed). Highly subjective and filled with commonplace details of life, such work also emphasizes the analytic or narrative structure that shapes the re-presented experience. It ranges from the diaristic recording of Hanne Darboven and William Wiley; to the photographic self-documentation of Hamish Fulton, Gilbert and George, Richard Long, and Lucas Samaras; to the fablelike autobiography of Vernon Fisher's constructed paintings, which leave unclear whether the "I" is actually the artist or a symbolic alterego; to the theatrically created persona of Eleanor Antin and Cindy Sherman.

Such work is conceptual in its selective assumption of a self-conscious mode of address. Personal revelation, exhibition, and exhibitionism—present to varying degrees in all these works—range from Jonathan Borofsky's projection of the innermost reaches of the psyche or Vito Acconci's evocation of embarrassing secrets to a theoretically objective recording of daily existence. These works are also significant in that the cultural phenomena they identify reflect our collective contemporary experience as well as the personal experience of the artist. Symbols typical of Terry Allen's native southwest are symbolic of all America. The melodramatic scenarios reflected in Cindy Sherman's photographs are meaningful to us all because of our exposure to the movie and soap opera sources to which she refers. Joseph Beuys's icons are particular to his own biography, but are imbued with mythic and political import by their relation to a more universal unconscious as well.

Hanne Darboven's work is affirmative of her personal identity and thus of life itself. Artists such as Hermann Nitsch, Walter Pichler, Paul Thek, and William Wiley, who work in a semimystical, shamanistic mode, are in many ways the least self-conscious about their identification with their work. They simply do what they do—and let other people respond to it as art.

Real or fictitious, such self-created biographies are at once form and content. In this kind of work artists have devised a format that presents broad possibilities for working in the modes particularly characteristic of our period—allusion, appropriation, diaristic recording, displacement, and

re-presentation—and for addressing issues that seem most deserving of attention. The content of work based on autobiography or persona-biography depends on sociology, history, and psychology, and often represents a political stance as well. The strong verbal component in much of this work ranges from the private writing of Hanne Darboven, to Vito Acconci's incantations, to the songs of Terry Allen and Laurie Anderson.

CONTEMPORARY CULTURE

A great deal of art produced in the last ten years refers directly to elements of high and popular culture. The meanings of works that incorporate cultural symbols, subject matter, or means of representation depend on the familiarity of particular referents. Such works of art are not predicated on an assumption that art reveals or supports commonly held beliefs or eternal truths. Rather, they presume that it is culture that gives meaning to our experience of life, and that art generates its own meaning by reference to recognizable phenomena of contemporary culture. All works that allude to contemporary culture reflect a particular artist's personal definition of and relation to it. Such art exists in dialogue with what these artists posit in their works as the dominant cultural experience and makes new meanings from what is commonly deemed "meaningful" in our culture. When artists include loaded cultural content in their work, they generally do so in a revisionist or critical spirit and from a particular, deliberately distanced point of view.

HIGH CULTURE

The aspects of "high" culture most frequently addressed are art, literature, history, myth and ritual, and Christianity. The wealth of these allusions attests to a multivalent culture and to the high level of education common among today's artists. Carefully chosen references to art of other times and places for purposes of enrichment of meaning or legitimization through association have been common in art since the Roman Empire. An artist's—or a society's—attitude toward the referent is an important determinant of the character of the work of art at hand. References can be quotations of style or specific formal configurations. In contemporary art, artists frequently assign a new meaning to an image or theme that has an established significance in the history of art, commenting on the original source by using it in a different context. Artists as diverse as Carlos Almaraz, Eleanor Antin, Francesco Clemente, Robert Colescott, Jörg Immendorff, Jannis Kounellis, Robert Morris, Susan Rothenberg, and Nancy Spero transpose images from sources as wide ranging as an Aztec ceremonial mask, a Winslow Homer lithograph, Indian miniatures, classical Greek sculpture, primitive cave painting, and medieval manuscripts. These artists use such allusions not only to reinforce the evocative power of their work but also to direct the viewers' attention to a sphere of meanings beyond those directly evident in a particular art object. Understanding of the artist's intention and of the work's fullest significance depends on recognition of the references and the nature of the dialogue with the source implied by its use in a particular context.

Whenever artists incorporate literary, philosophical, or historical references in their art, the focus may range from specific to categorical, and correspondence may vary from literal to tangential. Since these areas are external to art, however, interpretation of depicted personages or events (whether real or fictional) may be suggested by means of title or internal text. In *Day of the Locust*, Malcolm Morely uses the title of Nathaniel West's short story to reinforce the cataclysmic destruction of the world of his pictorial invention that is summarized by his painting. By contrast, Helen Mayer and Newton Harrison's *Meditation on the Gabrielino* is a poetic presentation of a historic episode of destruction.

Art has played a central role in the creation and perpetuation of myths, in the elaboration of ritual, and in the interpretation of religion since the beginning of human culture. Although these matters were major foci of artistic expression in western European society until the early nineteenth century, from that time until the recent past the increasingly specialized and self-referential purposes of art have moved in an opposite direction. Since the late sixties, however, artists have looked to the sources of culture as found in myth, ritual, and religion—and they have treated such subjects in a variety of ways. The fundamental assumption in works that refer to these areas of experience is that art plays a mediating role between nature and culture. Through such art, society comes to grips with the primal and the elemental, with fundamental instincts and universal relationships. This kind of art takes forms as various as painted Greek myths with timeless messages and temporally inconsistent details (Earl Staley); models of classical architecture evoking the grandeur and the fragility of civilization (Anne and Patrick Poirier); massive projects in the landscape that engage such forces as lightning or the sun in relation to a humanly structured order (Nancy Holt); enacted ceremonies of evisceration and sacrifice (Hermann Nitsch); a primal encounter of man and beast, civilization, and instinct (Joseph Beuys); mass-produced Christian icons stood on their heads, separated from today's life by a pane of glass (Italo Scanga); and a crucifix, dedicated to a contemporary martyr, made in a potent vernacular style (Michael Tracy). Works that have mythical, ritualistic, and religious content evoke ancient and exotic cultures, but how the sources are used has relevance to our experience of life today. Artists who work in this manner look to other cultures for ways of making meaning, and freely adopt and adapt what they find to our contemporary situation.

POPULAR CULTURE

Images and styles of popular culture have been an explicit part of the content of "high" art since the last half of the nineteenth century, although influences of popular culture are evident in the art of earlier periods. Twentieth-century art includes many references to popular culture, but before the Pop art of the 1960s, most of these references were "asides," decorative or descriptive details, rather than central elements in the meaning of a work of art.

Pop art made the icons and techniques of popular culture its subject. Focusing on the forms that are common denominators of contemporary

culture, this art showed us, by means of changed context and emphasis, how such images look and how to look at them. Wide-ranging and recognizable subject matter derived from magazines, newspapers, and television was presented in a forceful style that echoed the mass media in general and advertising in particular. Such work was related to life in both form and content, and the referentiality of the forms made it difficult to distinguish the two. The influences of Pop art's iconic imagery, commercial styles of presentation, and orientation toward today's life-world are evident in much art produced during the last ten years—and nowhere more so than in art that is itself involved with popular culture.

Certain aspects of popular culture have become particularly significant to the content of art in recent years: advertising images, styles, and techniques; the narrative conventions of television and film; regional and national cultural phenomena; and popular symbols. The varied uses of everyday culture in current art are based on the artists' understanding that "the appropriation of our existing means of visual communication is a complex and revealing process which makes apparent the role cultural symbols have in creating, not just reflecting, the convention of reality in [the] contemporary [world]."[7]

The appropriation of advertising forms and techniques ranges from the verbatim incorporation of a real newspaper advertisement (Hans Haacke), to use of a changing signboard (Jenny Holzer), to adaptation of the idiomatic images and arresting layouts of advertisements (Barbara Kruger), but in all cases the artists have adapted these forms to communicate specific messages that are very different from those normally conveyed by advertising media. Such artists, like commercial advertisers, are selling ideas, but they do so in ways that illuminate their intentions.

Film and television—powerful determinants of popular culture—provide conventions of re-presentation for much figurative and narrative art. Unlike genre art of earlier periods, which offered a reflection of real people in real life, today's narrative paintings convey fictive constructs twice removed from reality. Images of significant activity or melodramatic situations stereotypical of media reality are re-presented without context, often in juxtaposition or conjunction with other contextless views. Interpretation of such images depends on recognition of the signs of meaning that have been codified by films and television—a way of looking and thinking to which we all have been conditioned. Contemporary artists call attention to this by isolating, simplifying, and exaggerating the emblematic expressions of anxiety, hope, power, happiness, fear, life, and death presented by the media.

Just as our "high" culture is becoming more unified through time and space because of encyclopedic access to cultures of other times and locales, so too is popular culture becoming more broadly based, assimilating regional and national idioms. The homogenizing effect of worldwide commercial exchange on popular culture has been actively resisted by many artists whose works assert images, circumstances, or values particular to their

native areas. In art that bespeaks its regional character, particular experience serves as a microcosm of universal issues and concerns. Such work conveys a sense of immediacy and exoticism because the artist is speaking in a very specific accent, referring to things that are familiar in a regional context but rarely looked at in isolation. Terry Allen and Laurie Anderson draw their images and music from two extremes of American popular culture. Allen looks from and at ways of life in the southwestern United States for the meaning of contemporary reality, while Anderson's regional point of reference is the entire technologically saturated country; but both see their work as part of popular culture as well as a commentary on it. Artists whose works exist in dialogue with their immediate culture function with an acute sense of what is most distinctive and powerful in it, and make the meaning of their art out of these elements.

Investigation, manipulation, and creation of symbols are significant aspects of the art of the last ten years. Assuming that symbols are arbitrary conventions of meaning, their use by contemporary artists nonetheless affirms the power of symbols. The significance that inheres in certain symbols of popular culture is taken by the artist as a given, recognizable starting point from or around which to construct new meanings. Andy Warhol has been without a doubt the greatest creator and user of symbols in this decade, as he was in the decade preceding. He presents the faces of the "stars" of our world and images of endangered species, dollar bills, guns, and knives as the major determining forces of our time.

The wide range of images and objects used by artists as symbols attests to the synthetic and value-equalizing nature of popular culture. Such artists assume the ordinary icons of life—car, confessional, cross, crown, house, rabbit, Rodin's *Thinker*, rose, sled, swastika, wrestling ring—to be culturally, historically, socially, philosophically, and linguistically loaded images that make an immediate, provocative connection in the minds of those who encounter their work. This art is meaningful quite simply because it is composed of elements that are inherently meaningful, that refer to associations already established in our society. The artists emphasize the cultural common denominator in such a way as to call its accepted significance into question and posit new or additional meanings.

SOCIAL COMMENTARY

Social content has been more central to art in western Europe and America during the last ten years than at any time since the 1930s. Perhaps because art has become so much more public in its visibility and support, artists have become more conscious about the roles they are playing. There is in much contemporary work an affirmative acknowledgment that a work of art is never ideologically neutral but rather has in the fact of its existence both a position and a message. Furthermore, works of art can be used to assert specific social conditions or project particular messages. Such work directs attention to social concerns—sexual, communal, or political—or is made with a view to its relation to and reception by society. Although all art is to some extent a reflection of society, particular artists have taken the representation, analysis, or criticism of the social world as their principal

subject throughout history. Nowadays, such artists make the invisible forces that "shape our lives accessible to the public through their art"[8] by means as diverse as advertising and myth. They variously play the roles of interpreter, mediator, or agent provocateur. The social conditions and issues addressed are as disparate as the American Indian and nuclear war, virginity and matriarchy. There is a strong emotional tone to much socially oriented art, though approaches vary from uncritical replication, to documentary, to dogmatic exposition. Anger, fear, pride, shame, and violence imbue many of these re-presentations. They rely upon such diverse sources as American urban realism, Persian miniature paintings, B movies, and graffiti for part of their meaning. Some of the images are shocking; all shed light on social conditions or mores.

The fact that art with social content has become increasingly visible in art galleries and museums in spite of its often antiestablishment message raises questions about either the integrity of its statement or its propriety as art. While no longer seen only as subversive, such art can be powerful because it reaches a broad audience. It succeeds in artistic terms by putting situations that are intangible abstractions into comprehensible visual form.

Intrinsic to the meaning of socially relevant art is the artist's determination of the way the work of art functions in society. John Ahearn's portraits of his friends and neighbors in the South Bronx began as a glorification of these people and their way of life, and so function when exhibited in that community. When he puts these same works into the living rooms of art collectors, however, he is effecting a social transition in art that rarely happens in real life. Some works of art—Hans Haacke's most dramatically in this country—have been validated by museums as subversive to high culture, yet such works continue to question the character of our cultural institutions while being exhibited within them. Keith Haring has worked successfully by first going outside the traditional art venues to address his metamorphic messages of love, war, heaven and hell, money, and television to a vast audience in the New York subways, and then making the same kinds of images in durable materials for the gallery/museum audience.

As feminists and gay rights activists have pointed out during the past decade, sexuality is not simply a matter of personal preference. It is a social issue. This aspect of sexuality is significant in the work of artists as varied as Vito Acconci, Terry Allen, Eleanor Antin, Lynda Benglis, Derek Boshier, Louisa Chase, Francesco Clemente, Bernard Fauçon, Gilbert and George, Barbara Kruger, Robert Longo, Duane Michals, Tom Otterness, David Salle, Lucas Samaras, Cindy Sherman, Nancy Spero, and Earl Staley. Their points of view on sex and sexuality range from psychological to historical, cross-cultural, mythopoetic, narrative, and political. Some of the works reflect intimate experience while others are aggressively public, but the sexual content is stated clearly in ways that vary from confrontational directness, through matter-of-fact acceptance, to humor. It is not surprising that an art that addresses the most powerful questions of our day would include sexuality as one of its points of reference to the values, customs, and mechanisms of our society. Sex is a subject that has been forever loaded

with every possible kind of meaning—and it is a subject that is in itself universally meaningful.

Many artists address themselves to the communal circumstances of our society. Their work can be rich in historical allusion (Anselm Kiefer), mythic resonance (Joseph Beuys), psychosociology (Jane Dickson), ecological import (Helen Mayer and Newton Harrison), current events (Chris Burden and Leon Golub), or social symbols (Keith Haring and Andy Warhol). These artists isolate symptomatic elements of our society for our consideration, revealing the confluences of interest and contradictions with which we all contend. There are no solutions suggested or conclusions reached: the artist simply, in compelling visual terms, tells the viewer to look.

It is difficult to draw the line between what is a communal issue and what is a political one—a condition whose philosophical corollary is forcefully depicted in Les Levine's *Taking a Position*. An explicit "taking a position" is perhaps one way of describing political art as distinct from social. Although a point of view is implied in Keith Haring's hieroglyphics or even Conrad Atkinson's parables, these works are more metaphorical than Hans Haacke's. Works that are explicitly political declare an opinion as well as present the issue in a confrontational manner, and force the viewer into drawing conclusions as well.

The range of expression from subjective to objective is as great in art with primarily social content as it is in art with conceptual and cultural content, but the themes and subjects of the former are more broadly relevant, and the terms of address are generally more mundane and pragmatic. Much of such art relies on conventions of advertising, illustration, or journalism; explanatory text is frequently a component; photographs are often used to document the position implicit in the work; and allegorical procedures endow particular circumstances with a sense of history and universality.

NATURE The content of much recent art has been deeply influenced by nature, and how the natural world is defined and experienced in our culture. It is incorporated, referred to, or re-presented in contemporary art in several different ways, all of which indicate both the artists' personal engagement with nature and a more universal and timeless dialogue between humanity and the natural world. The artists' approaches to nature range from scientific to romantic, variously informed by anthropology, art, astronomy, ecology, geology, history, and literature. Nature is used as material or as space, as allegory, and as memory. Artists refer to their experience of nature in cultural or psychological terms, as well as phenomenologically. They convey in their work nature as experienced through time, as defined by a walk, by a solar equinox, or by ecological changes in the land itself. Nature is represented as a situation rather than a subject. In such art, a particular relationship between humanity and the natural world is implied by means as diverse as a Socratic dialogue or a metaphysical event.

Underlying most such works are several shared assumptions that

characterize both art and life at this moment. The first is the belief of many artists that there are enough objects in the world and that their addition to this accumulation should be minimal. The second is a desire to bypass the conceptual and physical limitations of painting and sculpture, and to work outside the art gallery/museum context. There is an awareness reflected in all such works that our experience of nature is conditional. The artists are interested in personal interaction with nature—something that requires uncommon deliberation in our increasingly urbanized society. Many of these works make evident that nature is not an absolute, that "pure" nature is extremely remote, and that the natural world is vulnerable to human intervention.

PSYCHOLOGICAL, SPIRITUAL, AND METAPHYSICAL CONTENT

For the first time since the heyday of Surrealism, works of art with psychological, spiritual, and metaphysical content have appeared in significant numbers during the last decade. There was a certain amount of the philosophical and mystical in Abstract Expressionism, but it was both more generalized and more personal than the references we find today. Art that involves itself with spiritual concerns ranges from the most personal revelations of individual psychic experience in works by Jonathan Borofsky and Louisa Chase to the most abstract realism of the universal unconscious in Walter Pichler's work. All art of this sort deals with questions of existential import: life (Charles Garabedian), death (Arnulf Rainer), sacrifice (Hermann Nitsch), survival (Joseph Beuys and Sandro Chia), redemption (Michael Tracy), ecstatic inspiration (Mimmo Paladino), and the underlying generative principles of the universe (Mario Merz). The notion of material transmutation and the coexistence of alternative realms of experience is central to much of this work, as is the duality of internal being and external reality (Alice Aycock, Joan Brown, Jiři Georg Dokoupil, Philip Guston, and Ken Kiff).

The content of such art can be defined as the intangible forces of human existence. The ways these forces are represented range from images that are almost childlike in their simplicity of form and directness of execution (Jonathan Borofsky, Louisa Chase, Enzo Cucchi, Mario Merz) to those that are rarefied and abstract (Alice Aycock). In projections of dreams, visualizations of primal oedipal fantasies, allegories of creation, and ceremonies of sanctification, artists reveal the extremes of human emotion that are at once intensely personal and universally experienced.

REFERENTIALITY

In 1974, Douglas Huebler predicted that the central issue for art was "whether or not 'association'—referencing to worldly matters—will be permitted back into art. It will be around that issue more and more artists will have to take a position."[9] The artists included in the present exhibition have taken their positions in making such referencing central to their work and we, the curators of this exhibition, take the position that referential art is the form of expression most characteristic of the past decade.

Concurring with Allan Kaprow's assumption that twentieth-century art can be viewed as being either primarily artlike or primarily lifelike, we can conclude that the dominant trend of the last ten years has been toward lifelike art. Kaprow suggests that "the root message of . . . all lifelike art is connectedness and wide angle awareness," rather than the "separateness and specialness" that distinguishes "artlike art."[10] Inclusiveness, indeterminacy, investigation, juxtaposition of diverse realities, mundane references, personal engagement, and attention to the underlying realities of art and life unite the art in this exhibition. These characteristics are concomitant with the referential content and ways of making meaning that have been central to the art of the years from 1974 to 1984.

NOTES

1. Edmund Husserl's term "life-world" has been equated by Donald Kuspit with realism in a broad sense, that is, with "anything having to do with a cultural or life-reference"; see Donald B. Kuspit, "Postmodernism, Plurality and the Urgency of the Given," *The Idea: At the Henry* 2 (April 1981): 15.

2. Frank Stella, in William S. Rubin, *Frank Stella* (New York: Museum of Modern Art, 1970), p. 42.

3. Achille Bonito Oliva, "Process, Concept and Behavior in Italian Art," *Studio International* 191 (January–February 1976): 4.

4. Rauschenberg declared: "Painting relates to both art and life. Neither can be made (I try to act in that gap between the two)"; in *Sixteen Americans*, exh. cat. (New York: Museum of Modern Art, 1959), p. 58.

5. Thomas McEvilley, "Heads It's Form, Tails It's Not Content," *Artforum* 21 (November 1982): 60–61.

6. Cited in David Hall, "The Video Show," *Art and Artists* 10 (May 1975): 21.

7. John Carlin and Sheena Wagstaff, "Beyond the Pleasure Principle: Comic Quotation in Contemporary American Painting," in *The Comic Art Show*, exh. cat. (New York: Whitney Museum of American Art, Downtown Branch, 1983), p. 55.

8. Conrad Atkinson, *1977 Current British Art: Approaching Reality*, exh. cat. (Newcastle-upon-Tyne, England: Northern Arts Gallery, 1977), p. 54.

9. Douglas Huebler, in Connie Fitzsimons, *Comment*, exh. pamphlet (Long Beach, Calif.: Long Beach Museum of Art, 1983), p. 3.

10. Allan Kaprow, "The Real Experiment," *Artforum* 22 (December 1983): 27.

VITO ACCONCI
born New York City, 1940;
lives New York City

1
Peeling House 1981
Mixed media
Approx. 243.8 × 243.8 × 243.8 (96 ×
96 × 96)
Vito Acconci, New York, courtesy Michael
Klein, Inc., New York

"I think of art as having a kind of instrumental use. The word exists, the category exists, so it does have a place. So when I say 'make art,' I don't mean a kind of—a kind of self-enclosed art, but I mean art as this kind of instrument in the world."
—Vito Acconci, in "Interview by Robin White," *View* (Oakland, Calif.: Crown Point Press, 1979), p. 18.

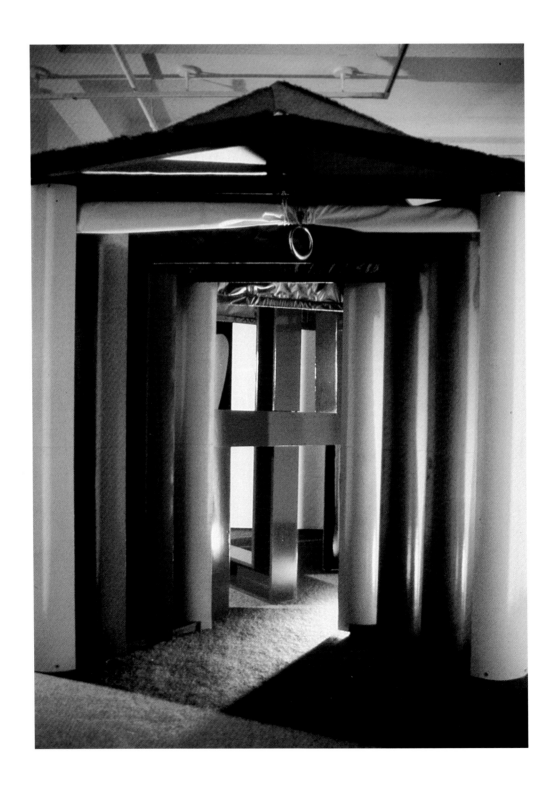

MAC ADAMS

born South Wales, 1943;
lives New York City

2

Smoke and Condensation 1978
Photographs, diptych
83.8 x 147.3 (33 x 58) over-all
Dolores and Hubert Neumann, New York

*"My interest in photographic theory and
semiology in relation to narrative was
made evident through the process of
constructing situations using models in
which an act had occurred, an act
which I felt had a mysterious element.
. . . What interested me in this process is
the information and deductive logic
which explains the relationship between
the images. Conclusions as to who, why
and what are left to the viewer to
solve."*
—Mac Adams, statement, 1983.

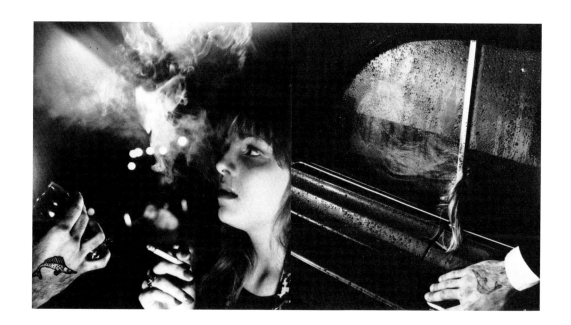

JOHN AHEARN
born Birmingham, New York, 1951;
lives New York City

3
Johnnie 1979
Painted plaster
38.1 x 30.5 x 20.3 (15 x 13 x 8)
Brooke Alexander, Inc., New York

4
Big City 1979
Painted plaster
35.5 x 33 x 20.3 (14 x 13 x 8)
Brooke Alexander, Inc., New York

5
Pregnant Girl 1979
Painted plaster
35.5 x 25.4 x 18.4 (14 x 10 x 7¼)
Brooke Alexander, Inc., New York

4

3

5

TERRY ALLEN
born Wichita, Kansas, 1943;
lives Fresno, California

6
The Embrace . . . 1979
Installation with videotape player and
monitor, boxing ring construction, painted
walls, colored lights, objects, and bleachers
609 × 609 (240 × 240)
Terry Allen, Fresno, California, courtesy
Morgan Art Gallery, Kansas City, Kansas

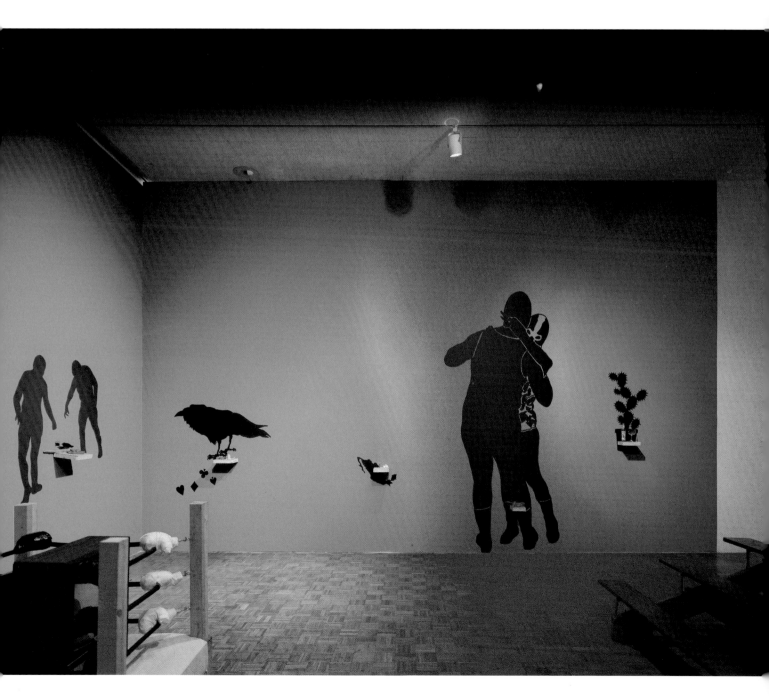

Carlos Almaraz

born Mexico City, Mexico, 1944;
lives Los Angeles, California

7
Europe and the Jaguar 1982
Oil on canvas
182 x 182 (72 x 72)
Ralph G. Mendez, Locus Gallery, San
Antonio, Texas

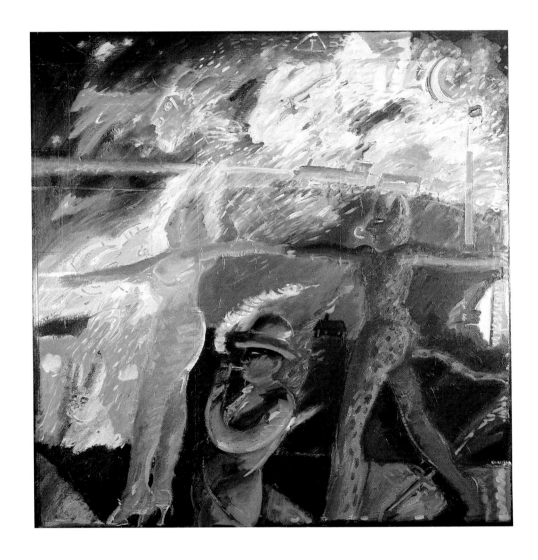

LAURIE ANDERSON

born Chicago, Illinois, 1947;
lives New York City

8
Jukebox 1977
Installation with jukebox, ten 45-rpm
records, and ten photocollages with text in
pencil on paper
Each photocollage 76.2 x 56.5 (30 x 22¼)
"Black Holes" and "Time to Go: A Film-
Song in 24/24 Time" lent by a private
collection
"Art and Illusion" lent by Harry H. Lunn,
Jr., Washington, D.C.
"From Photography and Good Design,"
"It's Not the Bullet (A Reggae Tune for
Chris Burden)," "Speak Softly: A Film-Song
in 24/24 Time," "Stereo Song for Steven
Weed," "Trophies," "Video Double Bank,"
"Is Anybody Home?" and records lent by
Holly Solomon Gallery, New York

*"I have received and continue to receive
psychological and intellectual support
from the art world and believe that the
structure and intentions of my work are
best understood by other artists.
However, in the past two years I have
found myself doing as many things for
nonart audiences as for art audiences. I
don't change the work according to the
audience. As a result, it is now possible
for me to think of American art as
something that can enter culture in
other ways, unescorted by institutional
art intermediaries. Radio, T.V. and a
variety of spaces—old movie houses,
rock clubs, bars, V.F.W.s and
amphitheatres—have become more
accessible to artists who work in live
situations."*
—Laurie Anderson, in Nancy Foote,
"Situation Esthetics: Impermanent Art
and the Seventies Audience," *Artforum*
18 (January 1980): 23.

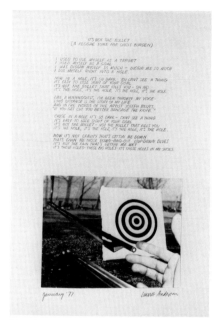

Detail.

Jukebox, installation at Holly Solomon Gallery, New York, 1977 (detail).

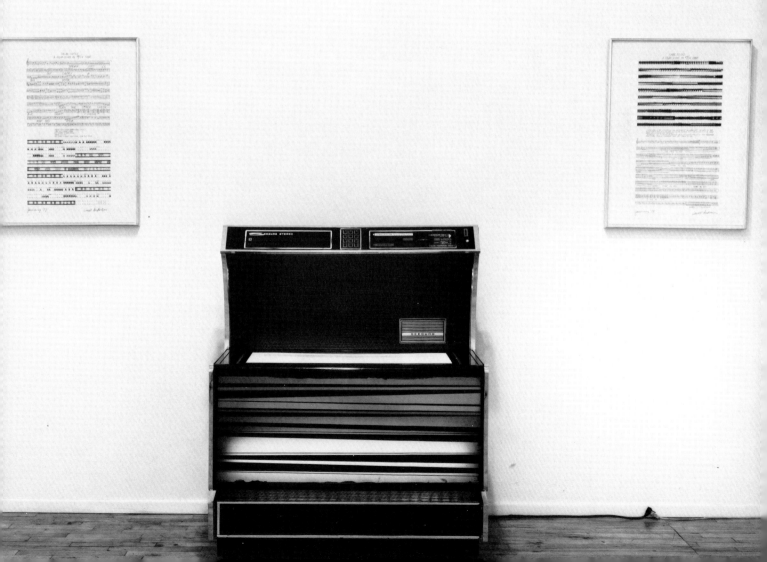

ELEANOR ANTIN

born New York City, 1935;
lives Del Mar, California

9
My Tour of Duty in the Crimea: The Angel of Mercy, from *The Angel of Mercy* 1977
Photograph mounted on handmade paper with text
76.2 × 55.8 (30 × 22)
Ronald Feldman Fine Arts, Inc., New York

10
My Tour of Duty in the Crimea: Learning to Walk, from *The Angel of Mercy* 1977
Photograph mounted on handmade paper with text
76.2 × 55.8 (30 × 22)
Ronald Feldman Fine Arts, Inc., New York

11
My Tour of Duty in the Crimea: The Wounded Drummer Boy, from *The Angel of Mercy* 1977
Photograph mounted on handmade paper with text
76.2 × 55.8 (30 × 22)
Ronald Feldman Fine Arts, Inc., New York
[Not illustrated]

12
My Tour of Duty in the Crimea: In the Trenches before Sebastopol, from *The Angel of Mercy* 1977
Photograph mounted on handmade paper with text
76.2 × 55.8 (30 × 22)
Ronald Feldman Fine Arts, Inc., New York
[Not illustrated]

"I am a post-conceptual artist concerned with the nature of human reality, specifically with the transformational nature of the self. . . . I am interested in defining the limits of myself, meaning moving out to, in to, up to and down to the frontiers of myself."
—Eleanor Antin, in Carl E. Loeffler and Darlene Tong, eds., *Performance Anthology* (San Francisco: Contemporary Arts Press, 1980), p. 406.

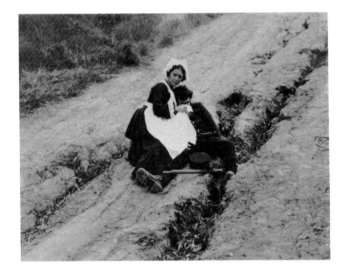

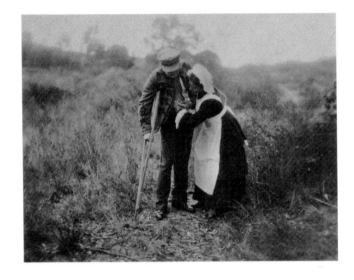

SIAH ARMAJANI

born Teheran, Iran, 1939;
lives Minneapolis, Minnesota

13
Fourth Bridge 1974–75
Enamel on balsawood with wooden
carrying case
54.6 × 132 × 53.3 (21½ × 52 × 21½)
Max Protetch Gallery, New York

*"In the mid-sixties ... there were certain
ideas, not only philosophical ones, which
could not be translated or expressed
directly in the forms of painting and
sculpture as they existed then. What
was needed was a reinvestigation of art
to determine what its properties and
capabilities are. And so many of us
turned to the social sciences as a model
for a compatible methodology which
would provide an interrelationship
between science and art. It was a
search for a new form, a form for our
content."*
—Siah Armajani, in Linda Shearer,
Young American Artists, exh. cat. (New
York: Solomon R. Guggenheim
Museum, 1978), p. 14.

RICHARD ARTSCHWAGER
born Washington, D.C., 1933;
lives Charlotteville, New York

14
Tower III (Confessional) 1980
Formica and oak
153 × 120 × 81 (60 × 47 × 32)
Doris and Charles Saatchi, London,
England

CONRAD ATKINSON

born Cleator Moore, Cumbria, England,
1940; lives London, England

15
For Wordsworth, for West Cumbria 1980
Photographs, acrylic paint, collage on
board, sixteen panels
Each 52 × 62 (20½ × 24½)
Trustees of the Tate Gallery, London,
England

*"I believe that one must start from a
belief that art is not about art, but that
art is about anything which is not art,
and my work should be seen as an
attempt to relate to the aims and
aspirations of the mass of the people,
the opposite in fact to the popular view
of the artist as an isolated individual
committed to the exploration of his own
psyche."*
—Conrad Atkinson, in Hugh Adams,
*Conrad Atkinson: 1975-80, Work about
the North*, exh. cat. (London: Carlisle
Museum and Art Gallery, 1980), pp. 8–9.

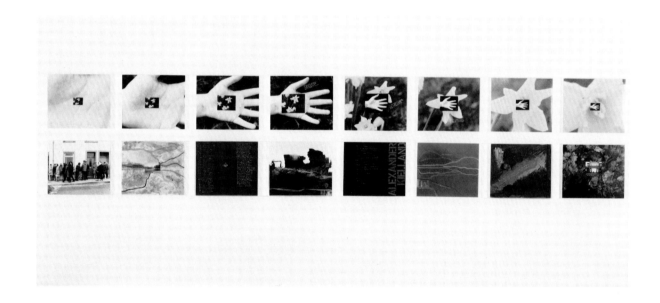

ALICE AYCOCK

born Harrisburg, Pennsylvania, 1946;
lives New York City

16
The Savage Sparkler 1981
Steel, sheet metal, heating coils, fluorescent
lights, motors, and fans
Dimensions variable
Permanent art collection, Myers/Kent
Galleries, Center for Art, Music and
Theater, State University College,
Plattsburgh, New York

*"The earlier pieces had a clearly defined
gestalt. Now, things begin to emerge
which have no boundaries, which lose all
definable edges and clarity and shape.
It's a kind of organizational system that I
keep at the back of my mind. . . . One
aspect of my work is the attempt to
understand what the structure of the
brain is like and that brain is so complex
and so fascinating and so illusive."*
—Alice Aycock, in "Conversation
between Alice Aycock, Tieman
Osterwold and Andreas Vowinckel in
July 1983," *Alice Aycock,* exh. cat.
(Stuttgart: Württembergischer
Kunstverein, 1983), unpaginated.

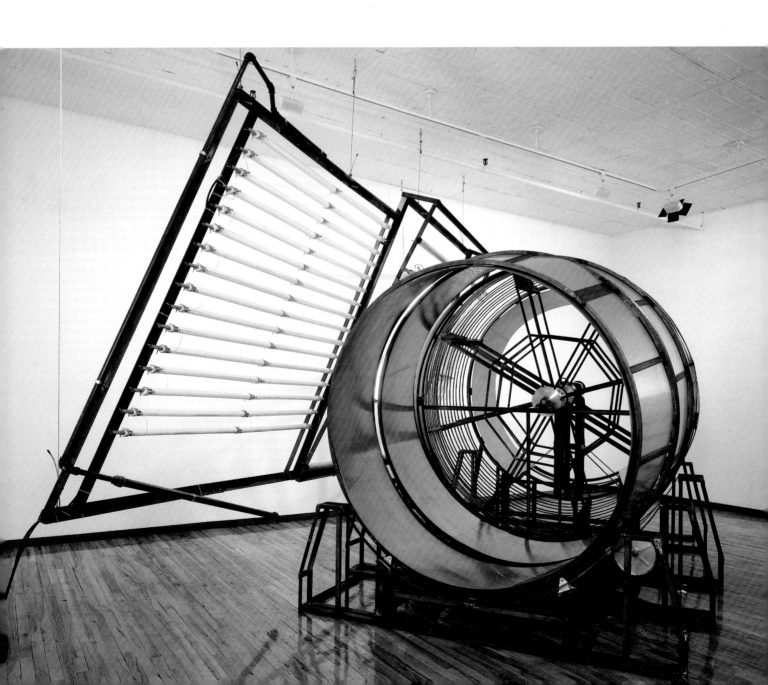

John Baldessari

born National City, California, 1931;
lives Los Angeles, California

17
Blasted Allegories (Stern Stoic Streak): (Y, O, R, V, B, G) 1978
C prints and black and white photographs mounted on board
78 × 102 (30¼ × 40)
Lowe Art Museum, University of Miami, Florida, Museum purchase through a grant from the National Endowment for the Arts
[Not illustrated]

18
Blasted Allegories (Colorful Sentences): Worried Appeal Cycle (Six Sentences Sharing Circular Green Intersection) 1978
C prints mounted on board
78 × 102 (30¾ × 40)
Sonnabend Gallery, New York

"The categorical title 'Blasted Allegories' is derived from a phrase used by the American author, Nathaniel Hawthorne. It is meant to describe the use of allegory/metaphor as a damnable process, a curse: blasted allegories!! An allegory is a useful device in the rich meanings it can generate but its very blessings is a curse in the multiplicity of meanings that can be generated, thus the possibility of confusion. . . . But the phrase can also mean 'exploded,' pieces and bits of meaning floating in the air, their transient syntax providing new ideas."
—John Baldessari, in Jan Debbaut, ed., *John Baldessari,* exh. cat. (Eindhoven: Municipal Van Abbemuseum, 1981), p. 49.

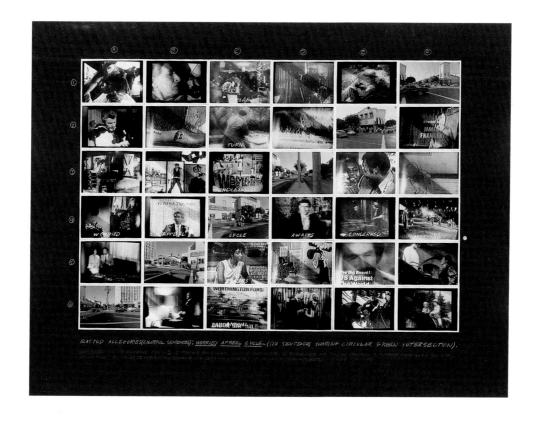

ROBERT BARRY
born New York City, 1936;
lives Teaneck, New Jersey

19
After All 1979
Slide installation
Robert Barry, Teaneck, New Jersey

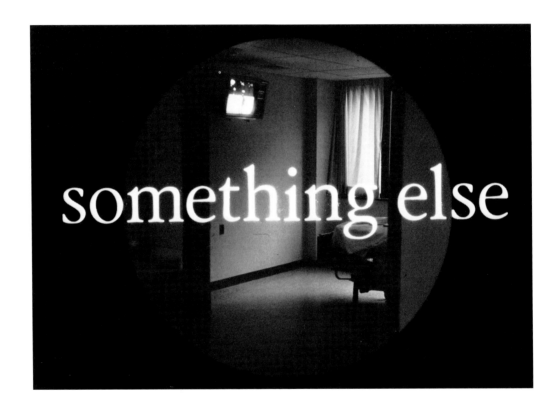

JEAN MICHEL BASQUIAT

born Brooklyn, New York, 1960;
lives New York City

20
Untitled 1983
Acrylic and oilstick on canvas, triptych
243.8 × 190.5 (96 × 75) over-all
Lori and Ira Young, West Vancouver,
British Columbia, courtesy Larry Gagosian
Gallery, Los Angeles, California

*"[My subject matter is] royalty, heroism,
and the street."*
—Jean Michel Basquiat, in Henry
Geldzahler, "Art from Subways to
Soho: Jean Michel Basquiat," *Interview*,
January 1983, p. 44.

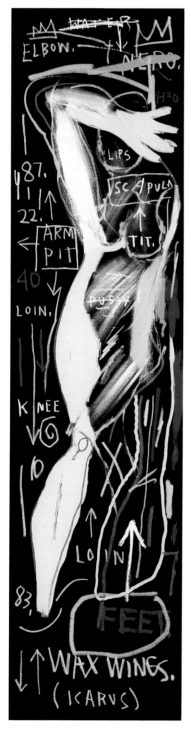
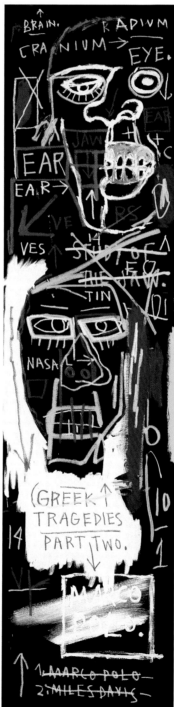
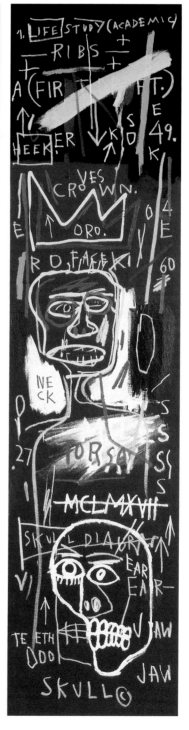

LYNDA BENGLIS

born Lake Charles, Louisiana, 1941;
lives New York City

21
Nu 1974
Aluminum screen, cheesecloth, plaster,
paint, and sparkle
110.4 x 73.6 x 38 (43½ x 29 x 15)
Storm King Art Center, Mountainville,
New York

JOSEPH BEUYS

born Krefeld, Germany, 1921;
lives Düsseldorf, West Germany

22
From Berlin: News from the Coyote (Aus Berlin: Neues vom Kojoten) 1979
Installation with plaster, wood lathing and other rubble, newspapers, felt hat, toenails, hair, felt, musical triangle, gloves, flashlight, wooden cane, acetylene lanterns, arc lamp, wooden sticks, fire extinguishers, hay, and sulphur
Dimensions variable
Dia Art Foundation, New York

"My objects are to be seen as stimulants for the transformation of the idea of sculpture, or of art in general. They should provoke thoughts about what sculpture can be and how the concept of sculpting can be extended to the invisible materials used by everyone:

Thinking Forms—	how we mould our thoughts or
Spoken Forms—	how we shape our thoughts into words or
SOCIAL SCULPTURE—	how we mould and shape the world in which we live: Sculpture as an evolutionary process; everyone an artist.

"That is why the nature of my sculpture is not fixed and finished. Processes continue in most of them: chemical reactions, fermentations, colour changes, decay, drying up. Everything is in a state of change."
—Joseph Beuys, in Caroline Tisdall, *Joseph Beuys,* exh. cat. (New York: Solomon R. Guggenheim Museum, 1979), p. 7.

From Berlin: News from the Coyote, original installation at Ronald Feldman Fine Arts, Inc., New York, November–December 1979. The installation included objects from Beuys's 1974 performance, *I Like America and America Likes Me,* at the René Block Gallery, New York (see Chronology, fig. 2), and materials from the walls of the René Block Gallery, Berlin, which closed in 1979.

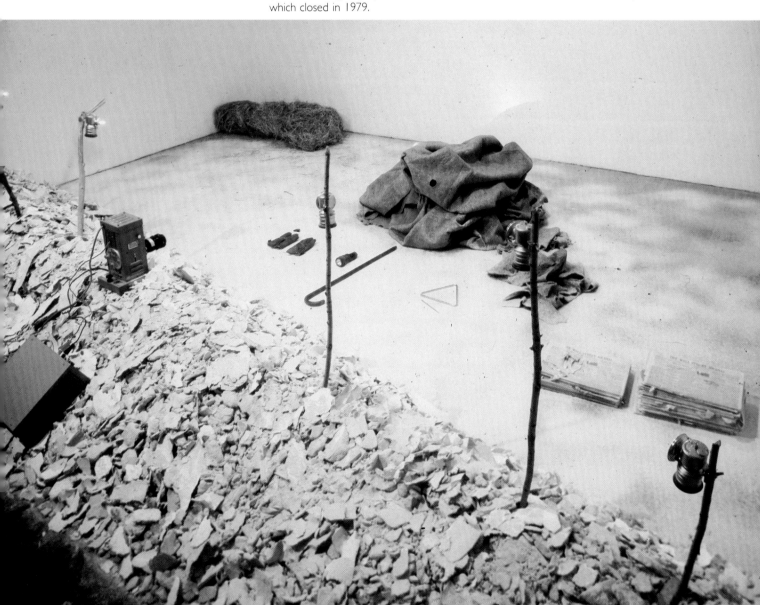

CHRISTIAN BOLTANSKI

born Paris, France, 1944; lives Paris, France

23
My Grandfather Remembers 1975
Five photographs and ink on paper
36.8 x 90.8 (14½ x 35¾)
Sonnabend Gallery, New York

24
The Father's Story 1975
Five photographs and ink on paper
36.8 x 111.12 (14½ x 43¾)
Sonnabend Gallery, New York

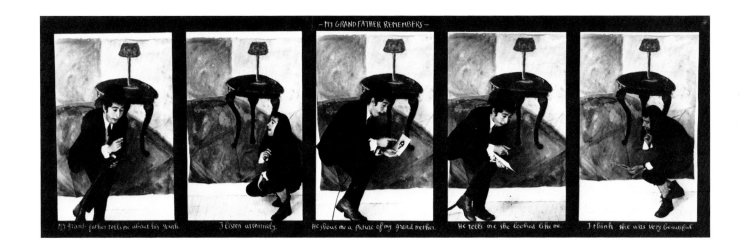

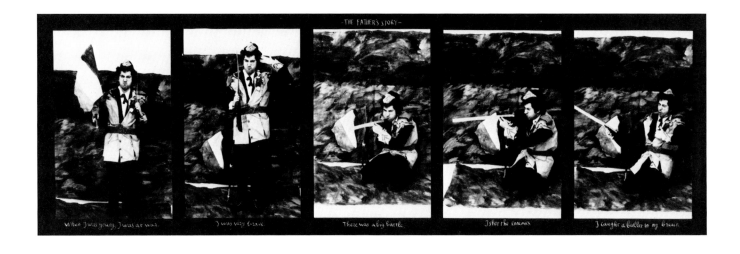

Jonathan Borofsky

born Boston, Massachusetts, 1942;
lives Venice, California

25
Hitler Dream 1977–84
Wall drawing
Approx. 457.2 × 609.6 (180 × 240) over-
all
Jonathan Borofsky, Venice, California,
courtesy Paula Cooper Gallery, New York

*"That side of me which is the core of
feeling—the heart, the spirit—is
connected up with the conceptual side
of me. . . . I've put the two together,
physically and symbolically."*
—Jonathan Borofsky, in Joan Simon,
"An Interview with Jonathan Borofsky,"
Art in America 69 (November 1981):
163.

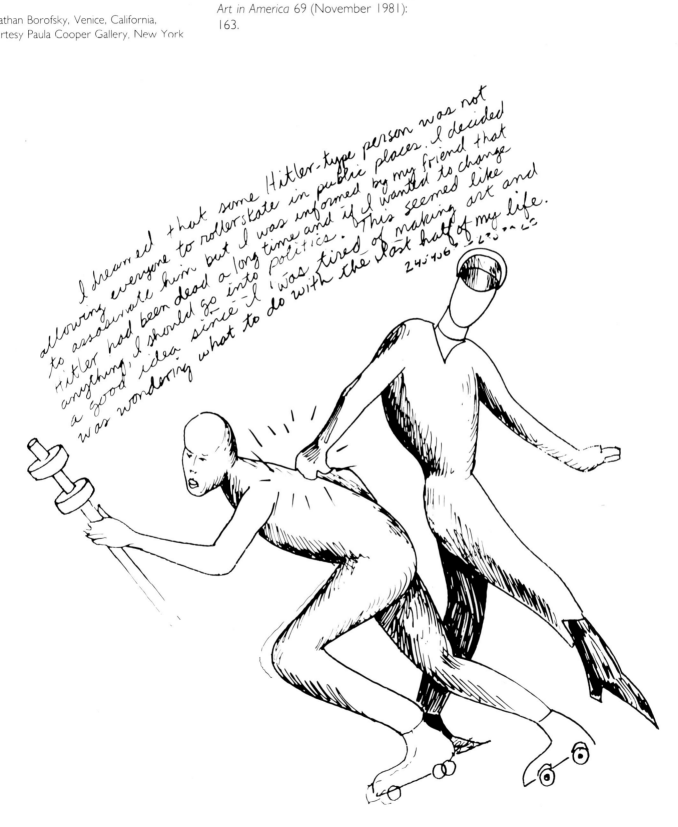

DEREK BOSHIER

born Portsmouth, England, 1937;
lives Houston, Texas

26
Frightened Cowboy 1980
Oil on canvas
152.4 × 99 (60 × 39)
Texas Gallery, Houston, Texas

*"I like the idea of myths and archetypes.
I thought the cowboy culture was not a
living culture. It's actually a living thing.
Even the urban cowboy is far more a
part of the culture than I'd thought. The
attitudes are real."*
—Derek Boshier, in David Brauer,
Texas Works, exh. cat. (London:
Institute of Contemporary Art, 1982), p. 7.

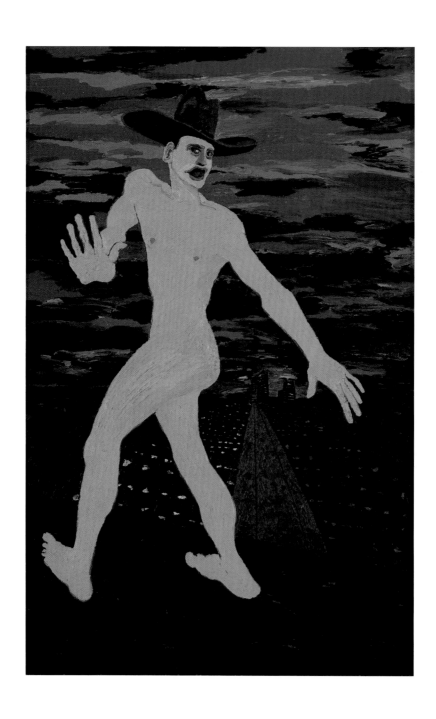

LOUISE BOURGEOIS

born Paris, France, 1911;
lives New York City

27
Fear Four 1984
Marble
91.4 (36) diameter
Robert Miller Gallery, New York

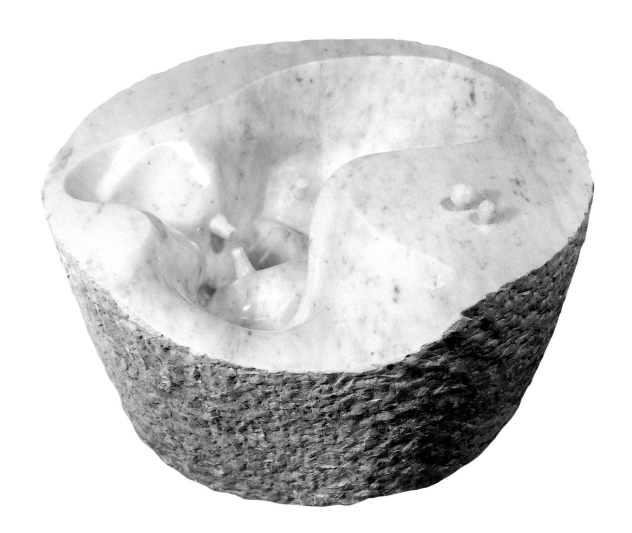

TROY BRAUNTUCH

born Jersey City, New Jersey, 1954;
lives New York City

28
Untitled 1982
Pencil on cotton
243.8 × 172.7 (96 × 68)
Speyer Family Collection, New York,
courtesy Mary Boone Gallery, New York

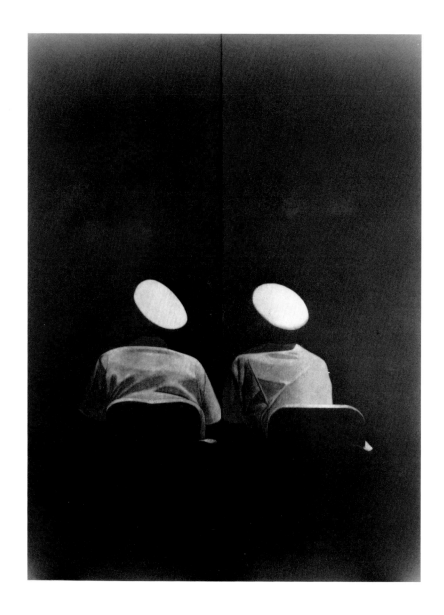

MARCEL BROODTHAERS
born Brussels, Belgium, 1924;
died Cologne, West Germany, 1976

29
Untitled 1975
Collar, shoes, wooden hoop, book, "Scout"
harmonium, four signs, and wooden shelf
Moderna Museet, Stockholm, Sweden

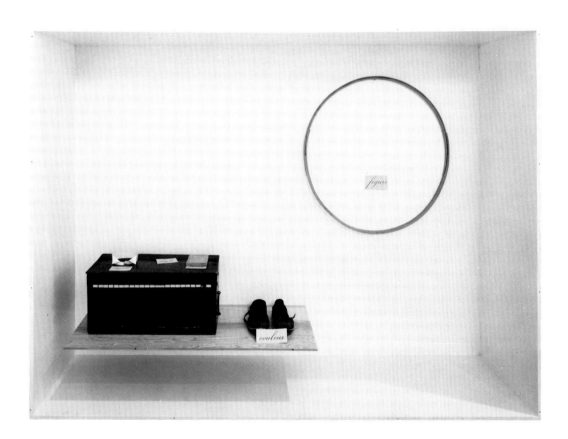

JOAN BROWN

born San Francisco, California, 1938;
lives San Francisco, California

30
The Invitation 1979
Oil enamel on canvas
243.8 x 198 (96 x 78)
Joan Brown, San Francisco, California,
courtesy Fuller Goldeen Gallery, San
Francisco, California

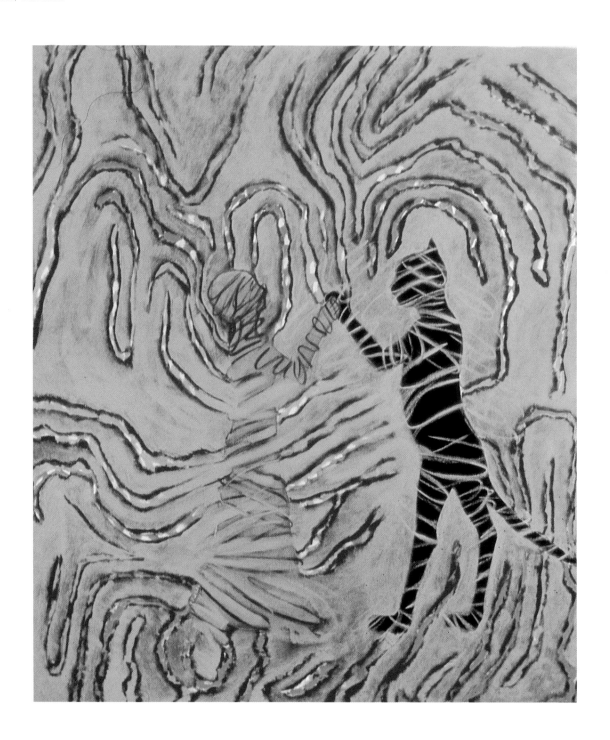

ROGER BROWN

born Hamilton, Alabama, 1941;
lives Chicago, Illinois

31
Assassination Crucifix 1975
Oil on canvas and papier-mâché
177.8 × 116.8 (70 × 46)
Gilda and Henry Buchbinder, Chicago,
Illinois

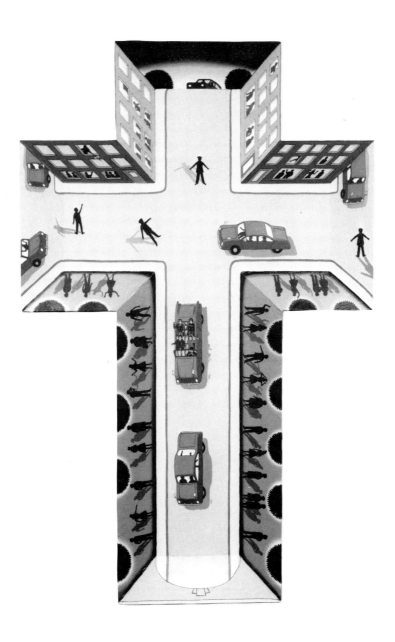

CHRIS BURDEN

born Boston, Massachusetts, 1946;
lives Venice, California

32
The Reason for the Neutron Bomb 1979
Fifty thousand nickels and matchsticks
939.8 × 533.4 (370 × 210)
Courtesy Ronald Feldman Fine Arts, Inc.,
New York

Detail.

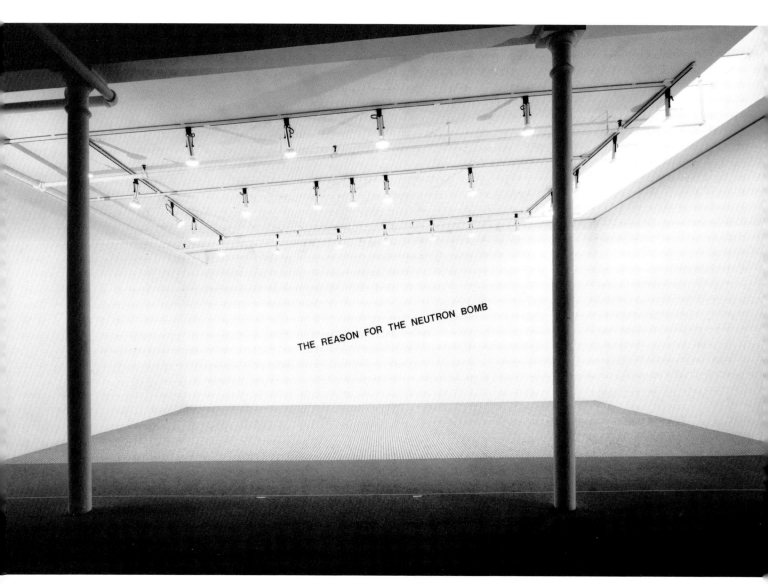

The Reason for the Neutron Bomb, original installation at Ronald Feldman Fine Arts, Inc., New York, 1979.

VICTOR BURGIN

born Sheffield, England, 1941;
lives London, England

33
Today Is the Tomorrow You Were Promised Yesterday 1976
Photograph mounted on aluminum
101.6 × 152.4 (40 × 60)
John Weber Gallery, New York

"Today advertising constitutes a massive ideological intervention in Western culture. . . . A job for the artist which no one else does is to dismantle the existing communication codes and to recombine some of their elements into structures which can be used to generate new pictures of the world."
—Victor Burgin, in "Acquisitions of Twentieth-Century Art by Museums," *Burlington Magazine* 122 (July 1980): 528.

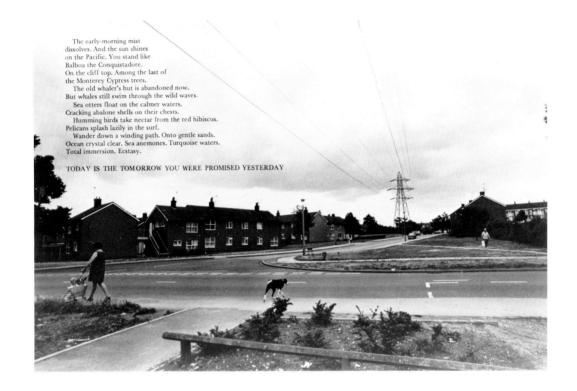

The early-morning mist dissolves. And the sun shines on the Pacific. You stand like Balboa the Conquistadore.
On the cliff top. Among the last of the Monterey Cypress trees.
The old whaler's hut is abandoned now. But whales still swim through the wild waves.
Sea otters float on the calmer waters. Cracking abalone shells on their chests.
Humming birds take nectar from the red hibiscus. Pelicans splash lazily in the surf.
Wander down a winding path. Onto gentle sands. Ocean crystal clear. Sea anemones. Turquoise waters. Total immersion. Ecstasy.

TODAY IS THE TOMORROW YOU WERE PROMISED YESTERDAY

SCOTT BURTON

born Greensboro, Alabama, 1939;
lives New York City

34
Lawn Chair 1976–77
Lacquered pine
111.25 × 78.7 × 129.5 (43 3/4 × 31 × 51)
Scott Burton, New York

"I see the beginning of some new and
significant form of decorative art—for
want of a better phrase—in work that
is jewelry, wall decoration, murals,
clothing and furniture. Not only have the
decorative arts been a major source for
me, but I'm vitally involved and
interested in their capacity to expand
beyond the art context, in the possibility
of appreciating them on a level other
than fine art."
—Scott Burton, in Linda Shearer,
Young American Artists, exh. cat. (New
York: Solomon R. Guggenheim
Museum, 1978), p. 19.

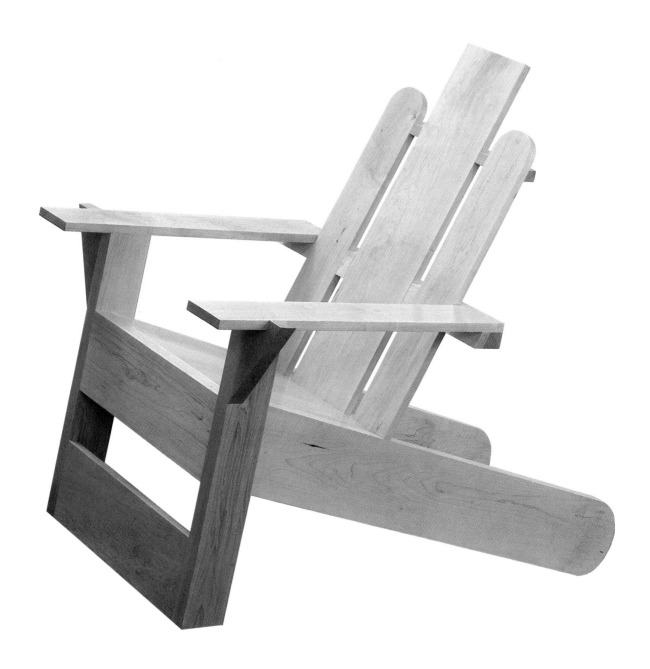

Jo Ann Callis

born Cincinnati, Ohio, 1940;
lives Culver City, California

35
Wet Jacket 1977
Color photograph
40.6 × 50 (16 × 20)
H. F. Manès Gallery, New York, and G.
Ray Hawkins Gallery, Los Angeles,
California

36
Woman in Red Dress 1977
Color photograph
40.6 × 50 (16 × 20)
H. F. Manès Gallery, New York, and G.
Ray Hawkins Gallery, Los Angeles,
California
[Not illustrated]

37
Woman with Black Line 1977
Color photograph
50 × 40.6 (20 × 16)
H. F. Manès Gallery, New York, and G.
Ray Hawkins Gallery, Los Angeles,
California

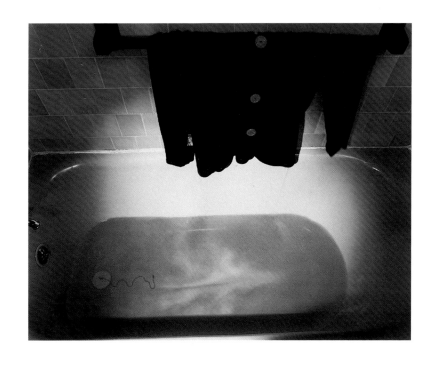

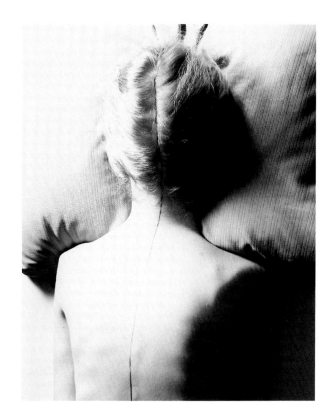

PETER CAMPUS

born New York City, 1937;
lives New York City

38
Woman's Head 1978
Photoprojection
Approx. 304 x 304 (120 x 120)
Joshua Mack, Byram, Connecticut

HENRY CHALFANT
born Pittsburgh, Pennsylvania, 1940;
lives New York City

39
I Love Zoo York 1980
Subway train mural by Ali, 1980
Color photograph
25.4 x 86.3 (10 x 34)
Fun Gallery, New York

40
Untitled 1980
Subway train mural by Seen and Mitch,
1980
Color photograph
25.4 x 86.3 (10 x 34)
Fun Gallery, New York; Thames and
Hudson, London, England; and Holt,
Rinehart and Winston, New York

41
Style Wars 1981
Subway train mural by Noc, 1981
Color photograph
25.4 x 86.3 (10 x 34)
Fun Gallery, New York; Thames and
Hudson, London, England; and Holt,
Rinehart and Winston, New York

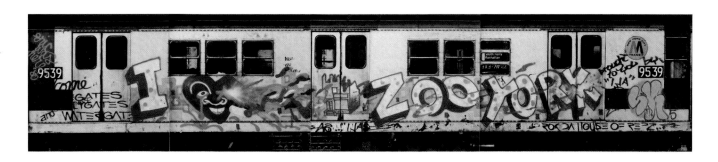

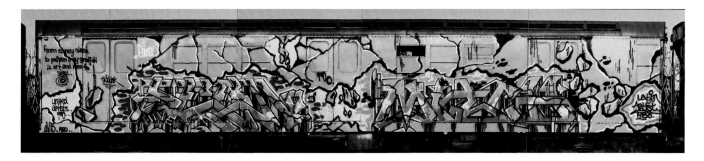

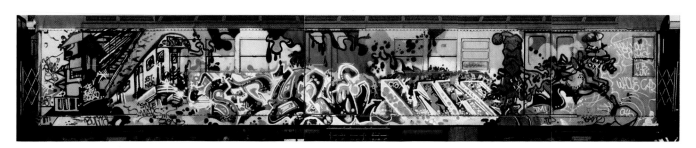

LOUISA CHASE

born Panama City, Florida, 1951;
lives New York City

42
Bramble 1980
Oil on canvas
182.8 x 243.8 (72 x 96)
Norma and William Roth, Winter Haven,
Florida

*"My work is a kind of psychological
cubism in that everything is splattered
with a different kind of organization."*
—Louisa Chase, in *New York/New
York*, exh. cat. (New York: New
Museum, 1980), p. 5.

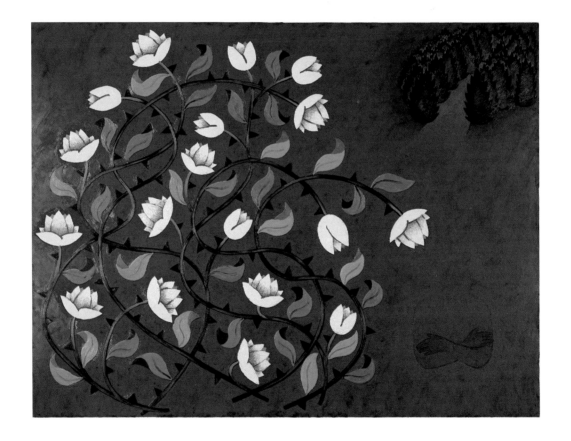

SANDRO CHIA

born Florence, Italy, 1946;
lives New York City

43
Rabbit for Dinner 1980
Oil on canvas
205.5 x 339 (81 x 133½)
Stedelijk Museum, Amsterdam

"Each artwork is a personal research for a certain identity. The work is the materialization of this research. Each painting, each sculpture is just a step that you reach in this opera, in all the work you do during your life and this is why art is more interesting than politics or society or anything else. Because this is the physical proof of metaphysical existence."
—Sandro Chia, in Joseph Kosuth, "Portraits: Necrophilia, Mon Amour," *Artforum* 20 (May 1982): 60.

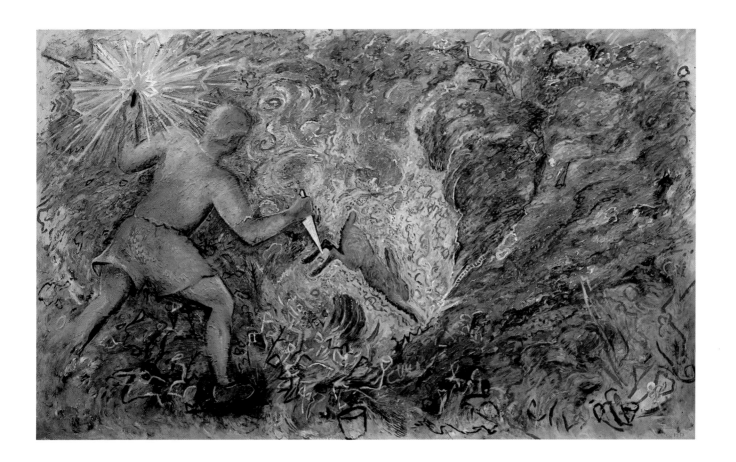

FRANCESCO CLEMENTE

born Naples, Italy, 1952;
lives Rome, Italy; Madras, India;
and New York City

44
Francesco Clemente Pinxit, 1581–
1981 1981
Twenty-four miniatures, natural pigment
on paper
Each 242 × 15.2 (8¾ × 6)
Sydney and Frances Lewis, Richmond,
Virginia

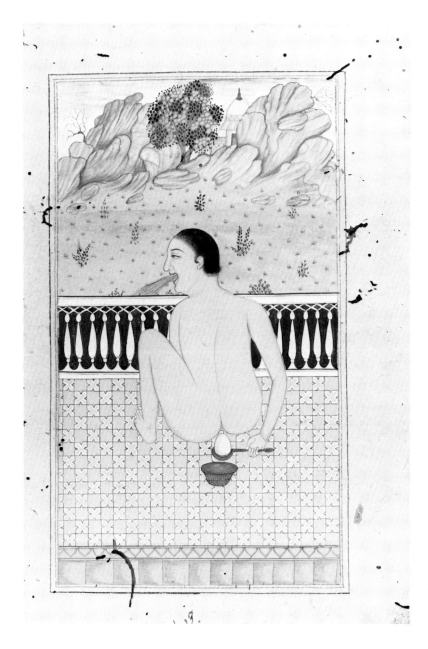

72

ROBERT COLESCOTT

born Oakland, California, 1925;
lives Oakland, California

45
A Legend Dimly Told 1982
Acrylic on canvas
213 × 182.8 (84 × 72)
Gregory T. Semler, Hanover,
Massachusetts

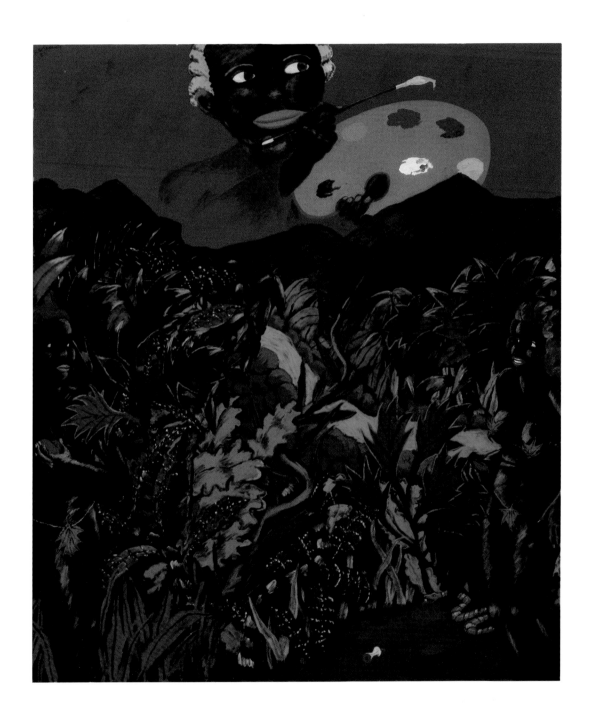

ENZO CUCCHI

born Morro d'Alba, Italy, 1950;
lives Ancona, Italy

46
*House of the Barbarians (La casa dei
barbari)* 1982
Oil on canvas
306 × 212 (120½ × 83½)
Emily and Jerry Spiegel, Kings Point,
New York

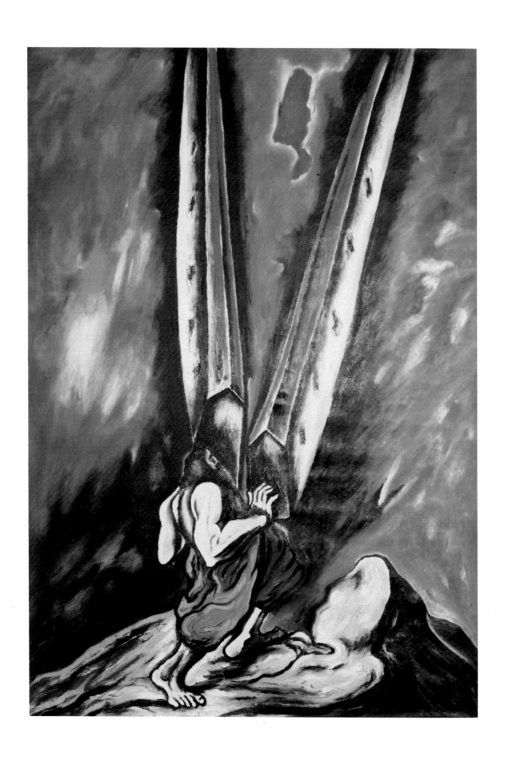

HANNE DARBOVEN

born Munich, Germany, 1944;
lives Hamburg, West Germany

47
Milieu 80: Heute 1979
Ink, black and white photographs, 266
pages
Each 42.5 x 30.4 (16¾ x 12)
Leo Castelli Gallery, New York

"I build up something by disturbing something (destruction-structure-construction). A system became necessary, how else could I see more concentratedly, find some interest, continue, go on at all? Contemplation had to be interrupted by action as a means of accepting anything among everything. . . . My so-called system . . . depends on things done previously. The materials consist of paper and pencil with which I draw my conceptions, write words and numbers, which are the most simple means for putting down my ideas; for ideas do not depend on materials. The nature of ideas is immateriality."
—Hanne Darboven, in Lucy R. Lippard, *From the Center* (New York: Dutton, 1976), p. 193.

Milieu 80: Heute, page 1.

Milieu 80: Heute, pages 16–30.

DONNA DENNIS

born Springfield, Ohio, 1942;
lives New York City

48
Tourist Cabin Porch 1976
Mixed media
198.1 x 290.6 x 66 (78 x 82½ x 26)
Donna Dennis, New York, courtesy Holly
Solomon Gallery, New York

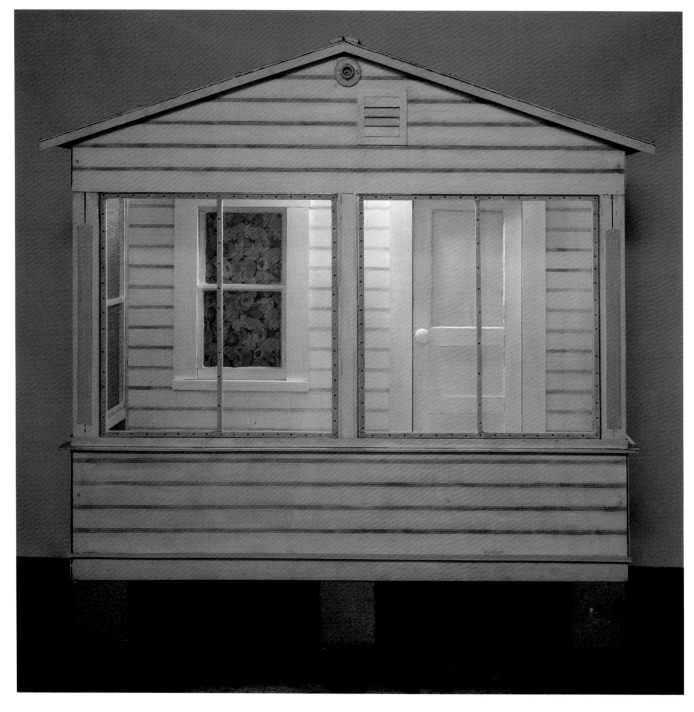

JANE DICKSON

born Chicago, Illinois, 1952;
lives New York City

49
Frisking 1983
Oilstick on canvas
228.6 × 101.6 (90 × 40)
Michael H. Schwartz, Philadelphia,
Pennsylvania

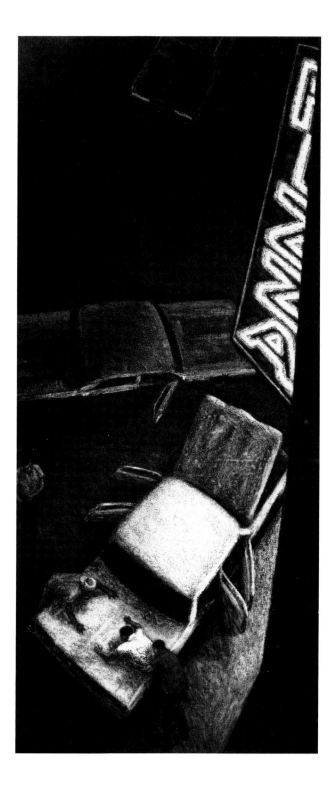

JIŘI GEORG DOKOUPIL

born Krnov, Czechoslovakia, 1954;
lives Cologne, West Germany

50
*Birthday of the Imprisoned Expert
(Geburtstag des gefangenen
Fachmanns)* 1982
Oil and acrylic on cotton, two panels
250 × 240 and 250 × 60 (97½ × 93¾ and
97½ × 23⅖)
Metzger Collection, Essen, West Germany,
extended loan to the Museum Folkwang,
Essen, West Germany

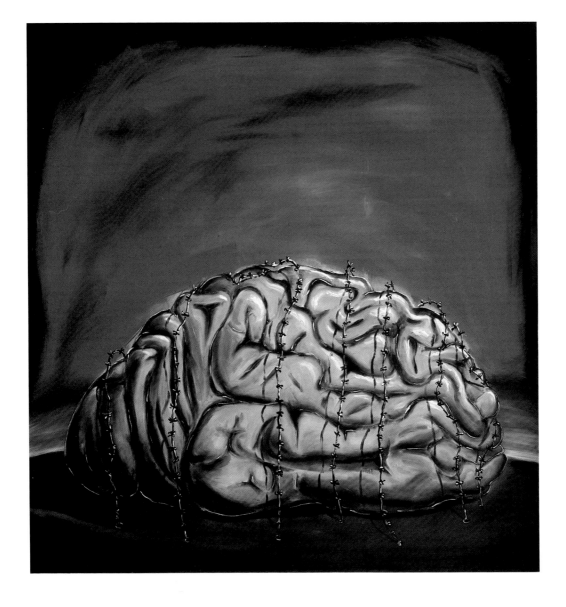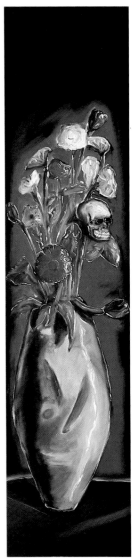

BERNARD FAUÇON

born Apt, France, 1951; lives Paris, France

51
Battle Field (Champ de bataille) 1978
Color photograph
30.4 × 30.4 (12 × 12)
Castelli Graphics, New York

52
The Comet (La Comète) 1979
Color photograph
30.4 × 30.4 (12 × 12)
Castelli Graphics, New York
[Not illustrated]

53
Friends (Les Amis) 1978
Color photograph
30.4 × 30.4 (12 × 12)
Castelli Graphics, New York
[Not illustrated]

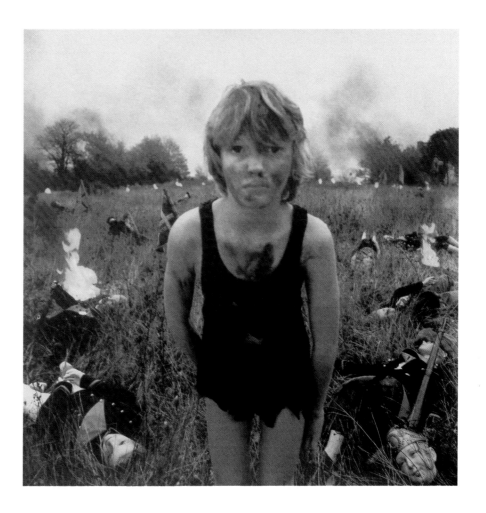

RAFAEL FERRER

born Santurce, Puerto Rico, 1933;
lives Philadelphia, Pennsylvania

54
Kayak: In the Torrid Zone 1974
Raffia, steel, paper, latex, and acrylic
304.8 x 33 x 33 (120 x 13 x 13)
Roger Brown, Chicago, Illinois

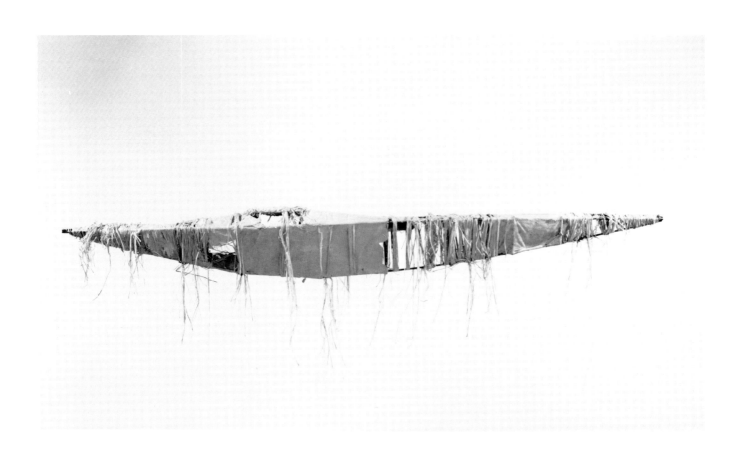

ERIC FISCHL

born New York City, 1948;
lives New York City

55
Birth of Love 1981
Oil on canvas
82.8 × 243.8 (72 × 96)
Barbara Gladstone, New York

"Central to my work is the feeling of awkwardness and self-consciousness that one experiences in the face of profound emotional events in one's life. These experiences, such as death, or loss, or sexuality, cannot be supported by a life style that has sought so arduously to deny their meaningfulness, and a culture whose fabric is so worn out that its public rituals and attendant symbols do not make for adequate clothing."
—Eric Fischl, statement, February 1982.

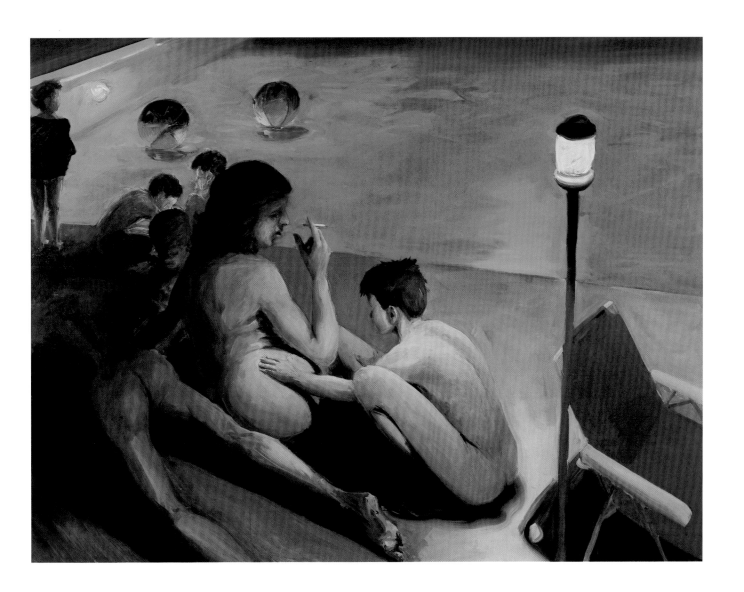

VERNON FISHER

born Fort Worth, Texas, 1943;
lives Denton, Texas

56
When I Was a Kid 1983
Eggs, plaster, metal, wood, and acrylic on
paper
153.6 × 332.7 × 12 (60½ × 131 × 4¾)
Fan on stool
88.9 × 38 × 38 (35 × 15 × 15)
Arthur and Carol Goldberg, New York,
courtesy Barbara Gladstone Gallery,
New York

*"My art is . . . polymorphic, impure, and
eccentrically inclusive, relatively unsifted
information. If less is more, then more is
more too. Truth is the result of thinking
aside or thinking parallel or thinking
through analogues. . . . The personal no
longer seems merely personal or
antithetical to the universal. One can
become more personal and more
universal simultaneously."*
—Vernon Fisher, in Miranda McClintic,
Directions 1981, exh. cat. (Washington,
D.C.: Hirshhorn Museum and
Sculpture Garden, 1981), p. 44.

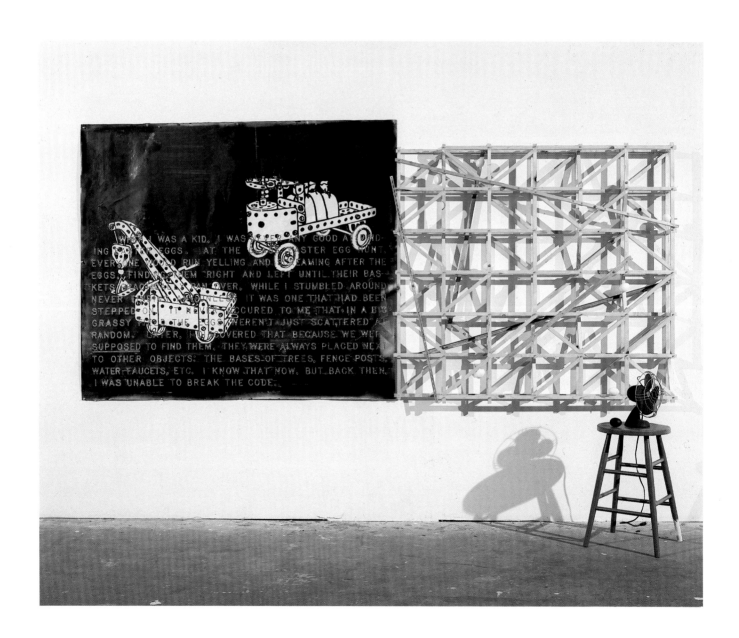

HAMISH FULTON

born London, England, 1946;
lives Canterbury, England

57
*Rain: A One Day 46 Mile Walk All On
Country Roads, Kent, Early Spring
1975* 1975
Framed photograph with text, 1/2
110 × 130.5 (43¼ × 51¼)
Hamish Fulton, Canterbury, England,
courtesy Waddington Galleries, London,
England

*"I am an artist and choose to make my
artworks from real life experiences. I
prefer to go out into the world and be
influenced and changed by events rather
than work from my imagination in one
fixed place."*
—Hamish Fulton, in Andrew Causey,
Nature as Material, exh. cat. (London:
Arts Council of Great Britain, 1980),
p. 3.

CHARLES GARABEDIAN

born Detroit, Michigan, 1923;
lives Santa Monica, California

58
Man Tearing His Heart Out 1974
Resin, fiberglass, and acrylic
254.6 × 264 (100¼ × 104)
Private collection, courtesy Hirschl and
Adler Modern, New York, and L. A.
Louver Gallery, Venice, California

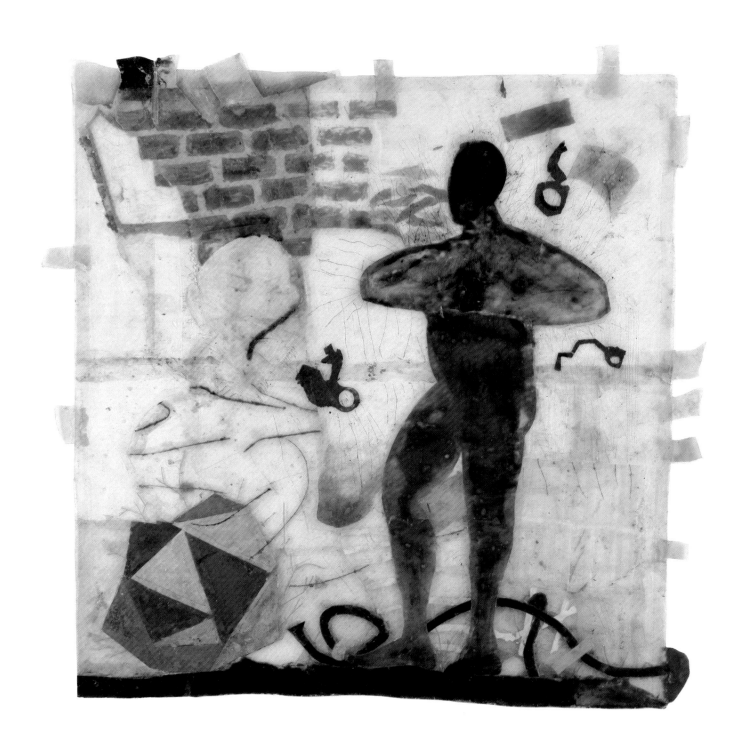

GILBERT AND GEORGE

GILBERT
born Dolomites, Italy, 1943;
lives London, England

GEORGE
born Devon, England, 1942;
lives London, England

59
Smash the Reds 1977
Photo-piece
300 × 250 (118 × 98½)
Anthony d'Offay Gallery, London, England

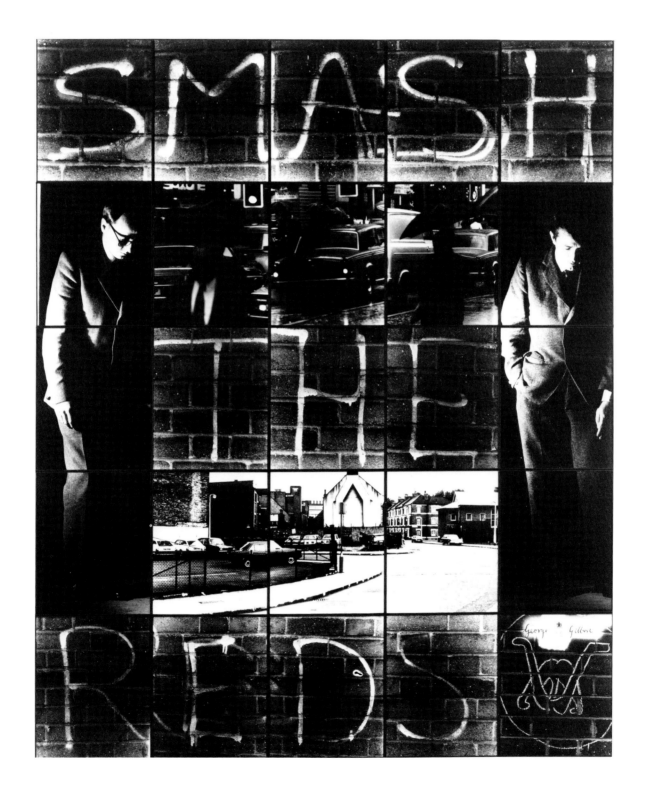

Leon Golub

born Chicago, Illinois, 1922;
lives New York City

60
Interrogation I 1981
Acrylic on canvas
304 × 447 (120 × 176)
Susan Caldwell, Inc., New York

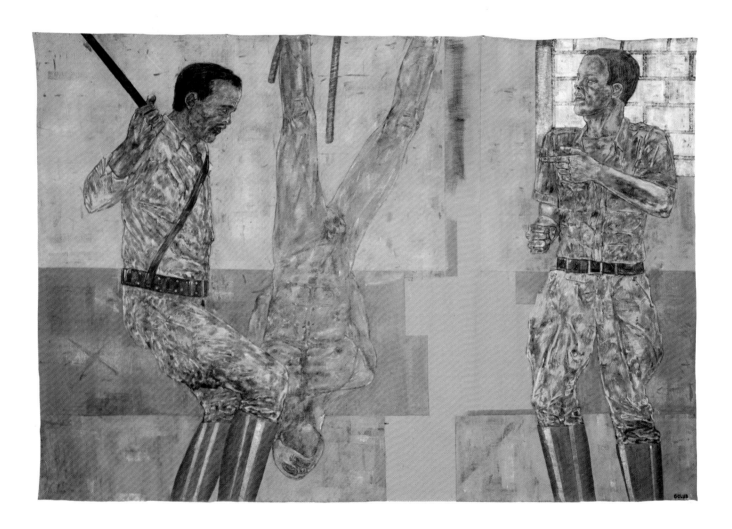

ROBERT GRAHAM
born Mexico City, Mexico, 1938;
lives Venice, California

61
Lise I 1977
Bronze
173.9 x 34.9 x 34.9 (68½ x 13¾ x 13¾)
J. U. Johnson, Jacksonville, Florida

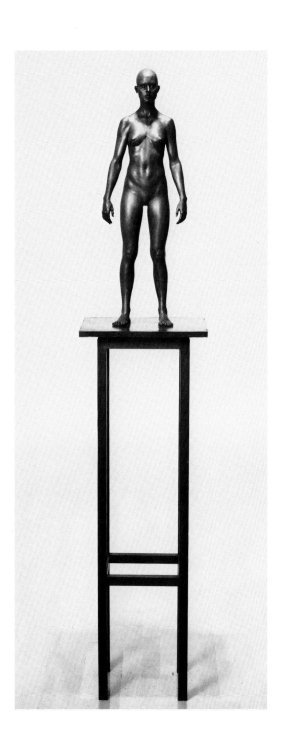

DENISE GREEN

born Melbourne, Australia, 1946;
lives New York City

62
For All and None 1978
Crayon, oil, and wax on canvas
152.4 × 152.4 (60 × 60)
Private collection

"I prefer to call the images I depict 'configurations.' They are not based on any literal description of a bridge or fan or vessel; rather, they give shape to my ideas about these objects."
—Denise Green, in Richard Marshall, *New Image Painting*, exh. cat. (New York: Whitney Museum of American Art, 1978), p. 26.

PHILIP GUSTON

born Montreal, Canada, 1913;
died Woodstock, New York, 1981

63
Source 1976
Oil on canvas
193.0 × 297.6 (76 × 117)
Edward R. Broida Trust, New York

*"The painting is not on a surface, but on
a plane which is imagined. It moves in a
mind. It is not there physically at all. It is
an illusion, a piece of magic, so what
you see is not what you see."*
—Philip Guston, in Renée KcKee, ed.,
"Philip Guston Talking," *Philip Guston*,
exh. cat. (London: Whitechapel Art
Gallery, 1982), p. 19.

HANS HAACKE

born Cologne, Germany, 1936;
lives New York City

64
Tiffany Cares 1977–78
Wood, metal, and fabric, with text from a
Tiffany & Co. advertisement in the *New
York Times*, June 6, 1977
83 x 55.8 x 55.8 (32¾ x 22 x 22)
John Weber Gallery, New York

ARE THE RICH A MENACE?

Some people think they are, so let's look at the record.

Suppose you inherit, win or otherwise acquire a million dollars net after taxes. That would make you rich, wouldn't it? Now, what's the first thing you'd do? Invest it, wouldn't you?— in stocks, bonds or in a savings bank.

So, what does that mean? It means that you have furnished the capital required to put about 30 people to work.

How is that? National statistics show that for every person graduating from school or college, at least thirty thousand dollars of capital must be found for bricks, fixtures, machinery, inventory, etc. to put each one to work.

Now, on your million dollar investments you will receive an income of sixty thousand, eighty thousand, or more dollars a year. This you will spend for food, clothing, shelter, taxes, education, entertainment and other expenses. And this will help support people like policemen, firemen, store clerks, factory workers, doctors, teachers, and others. Even congressmen.

So, in other words, Mr. Rich Man, you would be supporting (wholly or partially) perhaps more than 100 people.

Now, how about that? Are you a menace? No, you are not.

TIFFANY & CO.
FIFTH AVENUE & 57TH STREET
NEW YORK

*The 9,240,000 Unemployed in
The United States of America
Demand The Immediate Creation of
More Millionaires*

Text of *Tiffany Cares*, including advertisement in the *New York Times*, June 6, 1977.

KEITH HARING

born Kutztown, Pennsylvania, 1958;
lives New York City

65
Untitled 1982
Vinyl ink on vinyl tarpaulin
304.8 × 304.8 (120 × 120)
Ara Arslanian, New York

*"Drawing is still basically the same as it
has been since prehistoric times. It
brings together man and the world. It
lives through magic."*
—Keith Haring, in *Documenta 7*, exh.
cat. (Kassel, West Germany, 1982),
vol. 2, p. 144.

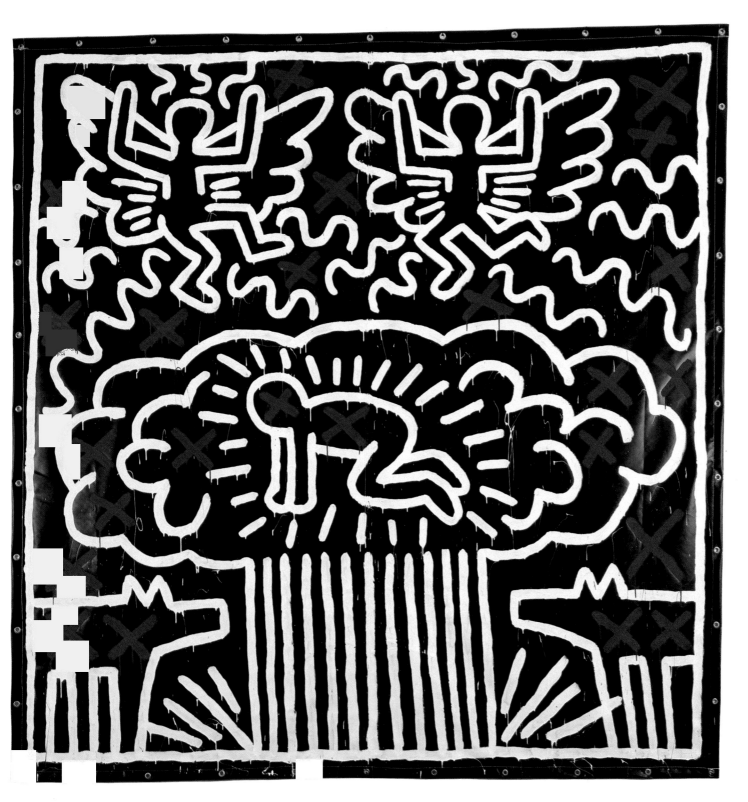

Helen Mayer Harrison
born New York City, 1929;
lives Del Mar, California

Newton Harrison
born New York City, 1932;
lives Del Mar, California

66
*Meditation on the Gabrielino Whose Name
for Themselves Is No Longer Remembered—
A Requiem—Although We Know That They
Farmed with Fire and Fought Wars by
Singing* 1976–77
Photo offset with pencil
116.4 x 243.1 (45¾ x 95¾)
Brooklyn Museum, New York, gift of
Agnes Denes

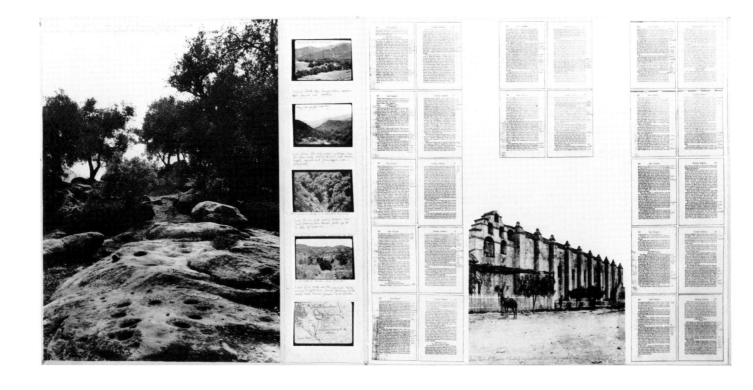

Mariusz Hermanowicz

born Olsztyn, Poland, 1950;
lives Warsaw, Poland

67
*The Day I Took This Photo Mr. Le Thanh
Nghi, the Vice-Prime Minister and President
of the State Planning Committee of the
Socialist Republic of Vietnam, Was Received
by Mr. A. Kosygin* 1977
Photograph
37.7 x 26.6 (14⅞ x 10½)
Muzeum Sztuki, Lódź, Poland

68
*At 12:15 P.M. 20 April 1978 a Man Passed
under the Window I Was Standing In: That Is
All I Have Known about Him* 1978
Photograph
37.7 x 26.6 (14⅞ x 10½)
Muzeum Sztuki, Lódź, Poland

69
*My Son Was Asleep in His Pram on the
Balcony from 1:55 P.M. till 5:00 P.M., 16
May 1978* 1978
Photograph
37.7 x 26.6 (14⅞ x 10½)
Muzeum Sztuki, Lódź, Poland
[Not illustrated]

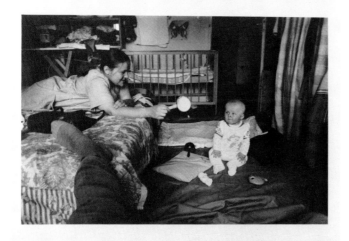

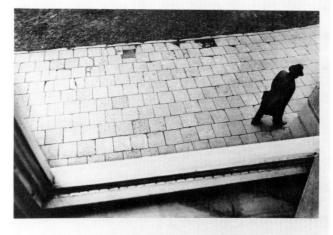

NANCY HOLT

born Worcester, Massachusetts, 1938;
lives New York City

70
Sun Tunnels 1973–76
Photographic documentation of concrete
site sculpture, Great Basin Desert, Utah
Eight color photographs mounted on
board
160 x 218.4 (63 x 86) over-all
John Weber Gallery, New York

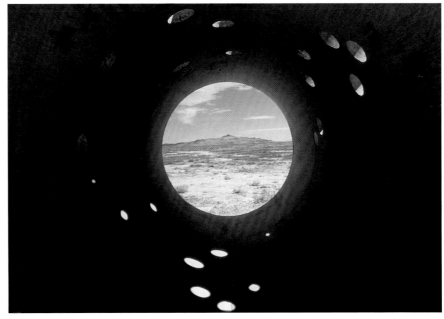

Interior of northwest tunnel, with holes cut in the configuration of the constellation Draco.

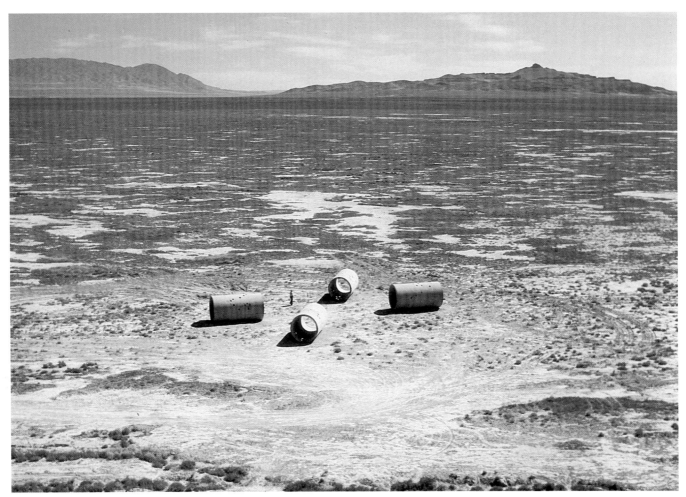

General view of *Sun Tunnels*, aligned with the sun on solstice.

JENNY HOLZER

born Gallipolis, Ohio, 1950;
lives New York City

71
Truisms 1983
Light emitting diode sign reading: IMPOSING
ORDER IS MANS VOCATION FOR CHAOS IS HELL
17.7 x 152.4 x 16.5 (7 x 60 x 6½)
Private collection

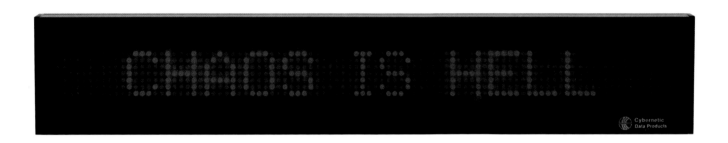

DOUGLAS HUEBLER

born Ann Arbor, Michigan, 1924;
lives Truro, Massachusetts; Van Neuys,
California; and Newhall, California

72
*Variable Piece #70 (In Process) Global, April
1981, Crocodile Tears: The Players, "Dirty
Players I"* 1981
Color photographs and photostat mounted
on board
82.5 × 81.28 (32½ × 32)
Leo Castelli Gallery, New York
[Not illustrated]

73
*Variable Piece #70 (In Process) Global, April
1981, Crocodile Tears: The Players, "Dirty
Players II"* 1981
Color photographs and photostat mounted
on board
82.5 × 81.28 (32½ × 32)
Leo Castelli Gallery, New York

"I am convinced that the most
compelling, the most pertinent issue
concerning any kind of art practice
today is one that began to surface in
the late '60s. It is the issue about
whether or not 'association'—
referencing to worldly matters—will be
permitted back into art."
—Douglas Huebler, in Connie
Fitzsimons, *Comment*, exh. pamphlet
(Long Beach, Calif.: Long Beach
Museum of Art, 1983), p. 3.

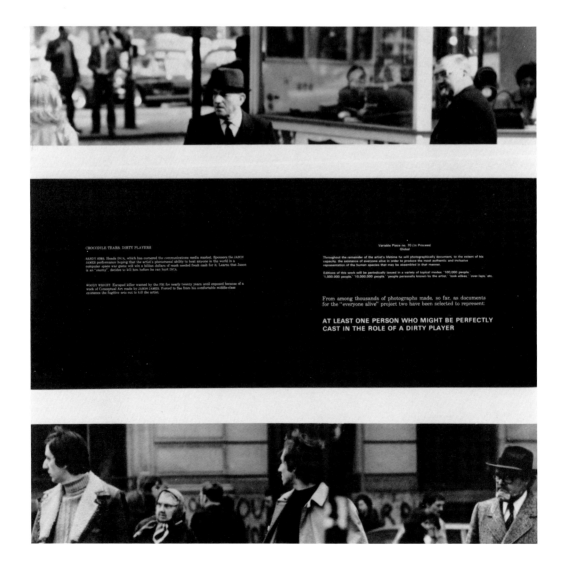

JÖRG IMMENDORFF

born Bleckede, Germany, 1945;
lives Düsseldorf, West Germany

74
*Café Deutschland XII—Eagle's Half (Café
Deutschland XII—Adlerhälfte)* 1982
Oil on canvas
282 × 400 (111 × 157½)
Mary Boone/Michael Werner Gallery,
New York

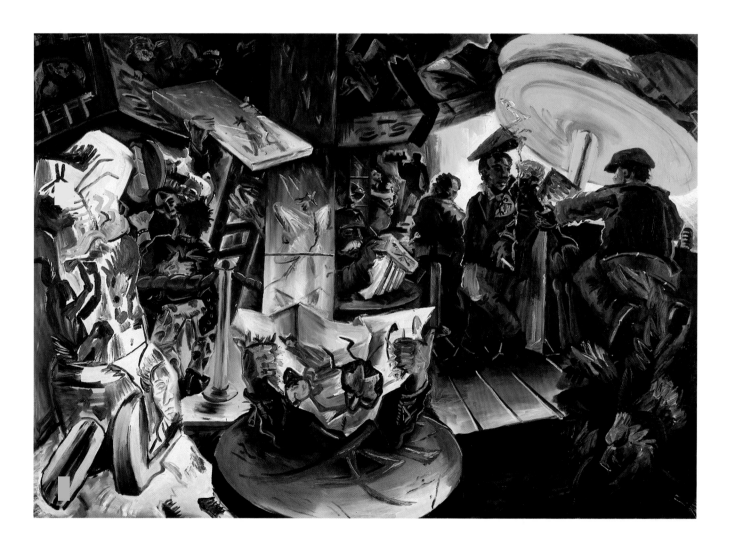

NEIL JENNEY

born Torrington, Connecticut, 1945;
lives New York City

75
The Bruce Hardie Memorial 1978–82
Oil on panel
187.96 × 213.36 (74 × 84)
Neil Jenney, New York

*"I don't think the artist should deal with
space or think about dealing with space.
He should think about adjusting culture
... I think realism ... resolves all the
problems that abstract paintings
resolved, but includes another level of
expression—meaning the significance of
the items depicted."*
—Neil Jenney, in Mark Rosenthal, *Neil
Jenney: Paintings and Sculpture 1967–
1980*, exh. cat. (Berkeley, Calif.:
University Art Museum, 1981), p. 47.

Anselm Kiefer

born Donaueschingen, Germany, 1945;
lives Hornbach, West Germany

76
Die Meistersinger 1982
Oil, acrylic, and straw on canvas
280 × 380 (110 × 150)
Doris and Charles Saatchi, London,
England

EDWARD KIENHOLZ
born Fairfield, Washington, 1927; lives
Berlin, West Germany, and Hope, Idaho

NANCY REDDIN KIENHOLZ
born Los Angeles, California, 1943; lives
Berlin, West Germany, and Hope, Idaho

77
In the Infield Was Patty Peccavi 1981
Mixed media
190 x 206 x 254 (74¾ x 81 x 100)
Edward Kienholz and Nancy Reddin
Kienholz, Hope, Idaho

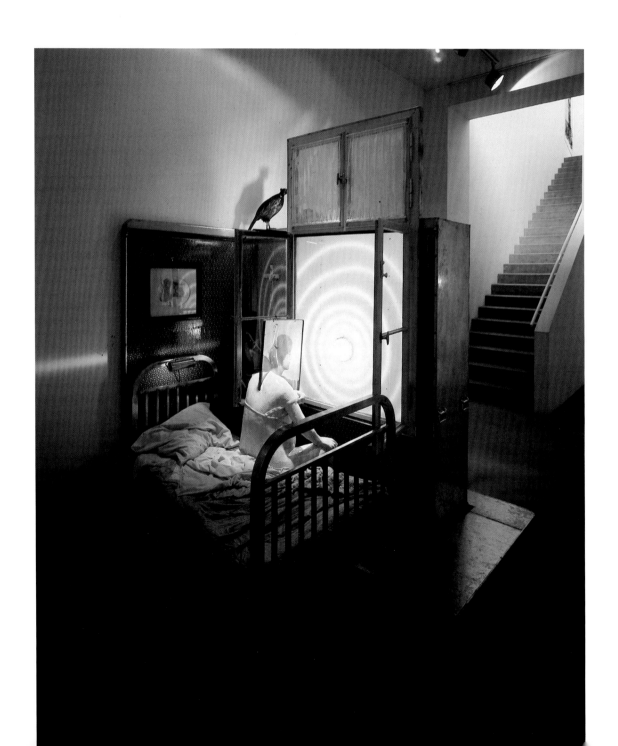

KEN KIFF
born Essex, England, 1935;
lives London, England

78
Triptych: The Cry; Rain on the Sea; The Street 1982–83
Oil and acrylic on board
114 × 266.7 (45 × 105) over-all
Private collection, courtesy Nicola Jacobs Gallery, London, England

Detail.

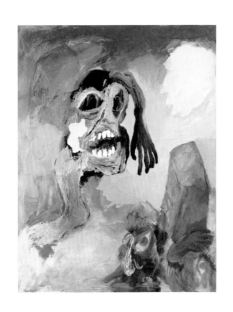

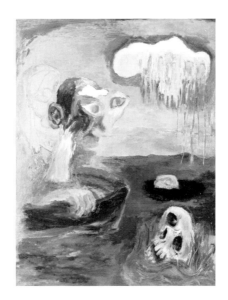

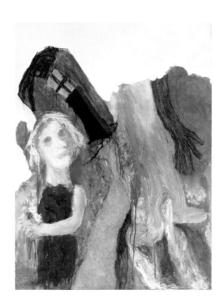

ALAIN KIRILI

born Paris, France, 1929; lives Paris,
France, and New York City

79
Untitled 1980
Forged iron
210 (82½) high
Alain Kirili, New York

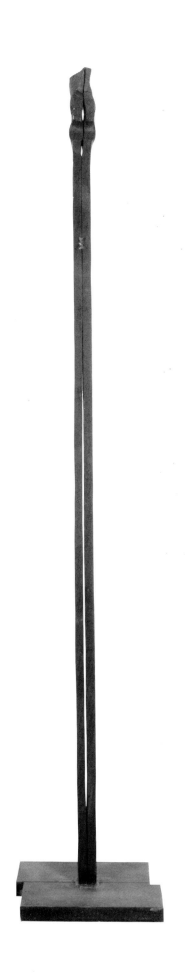

KOMAR AND MELAMID

VITALY KOMAR
born Moscow, USSR, 1943;
lives New York City

ALESANDER MELAMID
born Moscow, USSR, 1945;
lives Jersey City, New Jersey

80
*Stalin and the Muses (The Muse of Painting
Presents Clio, the Muse of History, to
Stalin)* 1981–82
Oil on canvas
182.8 × 139.7 (72 × 55)
Robert and Maryse Boxer, London,
England, courtesy Ronald Feldman Fine
Arts, Inc., New York

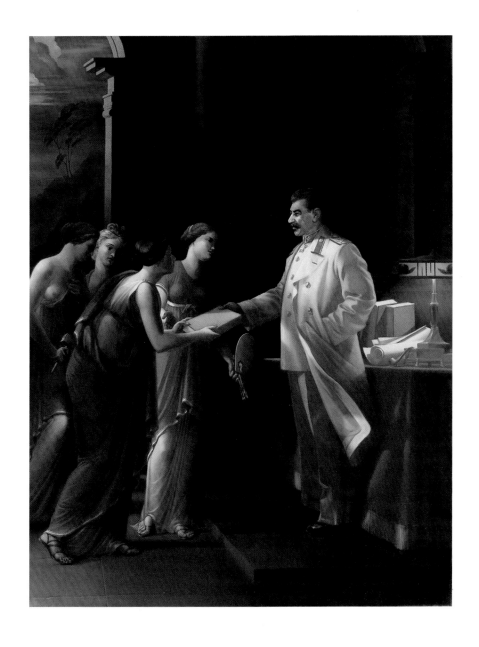

JOSEPH KOSUTH

born Toledo, Ohio, 1945;
lives New York City

81
Text/Context (Edinburgh) 1978
Billboard originally installed outdoors in
Edinburgh, Scotland
Redesigned for installation at Hirshhorn
Museum, 1984
365.7 x 457.2 (144 x 180)
Courtesy Leo Castelli Gallery, New York

"Anyway, as I have repeatedly said, and those who understand the value of hyperbole will appreciate it—artists work with meaning, not form (if such a separation were possible). To think the reverse is tantamount to saying that when you speak you think in terms of grammar. . . . [The individual artist] makes meaning by canceling, redirecting, or re-organizing the forms of meaning that have gone before. It is in this sense that the art of this century—the 'avant-garde' tradition—is associated with the political."

—Joseph Kosuth, "Portraits: Necrophilia, Mon Amour," *Artforum* 20 (May 1982): 60.

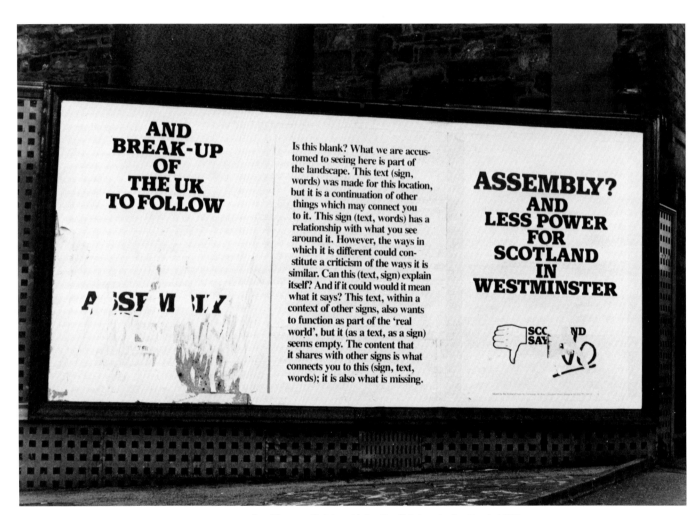

Text/Context (Edinburgh), in situ, Edinburgh, Scotland, 1978.

JANNIS KOUNELLIS

born Piraeus, Greece, 1936;
lives Rome, Italy

82
Untitled 1978
Plaster head with paint and steel sheet
100.3 × 69.8 (39½ × 27½)
Emily and Jerry Spiegel, Kings Point, New
York

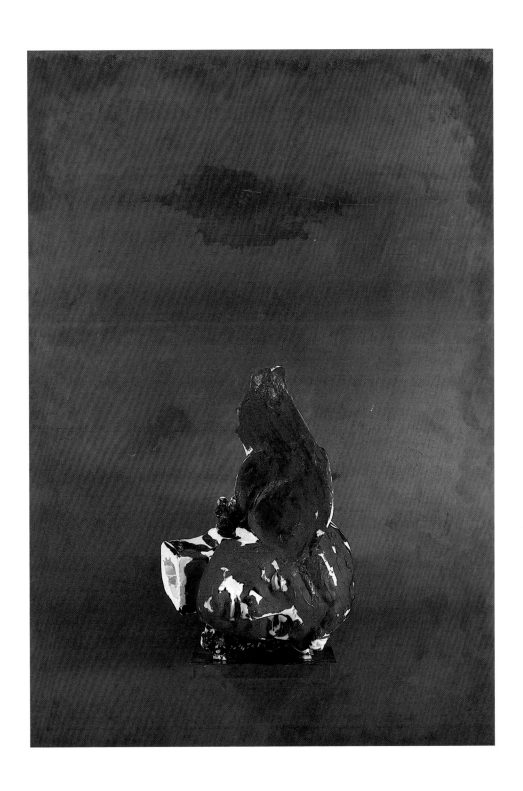

BARBARA KRUGER

born Newark, New Jersey, 1945;
lives New York City

83
Untitled (We Have Received Orders Not to Move) 1982
Photograph
182.8 x 122 (72 x 48)
Arthur and Carol Goldberg, New York

"In the hope of coupling the ingratiation of wishful thinking with the criticality of knowing better, I replicate certain words and pictures and watch them stray from or coincide with your notions of fact and fiction. I see my work as a series of attempts to ruin certain representations and to welcome a female spectator into the audience of men."
—Barbara Kruger, statement, November 1983.

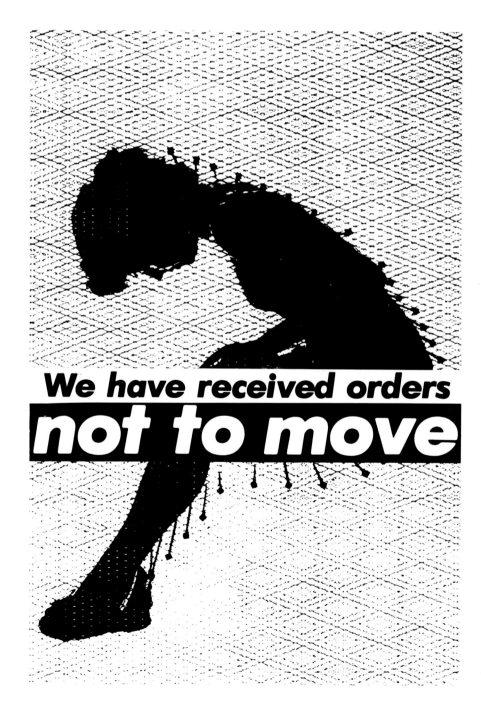

Thomas Lanigan-Schmidt

born Elizabeth, New Jersey, 1948;
lives New York City

84
A Child's Byzantium in New Jersey 1974–
75, 1982
Magic marker, cosmetics, disco tape, Saran
wrap, and aluminum foil on plaster crucifix
on cardboard, two panels
55.8 × 45.7 (22 × 18) and 45.7 × 22.8
(18 × 9)
Holly Solomon Gallery, New York

*"I try to use poor and inexpensive
materials . . . aluminum foils, plastic
wraps, cellophane tape, staples and felt-
tip markers. With these materials,
'knick-knacks' are constructed and used
as metaphors to dramatize the clash in
value systems among the different social
classes. . . . The materials used came
down from the top and are received at
the bottom. To survive, those on the
bottom must transform these materials
into one art form or another to express
self-worth in a society that considers
them almost worthless."*
—Thomas Lanigan-Schmidt, in Martin
James Boyce, "Thomas Lanigan
Schmidt: Joy of Life, Predestination
and Class-Clash Realism," *Flash Art* 114
(November 1983): 60.

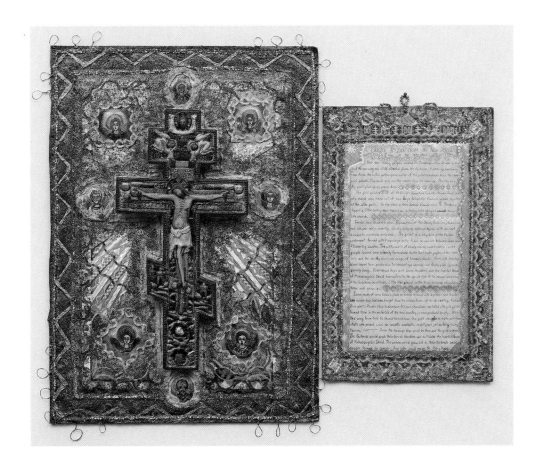

Jean Le Gac

born Alès, France, 1936; lives Paris, France

85
The Painter 1974
Ten photographs and text mounted on board
76.2 x 101.6 (30 x 40) over-all
John Gibson, New York

"Because art is an exile in language, and because I have a feeling of nostalgia for art (from the art of History, the art of Sunday painters whom I admired so much when I was a child, and because drawing or painting was always the most agreeable pastime for me), I like to get the toned-down echo of this through photography and text, this no man's land where the photo is not very photographic and the text has little other literary merit."
—Jean Le Gac, in *European Dialogue*, exh. cat. (Sidney: Art of New South Wales, 1979), unpaginated.

Detail.

opposed to work in the mines which was the activity of all the men he knew and which they did not exercise in broad daylight. The pictures these artists would paint with uncalculable slowness were true mysteries to him - he could not understand the interest they showed for this or that part of the countryside which he was familiar with, and which obviously had nothing about it that was fundamentally different from anything

Detail.

LES LEVINE

born Dublin, Ireland, 1935;
lives New York City

86
Taking a Position 1979
Model for billboard, crayon on canvas,
three panels
52.4 × 203 (60 × 80), 198 × 243.8 (78 ×
96), and 152.4 × 203 (60 × 80)
Ronald Feldman Fine Arts, Inc., New York,
and Ted Greenwald, Inc., New York

Detail.

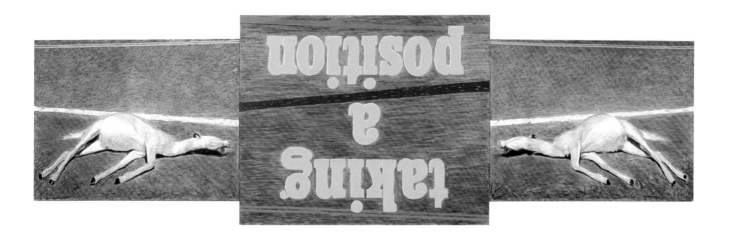

SHERRIE LEVINE

born Hazelton, Pennsylvania, 1947;
lives New York City

87
After Ernst Ludwig Kirchner 1982
C print
50.8 × 40.6 (20 × 16)
Sherrie Levine, New York

88
After Ernst Ludwig Kirchner 1982
C print
50.8 × 40.6 (20 × 16)
Sherrie Levine, New York

89
After Ernst Ludwig Kirchner 1982
C print
50.8 × 40.6 (20 × 16)
Sherrie Levine, New York
[Not illustrated]

"Instead of taking photographs of trees or nudes I take photographs of photographs. I choose pictures that manifest the desire that nature and culture provide us with a sense of order and meaning. I appropriate these images to express my own simultaneous longing for the passion of engagement and the sublimity of aloofness."
—Sherrie Levine, in Benjamin H. D. Buchloh, "Allegorical Procedures: Appropriation and Montage in Contemporary Art," *Artforum* 21 (September 1982): 52–53.

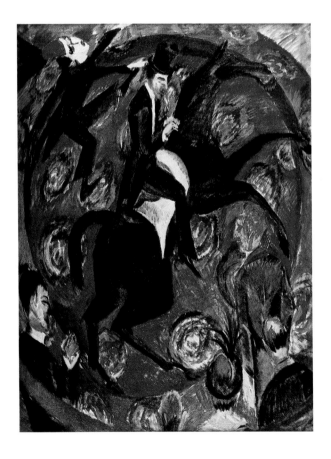 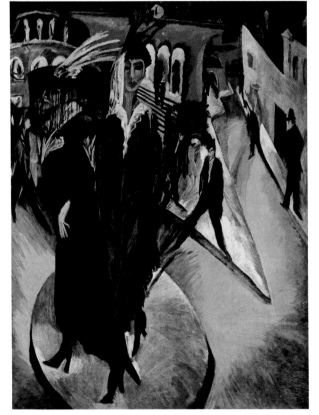

RICHARD LONG

born Bristol, England, 1945;
lives Bristol, England

90
Bluestone Circle 1978
Bluestone, ninety-six pieces
487.6 (192) diameter
Stedelijk Museum, Amsterdam, Holland

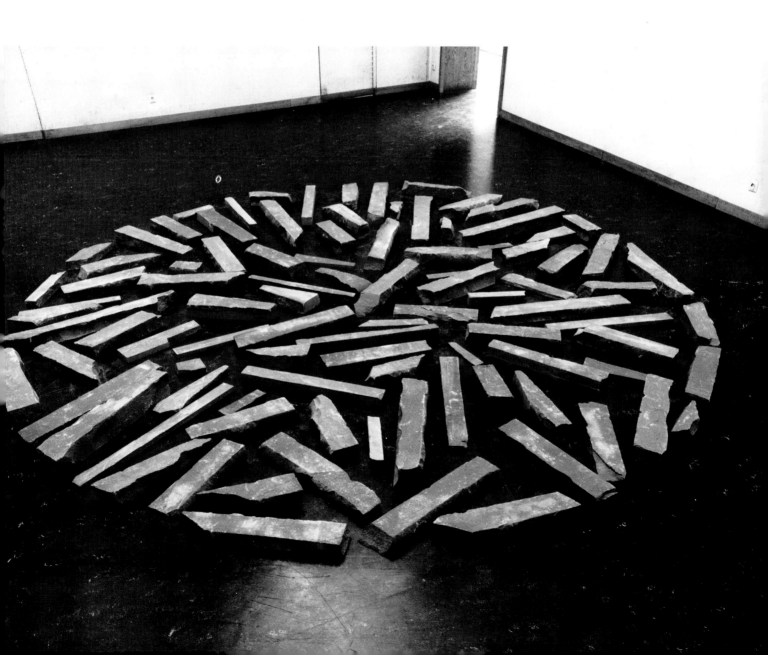

ROBERT LONGO

born Brooklyn, New York, 1953;
lives New York City

91
Master Jazz 1982–83
Mixed media
243.8 × 571.5 × 127 (96 × 225 × 12)
Robert Lehrman, Washington, D.C.,
courtesy Middendorf Gallery, Washington,
D.C.

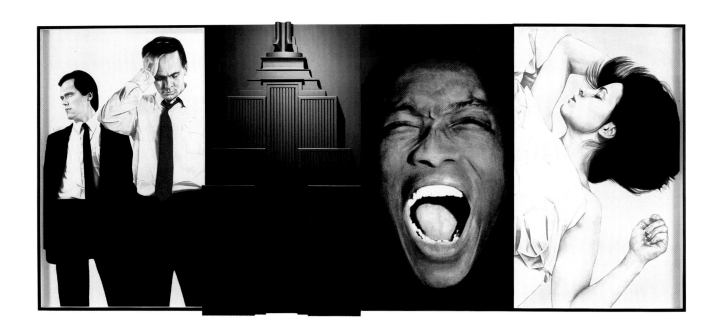

MARKUS LÜPERTZ

born Liberec, Bohemia, 1941;
lives Berlin, West Germany

92
*Black-Red-Gold Dithyrambic (Schwarz-Rot-
Gold Dithyrambisch)* 1974
Distemper on canvas, three panels
Each 260 × 200 (102¼ × 78⅜)
Private collection

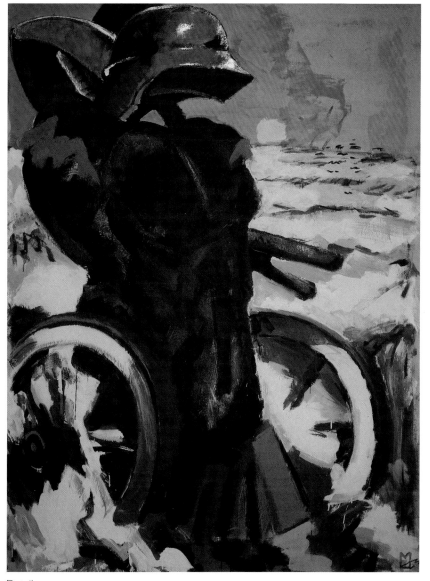

Detail.

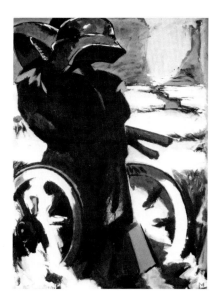

CARLO MARIA MARIANI

born Rome, Italy, 1931; lives Rome, Italy

93
Victorious Athlete (Atleta Vincitore) 1979–80
Oil on canvas
185.4 x 140.3 (73 x 55¼)
Mick Jagger, New York

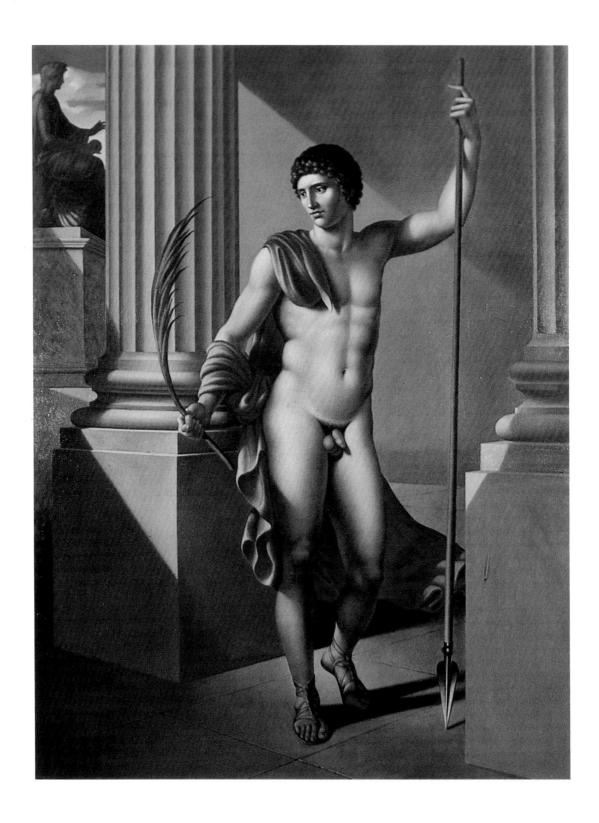

GORDON MATTA-CLARK

born New York City, 1945;
died New York City, 1978

94
House Splitting (Englewood, New Jersey) 1974–75
Cibachrome photograph
75.5 × 100.3 (29¾ × 39½)
Holly and Horace Solomon, New York

95
From "Splitting" 1974
Photographic collage
45.7 × 76.2 (18 × 30)
John Gibson, New York

"A simple cut or series of cuts, act as a powerful drawing device able to redefine spatial situations and structural components. What is invisibly at play behind a wall or floor, once exposed, becomes an active participant in a spatial drawing of the building's inner life. . . . There is a kind of complexity which comes from taking an otherwise completely normal, conventional, albeit anonymous situation and redefining it, retranslating it into overlapping and multiple readings of conditions past and present."
—Gordon Matta-Clark, in *Gordon Matta-Clark*, exh. cat. (Antwerp: International Cultural Centrum, 1977), p. 10.

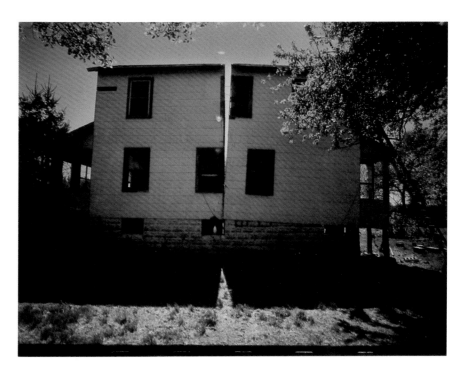

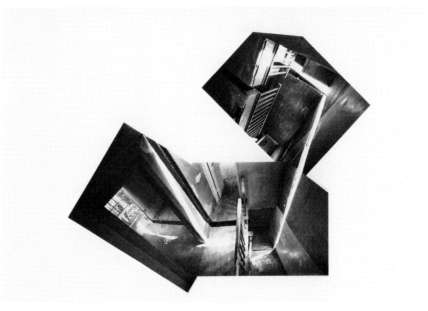

MARIO MERZ

born Milan, Italy, 1925; lives Turin, Italy

96
Old Bison on the Savannah 1979
Oil and charcoal on canvas, neon lance,
and three branches with two spray-painted
bottles
304.8 × 411.4 (120 × 162)
Private collection, courtesy Sperone
Westwater, New York

*"I start my work from the emotion which
is evoked by the archetypal, the
material nullifying structure. After I have
procured the object I try to seize
manually its structure by bringing it into
different positions until it is in harmony
with my own person. There I cut
through this form with a different
energy, e.g., with a standard weight or a
neon tube. I experience a very physical,
individual feeling of participation at the
primary life of this object while
equalizing (balancing) its energetic
present with another energy."*
—Mario Merz, in Peter Winter,
"Mario Merz," *Kunstwerk* 32 (April–
June 1979): 180 (translation by Regina
Hablützel).

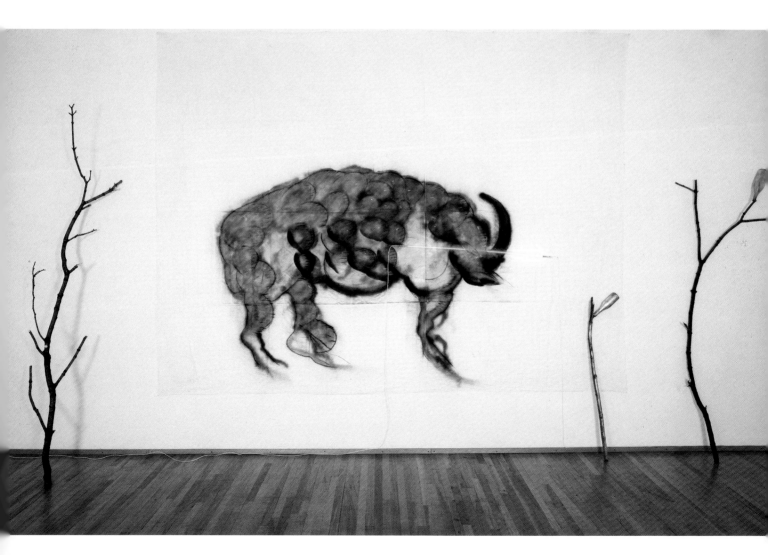

DUANE MICHALS

born Keesport, Pennsylvania, 1932;
lives New York City

97
Homage to Cavafy 1978
Ten photographs with text
Each 20 × 26 (8 × 10)
Sidney Janis Gallery, New York

"I am a short story writer. Most other photographers are reporters. . . . I use photography to help me explain my experiences to myself."
—Duane Michals, *Real Dreams* (Danbury, N.H.: Addison House, 1976), p. 1.

The son returned home in the afternoon, but he was too late. The father had died in the morning.

MALCOLM MORLEY

born London, England 1931;
lives New York City

98
The Day of the Locust 1977
Oil on canvas
183 × 152.5 (72 × 60)
Private collection

*"I like all my paintings to come out of
what I've actually seen and experienced
in one way or another. In a sense,
they're about being in the physical,
phenomenological, man-made world and
then retreating from it."*
—Malcolm Morley, in "Expressionism
Today: An Artists' Symposium," *Art in
America* 70 (December 1982): 68.

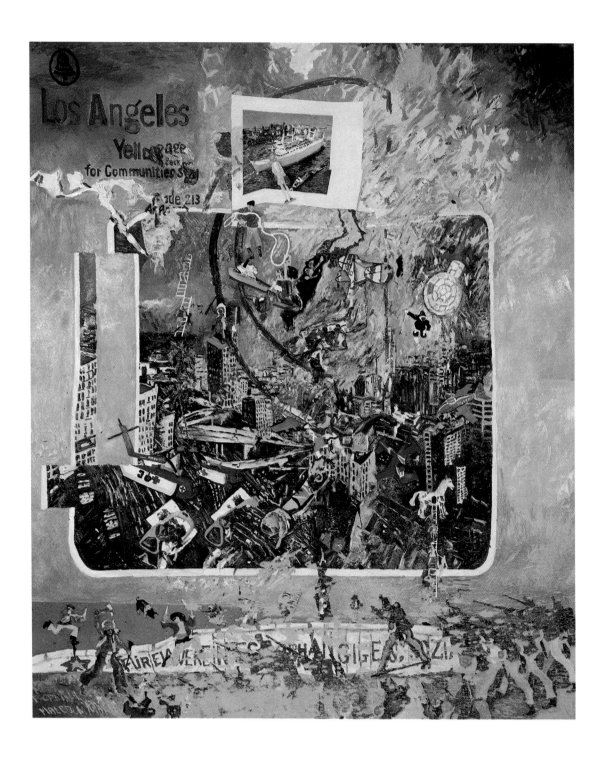

ROBERT MORRIS

born Kansas City, Missouri, 1931;
lives New York City

99
Labyrinth 1973, revised 1984
Painted drywall construction
Triangular, each side 792.5 × 243
(312 × 96)
Courtesy Leo Castelli Gallery, New York

"Throughout the '70s, Acconci, Oppenheim, Haacke, Baldessari, Aycock, myself and others developed works, especially installations, which drew on transformations, skewed systems, metaphysics, language, machinery and metaphor of all sorts. None of this could have existed without Duchamp's detonation of the static, self-sufficient esthetic object as the limit for art-making."
—Robert Morris, "American Quartet," *Art in America* 69 (December 1981): 100.

Drawing for *Labyrinth*, 1973.

REE MORTON

born Ossining, New York, 1936;
died Chicago, Illinois, 1977

100
Signs of Love 1977
Mixed media
Dimensions variable
Estate of Ree Morton, New York,
courtesy Michael Klein, Inc., New York

*"If I were to find the words for the
answers, and tell them to you, then how
quickly would that eliminate the
possibility that the work might have an
existence of its own, and continue to
grow in itself, and find new meaning,
and change its meaning, and contradict
its original meaning, and live?"*
—Ree Morton, in Phyllis Plous,
*Contemporary Tableaux/Constructions
1974–1977,* exh. cat. (Santa Barbara,
Calif.: University of California at Santa
Barbara Art Museum, 1977), p. 25.

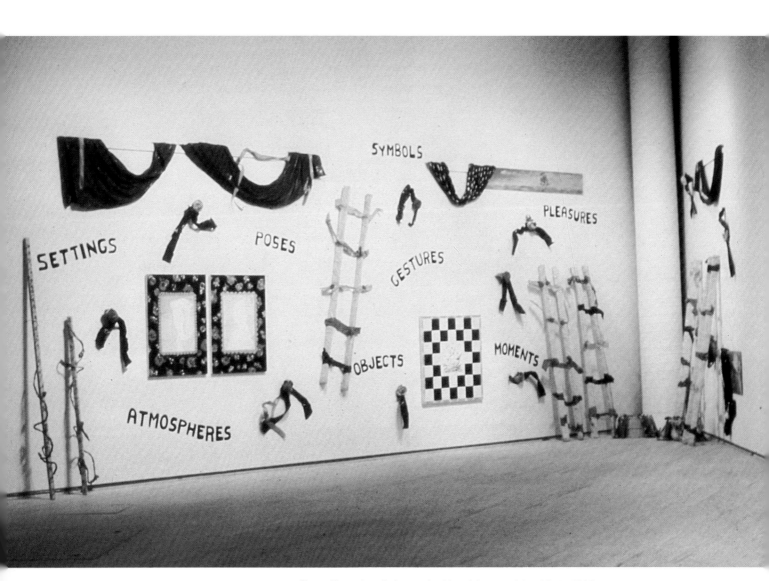

Signs of Love, installation at the New Museum, New York, 1980.

ROBERT MOSKOWITZ
born New York City, 1935;
lives New York City

101
Thinker 1982
Oil on canvas
274.3 x 160 (108 x 63)
Blum/Helman Gallery, New York

BRUCE NAUMAN

born Fort Wayne, Indiana, 1941;
lives Pecos, New Mexico

102
*Human Nature/Life Death/Knows Doesn't
Know* 1983
Neon and glass tubing
273 × 271.8 × 14.6 (107½ × 107 × 5¾)
Los Angeles County Museum of Art, Los
Angeles, California, purchased with funds
provided by the Modern and
Contemporary Art Council

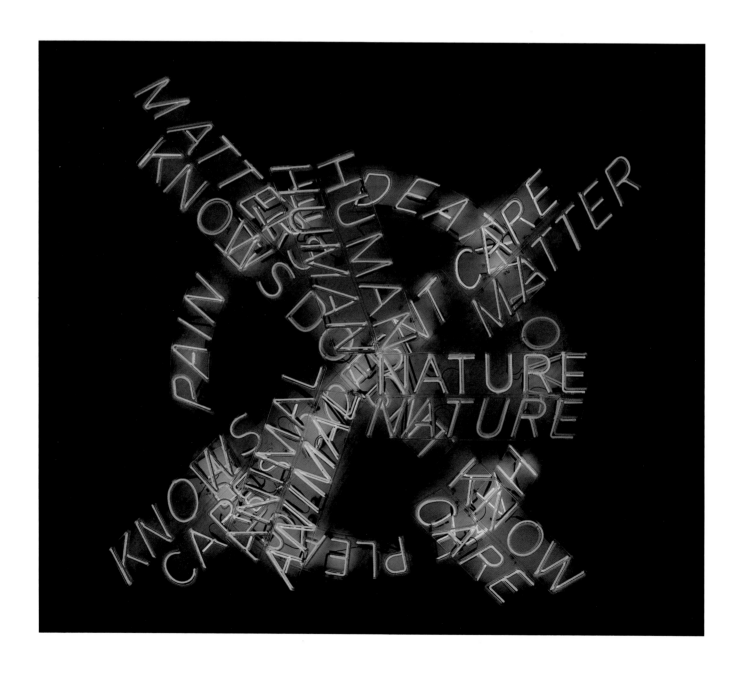

Hermann Nitsch

born Vienna, Austria, 1938;
lives Prinzendorf, Austria

103
Orgies-Mysteries Theater (Orgien Mysterien Theater) 1975
Photographic documentation of ritual
"action," Prinzendorf, Austria, July 1975
Nine photographs
Each approx. 70 × 70 (24 × 24)
Hermann Nitsch, Prinzendorf, Austria,
courtesy Galerie Ulysses, Vienna, Austria

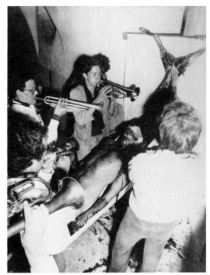

Detail.

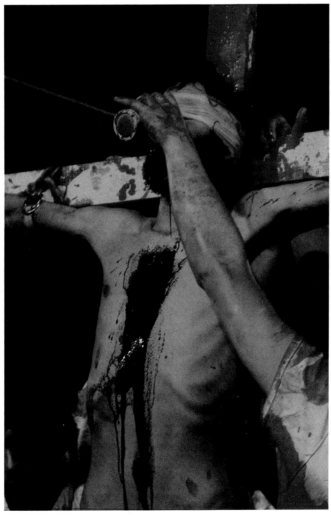

Detail.

ISAMU NOGUCHI

born Los Angeles, California, 1904; lives
New York City and Shikoku, Japan

104
Model for *Sacred Rocks of
Kukaniloko* 1976
Bronze
3.8 × 62.2 × 63.5 (1⅝ × 24½ × 25)
Isamu Noguchi Foundation, Inc., Long
Island City, New York

Overhead view.

JIM NUTT

born Pittsfield, Massachusetts, 1938;
lives Chicago, Illinois

105
Yes! I Understand . . . 1979
Colored pencil on brown kraft paper
33 × 45.7 (13⅛ × 18¹/₁₆)
Byron Meyer, San Francisco, California

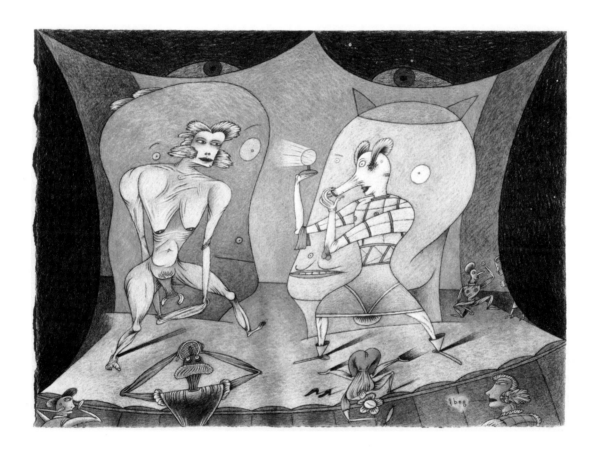

DENNIS OPPENHEIM

born Mason City (now Electric City),
Washington, 1938; lives New York City

106
Avoid the Issues 1974
Photographic documentation of red and
green fireworks sign, composed of
strontium nitrate and potassium
perchlorate flares, East River, New York,
1974
76.2 x 101.6 (30 x 40)
Dennis Oppenheim, New York

107
Pretty Ideas 1974
Photographic documentation of red,
yellow, and green fireworks sign,
composed of strontium nitrate flares, Long
Island, New York, 1974
76.2 x 101.6 (30 x 40)
Dennis Oppenheim, New York
[Not illustrated]

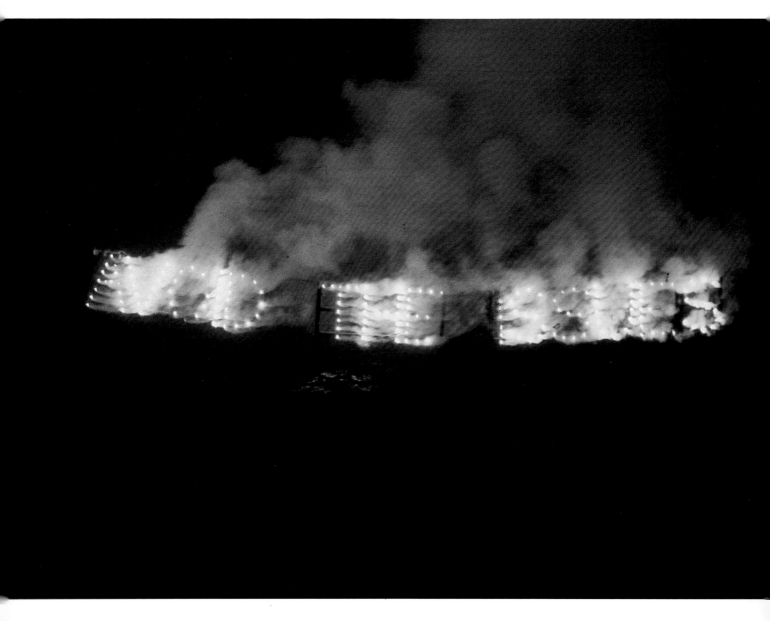

TOM OTTERNESS

born Wichita, Kansas, 1952;
lives New York City

108
Mass Workers 1983
Painted cast polyadam
355.6 x 119.3 x 13.9 (140 x 47½ x 5½)
Eli and Edythe L. Broad, Los Angeles,
California, courtesy Brooke Alexander,
Inc., New York

NAM JUNE PAIK
born Seoul, Korea, 1932;
lives New York City

109
TV Buddah 1974
Video installation with statue
60 × 200 × 80 (23½ × 78¾ × 31½)
Stedelijk Museum, Amsterdam, Holland

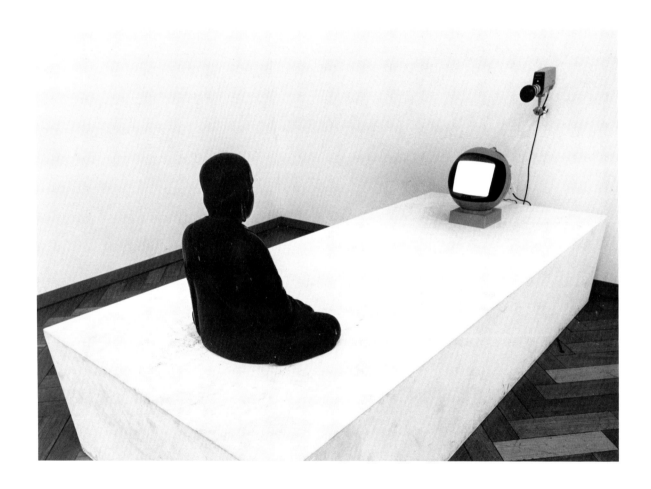

MIMMO PALADINO

born Paduli, Benevento, Italy, 1948;
lives Milan, Italy

110
Seizure of the Poets (Assediato dai poeti) 1983
Mosaic
257 × 400 (101 × 157)
Emilio Mazzol, Galleria d'Arte
Contemporanea, Modena, Italy

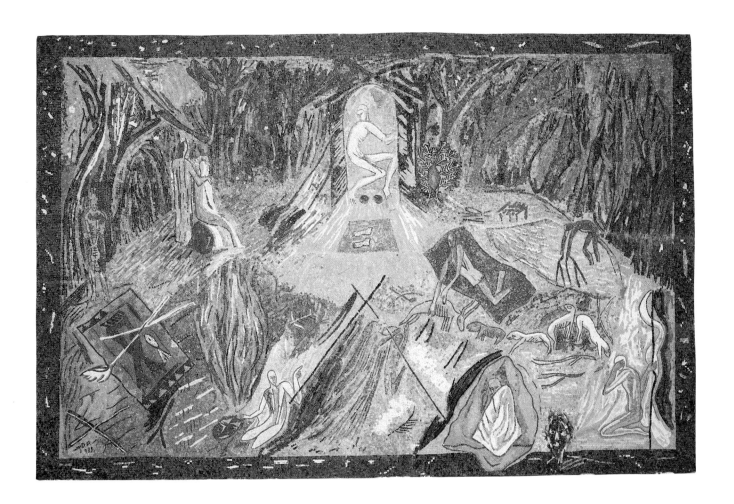

Esther Parada

born Grand Rapids, Michigan, 1938;
lives Oak Park, Illinois

111
Memory Warp II 1980
Twenty-five mounted silver-print
photographs
76.2 × 76.2 (30 × 30) over-all
Esther Parada, Oak Park, Illinois

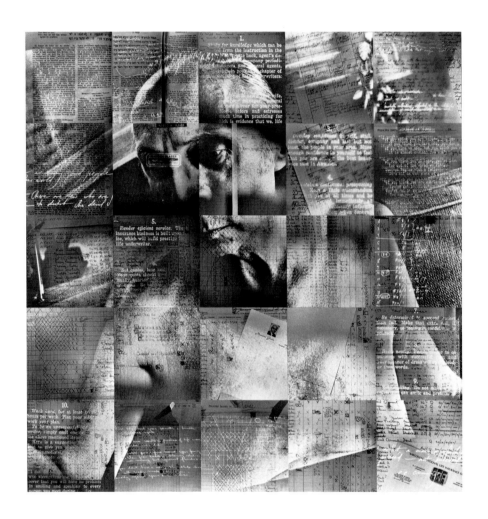

Ed Paschke

born Chicago, Illinois, 1939;
lives Chicago, Illinois

112
Gestapo 1979
Oil on canvas
76.2 × 116.8 (30 × 46)
Gary Goodwin, Chicago, Illinois

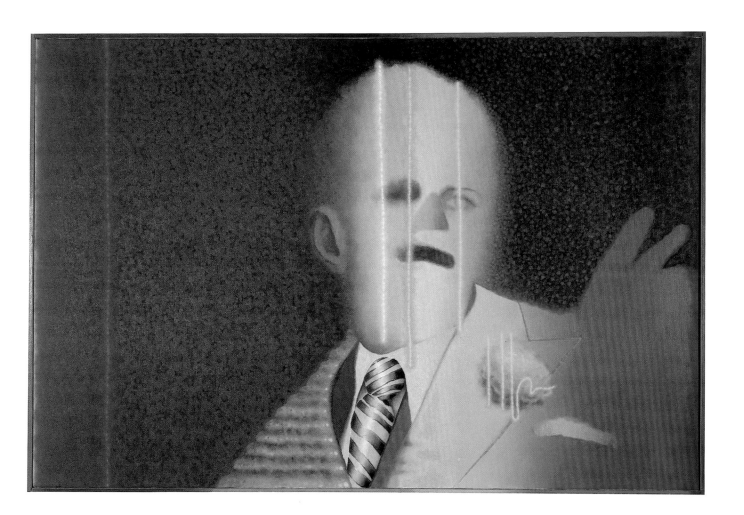

A. R. PENCK

born Dresden, Germany, 1939;
lives Cologne, West Germany

113
Requiem for Waltraud (N-Complex)
(Requiem für Waltraud [N-Komplex])
1976
Oil on canvas
285 × 285 (112½ × 112½)
Louisiana Museum, Humlebaek, Denmark,
donation Louisiana-Samlingens Venner

"I am a follower of the structuralistic theory. The images should apply to several situations in the political, economical, as well as biological and personal sphere. It is a question of passage from one system into the other, where the fundamental structure remains the same."

—A. R. Penck, in Peter Blum, "Penck Übergang," *Du*, no. 11 (1980), p. 20 (translation by Regina Hablützel).

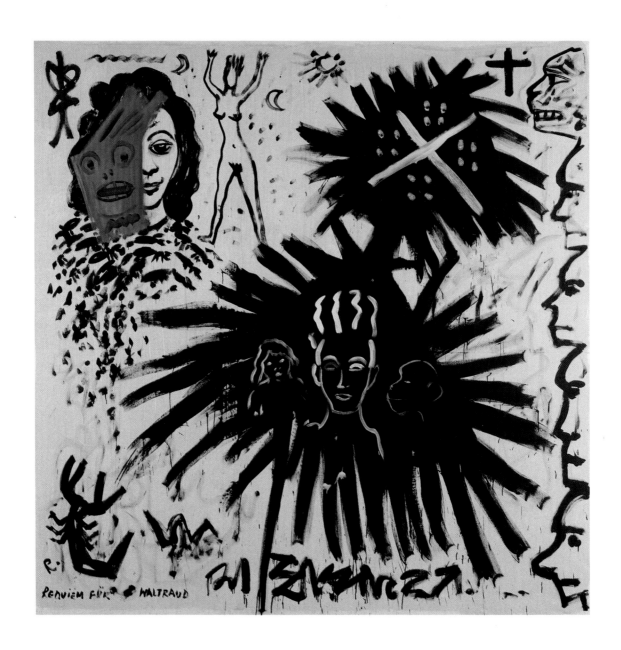

WALTER PICHLER

born Deutschnofen, Austria, 1936; lives
Saint Martin, Austria, and Vienna, Austria

114
Stand for the Crowns 1976
Egg tempera, colored ink, and wash on
paper
48.5 × 62 (19 × 24½)
Walter Pichler, Vienna, Austria

115
Three Birds 1981
Pencil, colored ink, and wash on paper
78 × 58.5 (30¾ × 23)
Walter Pichler, Vienna, Austria
[Not illustrated]

116
*The Glass House for the Mobile Figure: View
of the Interior of the Glass House* 1981
Pencil, egg tempera, colored ink, and wash
on paper
55.5 × 79 (21⅞ × 31⅛)
Walter Pichler, Vienna, Austria

117
House on the Reservoir 1982
Pencil, egg tempera, ink, and wash on
paper
49.5 × 50 (19½ × 19⅝)
Walter Pichler, Vienna, Austria
[Not illustrated]

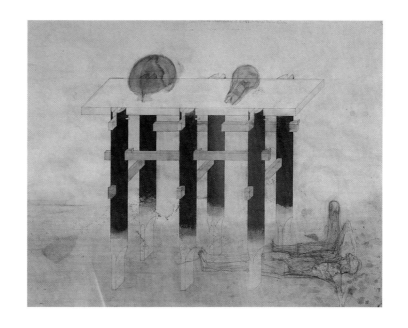

ANNE POIRIER

born Marseilles, France, 1942;
lives Paris, France

PATRICK POIRIER

born Nantes, France, 1942;
lives Paris, France

118
*Villa Adriana, Temple of 100
Columns* 1980
Plaster
300 × 300 × 40 (118 × 118 × 15 ¾)
Museé d'art contemporain, Montreal,
Canada

*"From landscapes to landscapes, from
ruins to gardens, our work is a series (or
succession) of wanderings: from lived
landscapes to desired landscapes, from
physical to mental wanderings, from
exiles to exiles—real landscapes and
dream scapes intermingle, their
boundaries become confused."*
—Anne et Patrick Poirier *Voyages et
caetera 1969–1983*, edited by Serena
Marchi, exh. cat. (Milan: Electa, 1983),
unpaginated (translation by Sarah
Tanguy).

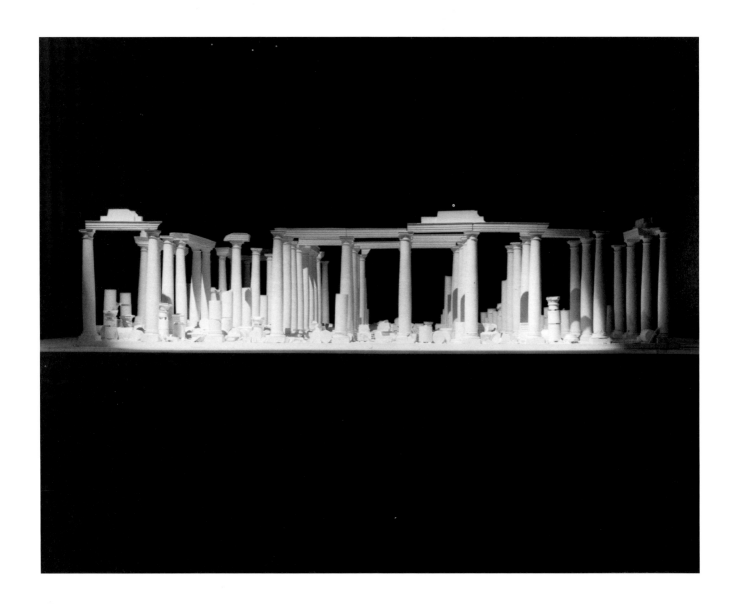

JAGODA PRZYBYLAK
lives Warsaw, Poland

119
Photograph II 1978
Three photographs
Each 22 × 30.5 (8⅝ × 12)
Muzeum Sztuki, Lódź, Poland

MARTIN PURYEAR

born Washington, D.C., 1941;
lives Chicago, Illinois

120
Three Rings 1979
Hickory and ebony
104 × 101 (41 × 40)
Don and Nancy Eiler, Madison, Wisconsin

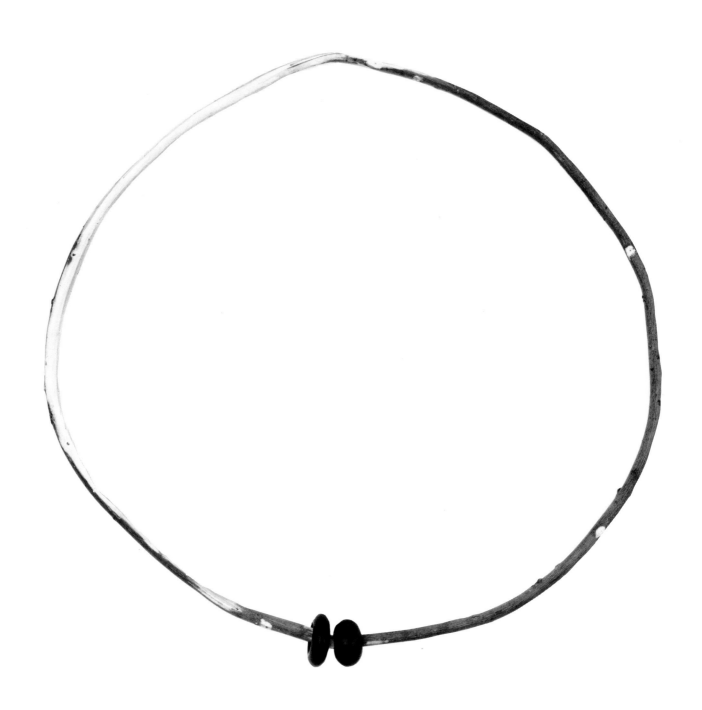

ARNULF RAINER

born Baden, Austria, 1929;
lives Vienna, Austria

121
Corpse's Face 1979
Oil on photograph
57 × 47 (22½ × 18½)
Galerie Ulysses, Vienna, Austria
[Not illustrated]

122
Corpse's Face 1979
Oil on photograph
59.7 × 47.5 (23½ × 18¾)
Galerie Ulysses, Vienna, Austria

123
Corpse's Face 1979
Oil on photograph
53.8 × 44.1 (21⅛ × 16¼)
Galerie Ulysses, Vienna, Austria
[Not illustrated]

124
Corpse's Face 1980
Oil on photograph
56.2 × 46.9 (22 × 18½)
Galerie Ulysses, Vienna, Austria
[Not illustrated]

"The motivation for my painting and drawing on photographs is my search for identity, self-mutation, dialogue, sympathy; at its least it is curiosity and an attempt to communicate. . . . I was touched by the mimic-physiognomic language of these faces; the transient and the suffering, a lack of interest and an affectlessness in the expression."
—Arnulf Rainer, *Arnulf Rainer: Tod—Death*, exh. cat. (Vienna: Galerie Ulysses, 1981), unpaginated.

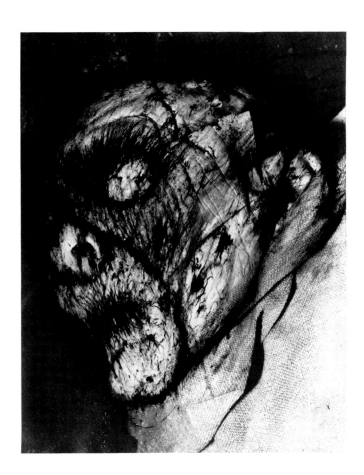

ALDO ROSSI

born Milan, Italy, 1931; lives Milan, Italy

125
Drawing for Cemetery at Modena:
Composition with Saint Apollonia
(Composizione con Santa Apollonia) 1977
Oilstick and ink on paper
43.8 x 63.5 (17¼ x 25¼)
Max Protetch Gallery, New York

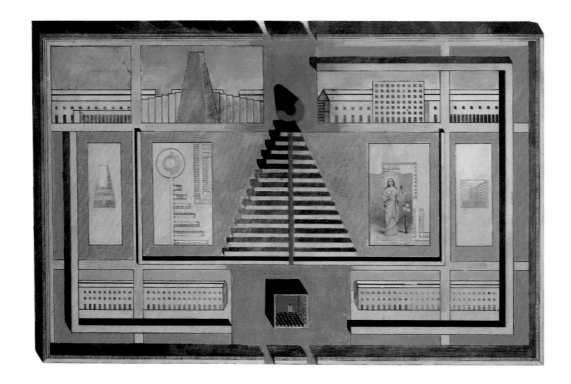

SUSAN ROTHENBERG

born Buffalo, New York, 1945;
lives New York City

126
IXI 1977
Acrylic on canvas
198.1 x 264.2 (77¾ x 104)
Donald B. Marron, New York

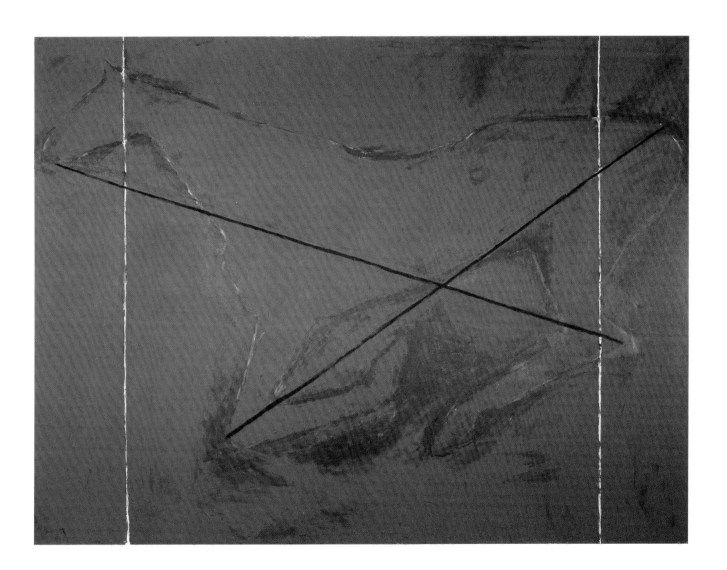

GEORGES ROUSSE
born Paris, France, 1947; lives Paris, France

127
Untitled 1982
Color photograph
127 × 156 (50 × 61½)
Galerie Farideh Cadot, Paris, France

128
Untitled 1983
Color photograph
130 × 160 (51.18 × 63)
Farideh Cadot, Paris, France

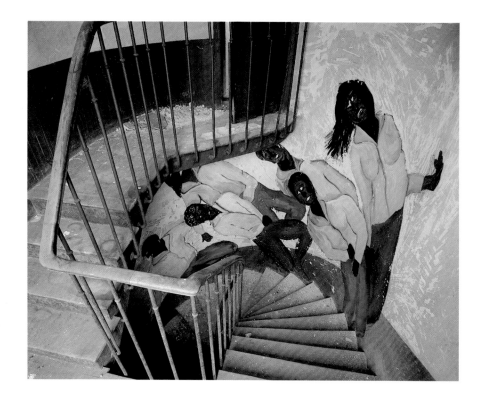

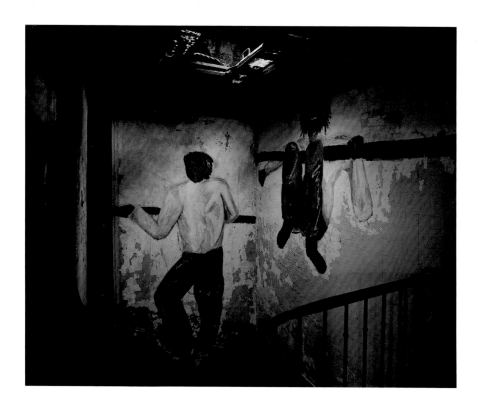

DAVID SALLE

born Norman, Oklahoma, 1952;
lives New York City

129
Archer's House 1980
Acrylic on canvas
213.4 × 304.8 (84 × 120)
Doris and Robert Hillman, New York,
courtesy Mary Boone Gallery, New York

*"I see my paintings as emphasizing a
dysfunctioning network of references
that establish possibilities outside
themselves."*
—David Salle, in Robert Pincus-
Witten, "David Salle: Holiday
Glassware," *Arts Magazine* 56 (April
1982): 58.

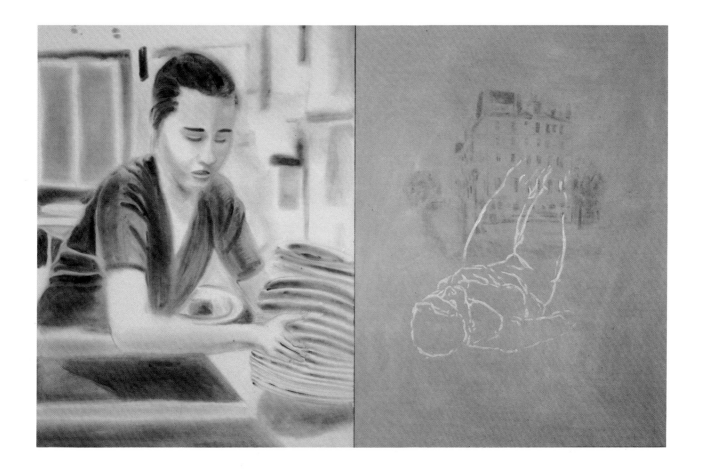

LUCAS SAMARAS

born Kastoria, Greece, 1936;
lives New York City

130
Sittings 20 x 24 (October 30, 1980) 1980
Color Polaroid photograph
61 x 50.8 (24 x 20)
Pace Gallery, New York

131
Sittings 20 x 24 (October 30, 1980) 1980
Color Polaroid photograph
61 x 50.8 (24 x 20)
Pace Gallery, New York

132
Sittings 20 x 24 (October 31, 1980) 1980
Color Polaroid photograph
61 x 50.8 (24 x 20)
Pace Gallery, New York

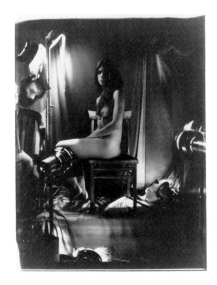
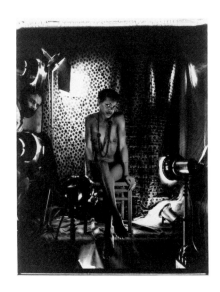

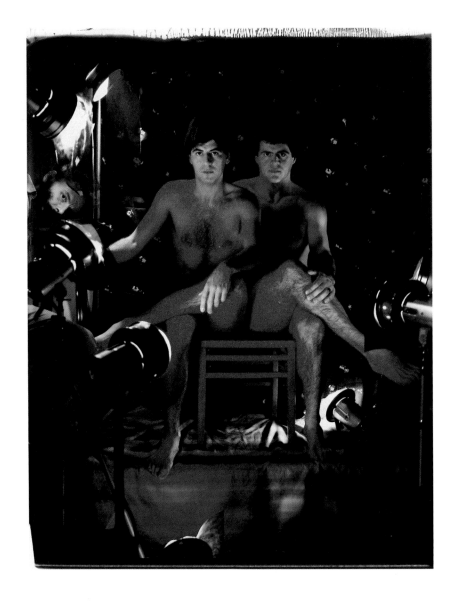

JIM SANBORN

born Washington, D.C., 1945;
lives Washington, D.C.

133
Lightning and Other Earthly Forces 1981–
82, reconstructed 1984
Sandstone, lodestone, and compass
213.5 × 304.8 × 426.7 (84 × 120 × 168)
Courtesy Diane Brown Gallery, New York

Lightning and Other Earthly Forces, studio installation, Washington, D.C., 1984.

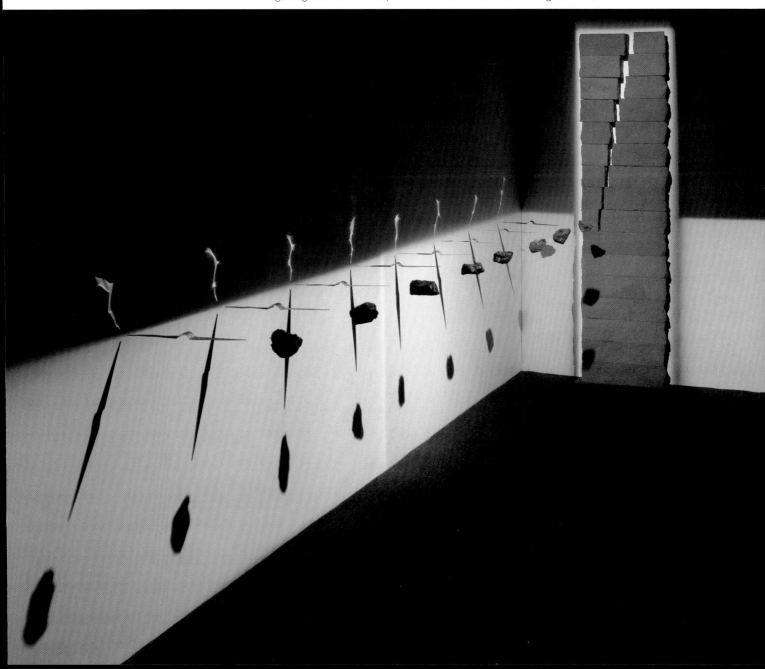

ITALO SCANGA

born Lago, Calabria, Italy, 1932;
lives La Jolla, California

134
Saint Joseph 1977
Plaster, acrylic, wood, and glass
152.4 × 137.2 × 61 (60 × 54 × 24)
Italo Scanga, La Jolla, California, courtesy
Delahunty Gallery, Dallas, Texas, and New
York

*"I have been involved with religious
imagery, neither to emphasize nor reject
it, but I use it as a reference point to
heighten the feeling of unresolved
cultural value, now that politics has
taken the place of folklore and religion.
The pieces are full of contradiction."*
—Italo Scanga, in *Italo Scanga*, exh.
pamphlet (Seattle: Modern Art
Pavilion, Seattle Art Museum, 1977),
cover.

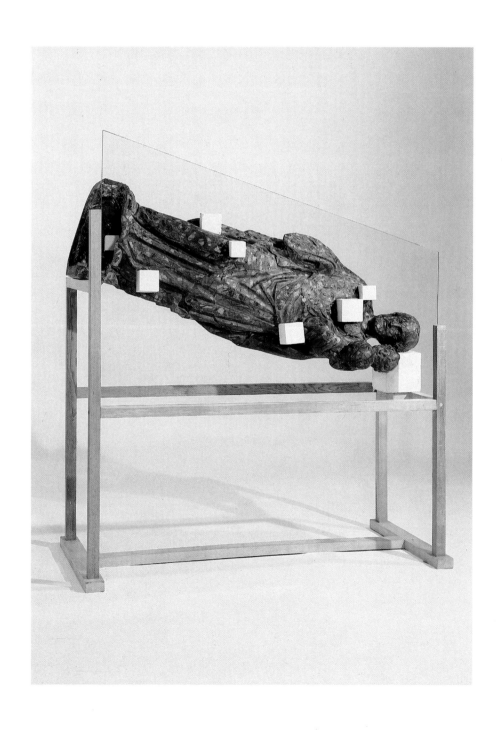

SALVATORE SCARPITTA

born New York City, 1919;
lives New York City

135
Cargo Sled 1975–76
Wood, resin, and oil webbing
280.6 × 84.5 × 91.4 (110½ × 33¼ × 36)
Sydney and Frances Lewis Foundation,
Richmond, Virginia

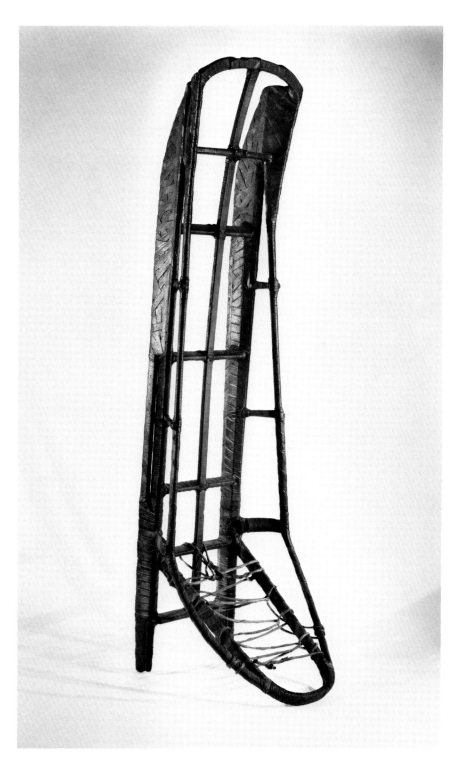

JULIAN SCHNABEL

born New York City, 1951;
lives New York City

136
*Oar: For the One Who Comes Out to Know
Fear* 1981
Oil, crockery, car body filler, and paste on
wood
318 × 438 × 32.5 (127 × 175 × 13)
Doris and Charles Saatchi, London,
England

"A painting is complete when it reveals
and illuminates that place where it
came from. It must describe both itself
and the world, its need to exist. It need
not be accessible to everyone, and
certainly not to everyone's
understanding, for although my work is
about meaning, it is not necessarily your
meaning."
—Julian Schnabel, in "The Patients and
the Doctors," *Artforum* 22 (February
1984): 56.

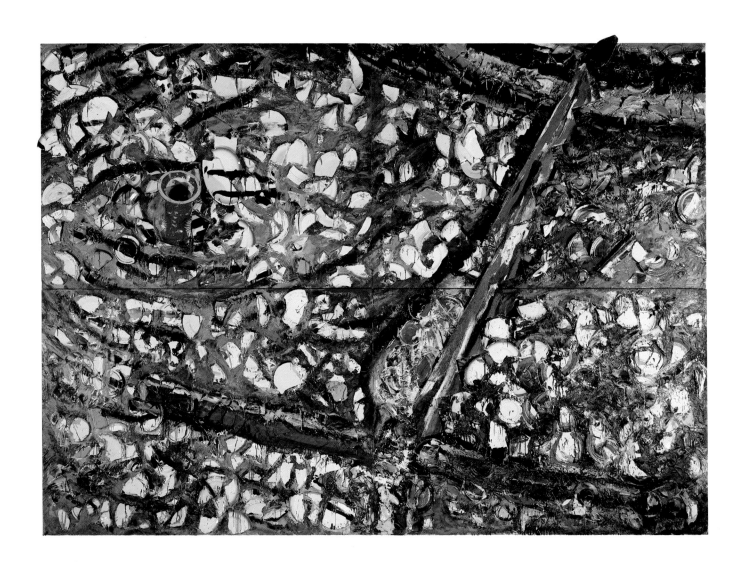

CINDY SHERMAN

born Glen Ridge, New Jersey, 1954;
lives New York City

137
Untitled Film Still　1978
Photograph
20.3 × 25.4 (8 × 10)
Arthur and Carol Goldberg, New York

138
Untitled Film Still　1978
Photograph
20.3 × 25.4 (8 × 10)
Barbara and Eugene Schwartz, New York

139
Untitled Film Still　1980
Photograph
20.3 × 25.4 (8 × 10)
Suzanne and Howard Feldman, New York

"These are pictures of emotions personified, entirely of themselves with their own presence—not of me. The issue of the identity of the model is no more interesting than the possible symbolism of any other detail.

When I prepare each character I have to consider what I'm working against; that people are going to look under the make-up and wig for the common denominator, the recognizable. I'm trying to make other people recognize something of themselves rather than me."
—Cindy Sherman, in *Documenta 7*, exh. cat. (Kassel, West Germany, 1982) vol. 2, p. 411.

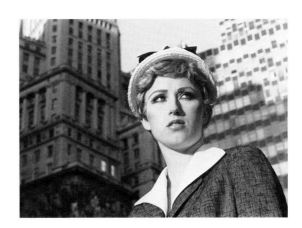

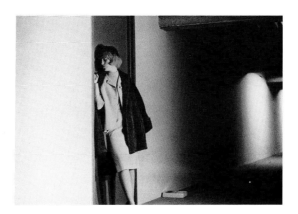

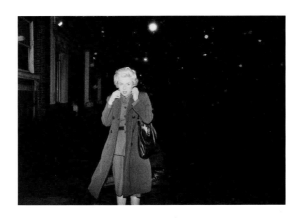

NED SMYTH

born New York City, 1948;
lives New York City

140
Twin (Support) 1982
Concrete mixed with pigment
208 × 91.4 × 40.6 (82 × 36 × 16)
Holly Solomon Gallery, New York

141
*To Have Is to Have Not (Power
Dynamic)* 1982
Concrete mixed with pigment
208 × 91.4 × 40.6 (82 × 36 × 16)
Holly Solomon Gallery, New York
[Not illustrated]

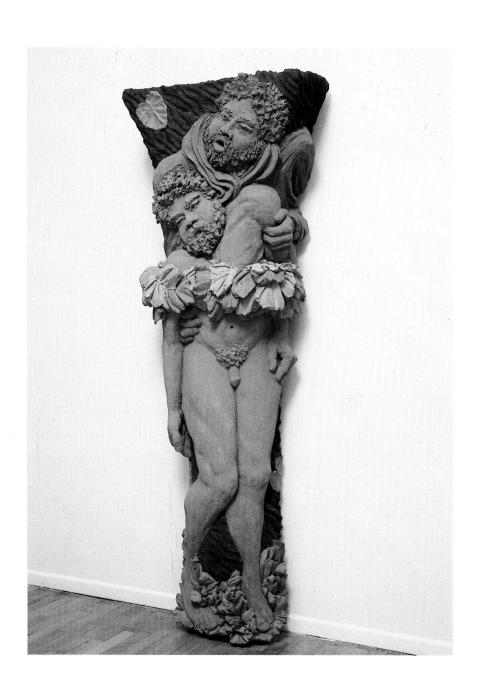

NANCY SPERO

born Cleveland, Ohio, 1926;
lives New York City

142
The First Language 1981
Painting, collage, hand printing on paper,
ten (of twenty-two) panels
Each 50.8 × 274.3 (20 × 108)
Willard Gallery, New York

EARL STALEY

born Oak Park, Illinois, 1938;
lives Houston, Texas

143
The Story of Acteon, I 1977
Acrylic on canvas
152.4 x 304.8 (60 x 120)
Chase Manhattan Bank, New York

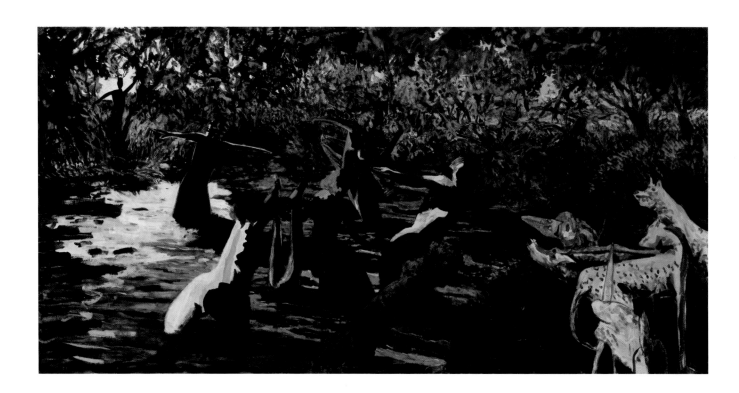

PAT STEIR

born Newark, New Jersey, 1938;
lives New York City

144
Word Unheard 1974
Oil on canvas
213.3 × 213.3 (84 × 84)
Albright-Knox Art Gallery, Buffalo, New
York, promised gift of Mr. and Mrs.
Armand J. Castellani

*"My subject matter is always the same
and it's always really about illusion, and
the illusion of meaning. . . . When I
painted the rose paintings in 1974, I
chose the rose because it could mean so
many things."*
—Pat Steir, in *Arbitrary Order:
Paintings by Pat Steir*, exh. cat.
(Houston: Contemporary Arts
Museum, 1983), p. 19.

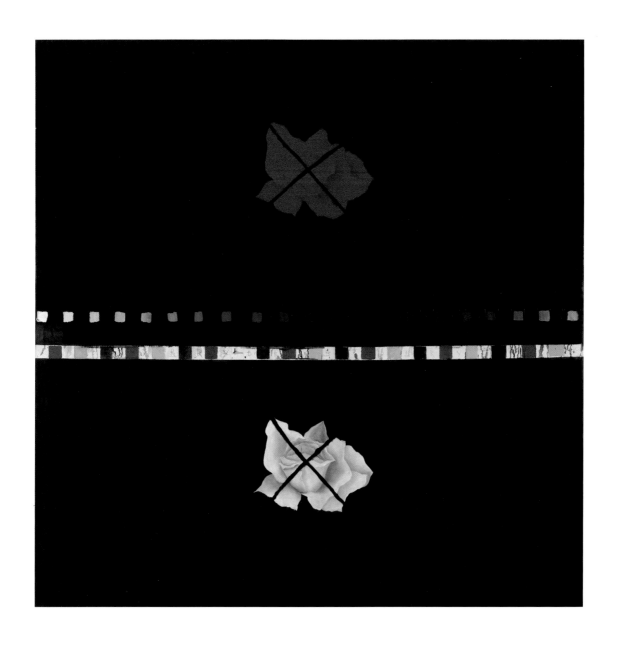

PAUL THEK

born Brooklyn, New York, 1933;
lives New York City

145
Missiles and Bunnies 1984
Mixed media installation
Approx. 457.2 × 548.6 × 609.6 (180 ×
216 × 240)
Courtesy Barbara Gladstone Gallery, New
York

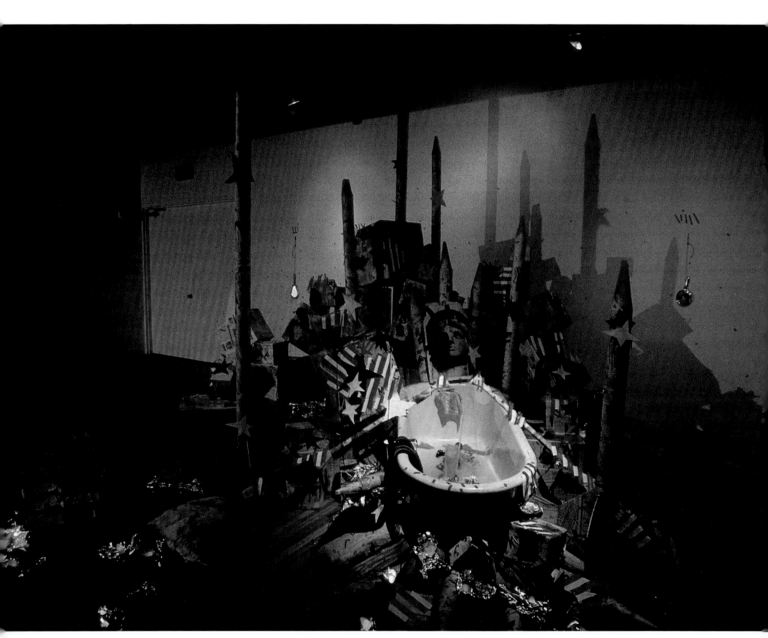

Missiles and Bunnies, version at Pittsburgh Plan for the Arts, Pittsburgh, Pennsylvania, 1983.

MICHAEL TRACY

born Bellevue, Ohio, 1943;
lives San Ygnacio, Texas

146
Cruz for Bishop Oscar Romero, Martyr of El
Salvador 1981
Acrylic on rayon cloth over wood, horn,
iron spikes, hair, cloth braids, oil paint, and
silk-covered wood on rods
152.4 x 121.9 x 91.4 (60 x 48 x 36)
Michael Tracy, San Ygnacio, Texas,
courtesy Hadler/Rodriquez Gallery,
Houston, Texas, and New York

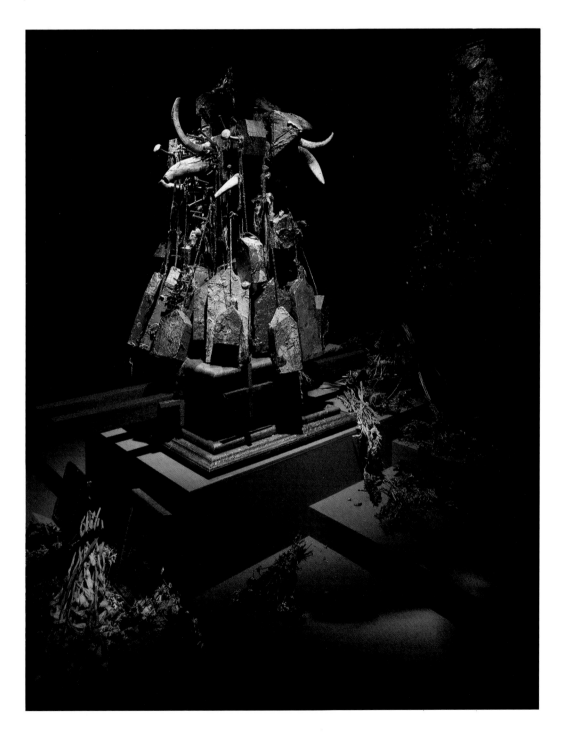

ANDY WARHOL

born Cleveland, Ohio, 1928;
lives New York City

147
Myths 1981
Acrylic and silkscreened enamel on canvas
254 × 254 (100 × 100)
Ronald Feldman Fine Arts, Inc., New York

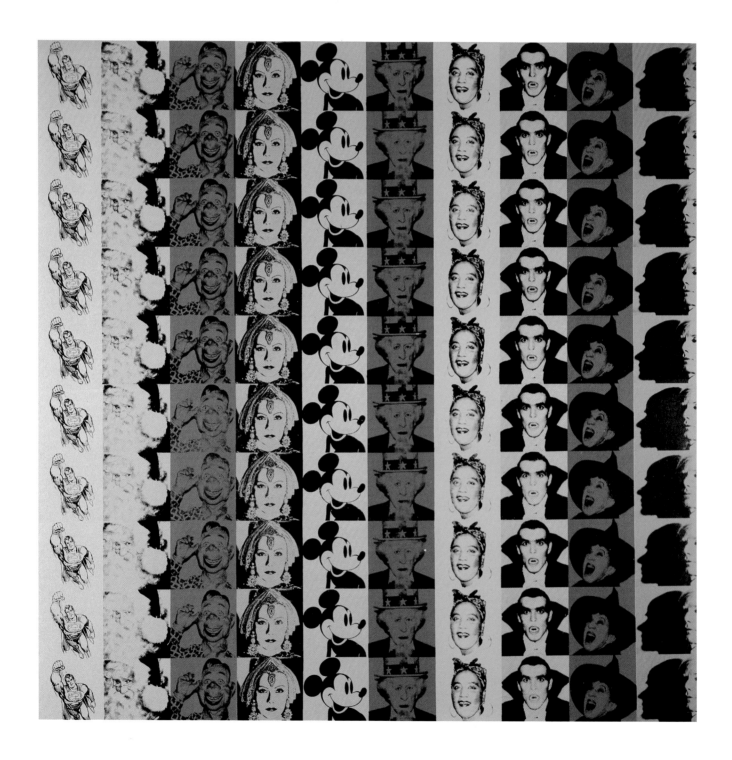

WILLIAM WEGMAN
born Holyoke, Massachusetts, 1943;
lives New York City

148
Double Profile 1980
Color Polaroid photograph
60.9 × 50.8 (24 × 20)
University Gallery, University of
Massachusetts at Amherst

149
Broken Arrow 1980
Color Polaroid photograph
60.9 × 50.8 (24 × 20)
Bonnier Gallery, New York
[Not illustrated]

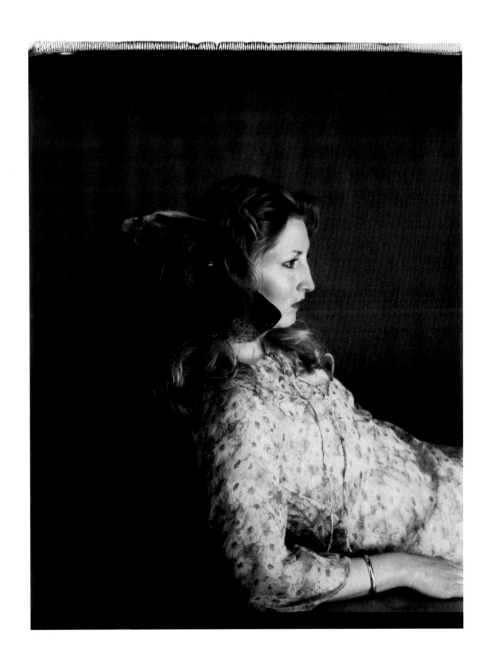

LAWRENCE WEINER

born Bronx, New York, 1940;
lives New York City

150
Being within the Context of Reaction 1974
Text, silkscreened on wall
335.3 x 457.2 (132 x 180)
Stedelijk Van Abbemuseum, Eindhoven,
Holland

*"The questions to be found revolve
around the content of art."*
—Lawrence Weiner, in Connie
Fitzsimons, *Comment*, exh. pamphlet
(Long Beach, Calif.: Long Beach
Museum of Art, 1983), p. 1.

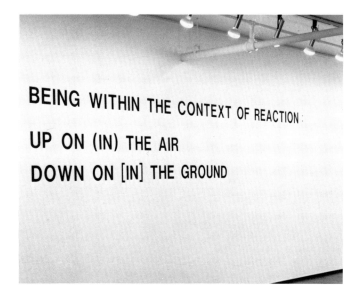 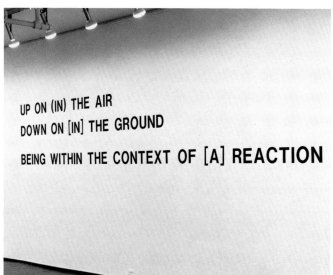

Being within the Context of Reaction, original installation at Leo Castelli Gallery,
New York, 1974.

WILLIAM WILEY

born Bedford, Indiana, 1937;
lives Woodacre, California

151
Slightly Hystarekill Perspective 1979
Acrylic and charcoal on canvas
226 × 259 (89 × 102)
William H. Plummer, Chicago, Illinois

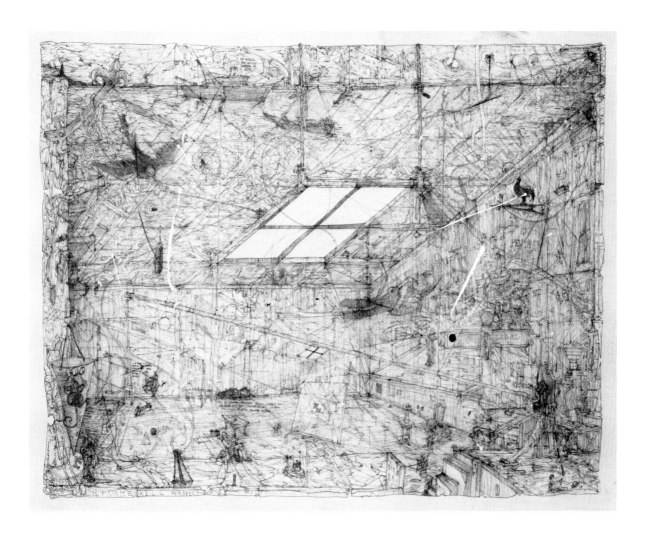

JACKIE WINSOR

born Newfoundland, Canada, 1941;
lives New York City

152
Burnt Piece 1977–78
Wood, cement, and wire
91.4 x 91.4 x 91.4 (36 x 36 x 36)
Private collection

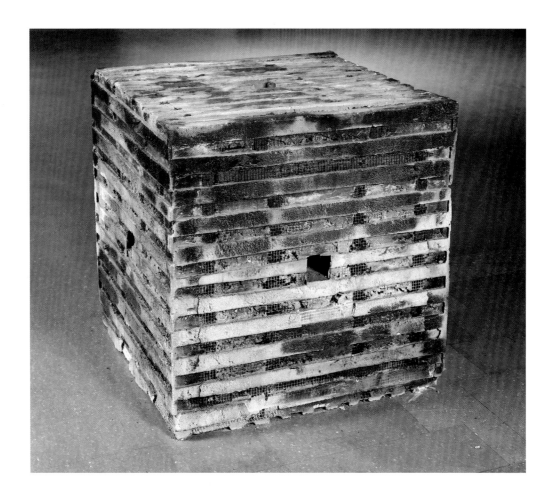

JOEL-PETER WITKIN
born Brooklyn, New York, 1939;
lives Albuquerque, New Mexico

153
*Expulsion from Paradise of Adam and
Eve* 1981
Photograph
37.5 x 37.5 (14.7 x 14.7)
Fraenkel Gallery, San Francisco, California,
and Pace-MacGill Gallery, New York

154
Venus and Eros in Purgatory 1981
Photograph
37 x 37 (14.5 x 14.5 inches)
Fraenkel Gallery, San Francisco, California,
and Pace-MacGill Gallery, New York

155
Mother and Child 1979
Photograph
37.5 x 37.5 (14.7 x 14.7)
Fraenkel Gallery, San Francisco, California,
and Pace-MacGill Gallery, New York

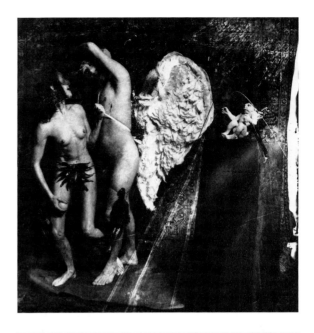

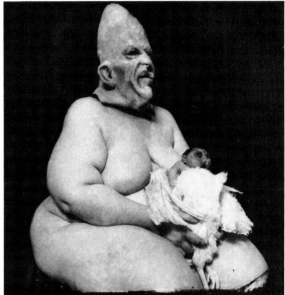

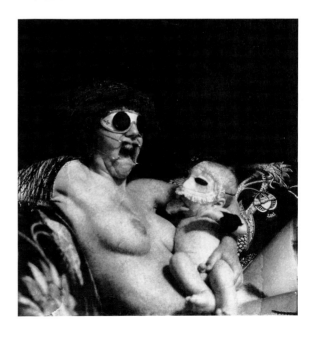

YURIKO YAMAGUCHI

born Osaka, Japan, 1948;
lives Falls Church, Virginia

156
Nexus #4 1981
Wood
149.8 × 17.7 × 5 (59 × 7 × 2)
Sandy and Jim Fitzpatrick, Washington,
D.C.

JOE ZUCKER

born Chicago, Illinois, 1941;
lives New York City

157
Paying Off Old Debts 1975
Acrylic, cotton, and Rhoplex on canvas
243.8 × 304.8 (96 × 120)
Holly and Horace Solomon, New York

*"The subjects I paint—plantations, sailing
ships, alchemists, etc.—are metaphors.
They have many implications, which are
left to what the viewer brings to them."*
—Joe Zucker, in *New Image Painting*,
exh. cat. (New York: Whitney
Museum of American Art, 1978), p.68.

VIDEO AND FILM PRESENTATIONS

MARINA ABRAMOVIĆ
born Belgrade, Yugoslavia, 1946;
lives Amsterdam, Holland

ULAY
born Solingen, Germany, 1943;
lives Amsterdam, Holland

Excerpts from *Relation in Space*, 1976;
Imponderable, 1977; *Light Dark*, 1977;
Ah Ah Ah Ah, 1978
Video, color and black-and-white, 40:00
Marina Abramović and Ulay, Amsterdam,
Holland, courtesy Michael Klein, Inc., New
York

VITO ACCONCI
born New York City, 1940;
lives New York City

Face the Earth, 1974; *Shoot*, 1974; *Open
Book*, 1974
Video, black-and-white, 40:00
Distributor: Castelli-Sonnabend Videotapes
and Films, New York

MAX ALMY
born Omaha, Nebraska, 1948;
lives Oakland, California

Perfect Leader, 1983
Video, color, 5:00
Distributor: Video Data Bank, Chicago,
Illinois

LAURIE ANDERSON
born Chicago, Illinois, 1947;
lives New York City

O Superman, 1981
Video, color, 8:00
Distributor: The Kitchen, New York

ANT FARM
CHIP LORD
born Cleveland, Ohio, 1944;
lives San Francisco, California
DOUG MICHELS
born Seattle, Washington, 1943;
lives Los Angeles, California
CURTIS SCHREIER
born Philadelphia, Pennsylvania, 1944;
lives San Francisco, California

Media Burn, 1975
Video, color, 25:00
Distributor: Electronic Arts Intermix, Inc.,
New York

JOHN BALDESSARI
born National City, California, 1931;
lives Los Angeles, California

The Italian Tapes, 1974
Video, black-and-white, 8:00
Distributor: Castelli-Sonnabend Videotapes
and Films, New York

Six Colorful Inside Jobs, 1977
Film, color, 30:00
Distributor: Castelli-Sonnabend Videotapes
and Films, New York

ROS BARRON
born Boston, Massachusetts, 1933;
lives Brookline, Massachusetts

Magritte sur la plage, 1977
Video, color, 14:00
Distributor: Electronic Arts Intermix, Inc.,
New York

JOSEPH BEUYS
born Krefeld, Germany, 1921;
lives Düsseldorf, West Germany

I Like America and America Likes Me, 1974
Film, black-and-white, 35:00
René Block, Berlin, West Germany

DARA BIRNBAUM
born New York City, 1946;
lives New York City

Wonder Woman, 1978
Video, color, 7:00
Distributor: Electronic Arts Intermix, Inc.,
New York

SCOTT BURTON
born Greensboro, Alabama, 1939;
lives New York City

Pair Behavior Tableaux, 1975–76
Video, black-and-white, 60:00
Scott Burton, New York

PETER CAMPUS
born New York City, 1937;
lives New York City

Four Sided Tape, 1976; *East Ended Tape*,
1976; *Third Tape*, 1976; *Six Fragments*,
1976

Video, color, 19:30
Peter Campus, New York

DOUGLAS DAVIS
born Washington, D.C., 1933;
lives New York City

Double Entendre, 1981
Video, color and black-and-white, 30:00
Distributor: Electronic Arts Intermix, Inc.,
New York

KIT FITZGERALD
born Springfield, Massachusetts, 1953;
lives New York City

JOHN SANBORN
born Copiague, New York, 1954;
lives New York City

Still Life, 1981
Video, color, 12:30
Distributor: Electronic Arts Intermix, Inc.,
New York

RICHARD FOREMAN
born New York City, 1937;
lives New York City

City Archives, 1978
Video, color, 30:00
Distributor: Electronic Arts Intermix, Inc.,
New York

TERRY FOX
born Seattle, Washington, 1943;
lives Minneapolis, Minnesota

Children's Tapes, 1974
Video, black-and-white, 30:00
Distributor: Electronic Arts Intermix, Inc.,
New York

NANCY HOLT
born Worcester, Massachusetts, 1938;
lives New York City

Sun Tunnels, 1978
Film, color, 26:00
Distributor: Castelli-Sonnabend Videotapes
and Films, New York

LES LEVINE
born Dublin, Ireland, 1935;
lives New York City

Einstein: A Nuclear Comedy, 1983
Video, color, 22:00
Les Levine, New York

BRUCE NAUMAN
born Fort Wayne, Indiana, 1941;
lives Pecos, New Mexico

Pursuit, 1975
Film, color, 28:00
Distributor: Castelli-Sonnabend Videotapes
and Films, New York

TONY OURSLER
born New York City, 1957;
lives New York City

Weak Bullet, 1980
Video, color, 14:00
Distributor: Video Data Bank, Chicago,
Illinois

NAM JUNE PAIK
born Seoul, Korea, 1932;
lives New York City

Guadalcanal Requiem, revised version, 1979
Video, color and black-and-white, 29:08
Distributor: Electronic Arts Intermix, Inc.,
New York

VICKI ROBINSON
born Canberra, Australia, 1960;
lives Jersey City, New Jersey

Pier 34, 1983
Video, color, 5:00
Vicki Robinson, Jersey City, New Jersey

MARTHA ROSLER
born Brooklyn, New York, 1943;
lives Brooklyn, New York

Secrets from the Street: No Disclosure, 1980
Video, color, 10:00
Distributor: Video Data Bank, Chicago,
Illinois

RICHARD SERRA
born San Francisco, California, 1939;
lives New York City

Prisoner's Dilemma, 1974
Video, black-and-white, 60:00
Distributor: Castelli-Sonnabend Videotapes
and Films, New York

Steelmill, 1979
Film, black-and-white, 30:00
Distributor: Castelli-Sonnabend Videotapes
and Films, New York

MICHAEL SMITH
born Chicago, Illinois, 1951;
lives New York City

Secret Horror, 1980
Video, color, 13:30
Distributor: Video Data Bank, Chicago,
Illinois

LAWRENCE WEINER
born Bronx, New York, 1940;
lives New York City

Altered to Suit, 1979
Film, black-and-white, 23:00
Distributor: Castelli-Sonnabend Videotapes
and Films, New York

ROBERT WILSON
born Waco, Texas, 1941;
lives New York City

Video Fifty, 1980
Video, color, 50:00
Robert Wilson, New York, courtesy Byrd-
Hoffman Foundation, New York

Chronology 1974–1984

Phyllis Rosenzweig

This exhibition takes as its premise that one of the major issues characterizing the art of the decade since 1974, when the Hirshhorn Museum and Sculpture Garden opened, has been a desire to reinvest the work of art with content, or meaning—that is, meaning beyond that of the formal content by which a work of art defines itself as a unique and discrete object separated from the world.

The exhibition traces the development of this attitude or desire as it is expressed through various works. Chronologically, the exhibition might begin with a Robert Morris labyrinth—a historically significant work created in the autumn of 1974, shortly before the Museum's opening—and end with an example of international expressionist painting. The exhibition establishes an organic link between these two stylistically dissimilar works, a link reflecting the evolution of a philosophical attitude that is both coherently traceable and visually demonstrable. This development can be traced, particularly in the United States, in a progression from environmental work (with its roots in the sixties), which investigates human behavior and perception in a general way, toward an increasing orientation to specific cultural referents. In Germany, Italy, and elsewhere in Europe, a parallel concern emerged in the work of such artists as A. R. Penck, Anselm Kiefer, and Jörg Immendorff, who take as their themes the subjects and styles of history and culture. Simultaneously, image/content was being reintroduced into American art through the work of artists like Susan Rothenberg and Alice Aycock. Pop art, whose influence in the United States seems to have skipped a generation, now serves as an antecedent, giving "permission"—as it were—to a new generation of young artists to take the artifacts of popular culture as their subject matter.

If one believes that, as a history teacher once told me, to understand people, you have to start with their grandparents, it is clearly true that any chronology of the art of a given decade should be preceded by that of the previous twenty years. To a certain extent the art of 1974 to 1984 makes sense only in light of the sixties. If one further believes that art is best understood as part of a larger history of human inquiry and philosophical thought, and not merely a succession of "styles" based on whimsy or indiscriminate desire for change, then one must also address the art of this decade within the context of the intellectual climate in which both artists and critics have matured. It is therefore important to note the influence of ideas generated by the work of the structural anthropologist Claude Lévi-Strauss and the linguistic, psychological, and philosophical writings of such French intellectuals as Roland Barthes, Jacques Derrida, Jacques Lacan, and their followers. In their investigations of the mechanics of thought and perception, these seminal thinkers—many of whose ideas are also linked to a dialectical Marxist social orientation—suggest that all aspects of a culture are equally significant, that consequently the barriers between popular culture and "high" art are apocryphal, and that "high" art is therefore another form of, or analyzable as part of, culture in general.

This line of thinking seems to have contributed in the last decade to the emergence of a milieu in which individuals are highly conscious of the emotive or evocative effect of signs, symbols, representation, metaphor; it

is this awareness—coinciding perhaps with the academization of formalist thinking which limits itself to issues of flatness, color, and edge—that accounts for a shift away from purely formal thinking.

From the mid-1960s on, art in the United States was increasingly concerned not with defining the qualities of the art object as distinct from the world, but with defining its relationship *to* the world. This took several directions: work that physically incorporated the physical world; work that explored linguistic concepts of understanding and meaning as they are dependent on context and social referents; and work that made reference to the world by allusion, metaphor, and signs.

At the same time critical thinking, as reflected in the major art magazines and publications, moved increasingly away from formal analysis to structural/political analyses, both in terms of re-evaluating older work—direct rebuttal of formalist criticism—and with critiques of contemporary works that relied on the methodology and vocabulary of structural, linguistic, and Marxist theory.

The growth of Marxist/structuralist/poststructuralist theory in opposition to formalist criticism through the past decade is evidenced by the launching of such critical magazines as *October* and *The Fox*; by the increased coverage of film, video, performance, and crossover forms in these and other art magazines; and by the evolution of alternative spaces to accommodate site- or process-oriented work.

The chronology and bibliography that follow are not intended to serve as an over-all, objective survey of the decade. Rather, they are meant to reflect the development of a varied body of work and the concurrent evolution of a critical framework for that work, in which the extra-formal, social content of the work is a major issue.

To that end, I have eschewed the traditional comprehensive listing of solo and group exhibitions in which the one hundred and forty-seven artists represented in this exhibition have appeared. Rather, the chronology focuses on selected exhibitions that document the growing relevance of these artists and the evolution of philosophical, critical, and curatorial thinking, parallel to the organizational criteria of this exhibition. Many major national and international biennial exhibitions are not included in this survey. Although they would further illustrate the growing recognition of certain artists, the purposes of this chronology are better served by the inclusion of "theme" exhibitions with specific organizational criteria.

I have quoted extensively from exhibition catalog essays that present or reflect pertinent curatorial thinking and from articles that document the evolution of certain critical ideas about the interpretation of the works of art with which they are engaged. This is not intended to be a complete survey by any means, but a road map illustrating the growth of major ideas relevant to this exhibition.

An asterisk (*) indicates that a work is cited in full in the Bibliography.

The conference "Open Circuits: The Future of Television" was held at the Museum of Modern Art, New York, January 23–25 (see Hollis Frampton, "The Withering Away of the State of the Art"*).

Donald Kuspit's "A Phenomenological Approach to Artistic Intention"* was published in the January *Artforum*. Citing T. W. Adorno, Edmund Husserl, and others, Kuspit dealt with the limitations of formalist criticism and presented an argument for art's awareness of its condition in the world. Lizzie Borden continued this argument in "The New Dialectic"* in the March *Artforum*.

The exhibition *Idea and Image in Recent Art* was held at the Art Institute of Chicago, March 23–May 5, in conjunction with a Marcel Duchamp retrospective organized by the Museum of Modern Art, New York, and the Philadelphia Museum of Art in 1973. Included were works by Vito Acconci, John Baldessari, Joseph Beuys, Christian Boltanski, Hanne Darboven, Douglas Huebler, Edward Kienholz, Joseph Kosuth, Robert Morris, Bruce Nauman, Andy Warhol, William Wegman, Lawrence Weiner, and William Wiley. The catalog included statements by the artists and an essay by Anne Rorimer, who noted Duchamp's statement of purpose, to "reduce the idea of aesthetic consideration to the choice of the mind, not to the ability or cleverness of the hand" (p. 10), as an attitude defining the intellectual assumptions of the artists in the exhibition.

The Robert Morris exhibition *Labyrinths-Voice-Blind Time*, held at the Castelli-Sonnabend Gallery, New York, April 6–27, was promoted with a controversial poster depicting Morris bare-chested and wrapped in chains (fig. 1). In "Robert Morris: The Complication of Exhaustion," Jeremy Gilbert-Rolfe interpreted the poster as a reference to both the "political-sexual atmosphere of the immediate present" and the theme of the exhibition, "which is about individual willfulness in the face of extra-personal terminology. . . . As it enters one's consciousness at that point where the analytic vocabulary of art objects becomes blurred with the social vernacular of the art world . . . Morris' poster serves as a mild reminder that it's the language having the most developed self-critical faculty which has the most subversive effect in the world at large" (p. 44).*

I Like America and America Likes Me, Joseph Beuys's "action" event, was staged, with a live coyote, for the opening of René Block Gallery, New York, May 23–25 (fig. 2). This was Beuys's first major appearance in the United States.

Kunst bleibt Kunst, Projekt '74: Aspekte internationaler Kunst am Anfang der 70er Jahre, an international exhibition of contemporary art since the mid-sixties, was held at Wallraf-Richartz-Museum, Cologne, July 6–September 9. Emphasizing Conceptual art and concerned with such topics as time and perception, the exhibition included film, video, performance, and projects by such artists as Vito Acconci, Alice Aycock, Hanne Darboven, Helen Mayer and Newton Harrison, Joseph Kosuth, Bruce Nauman, and A. R.

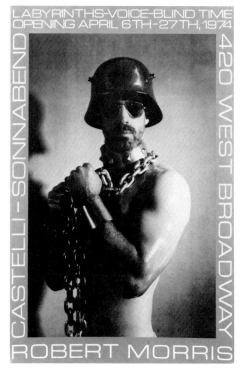

Figure 1
Robert Morris, poster for *Labyrinths-Voice-Blind Time*, Castelli-Sonnabend Gallery, New York, April 6–27, 1974.

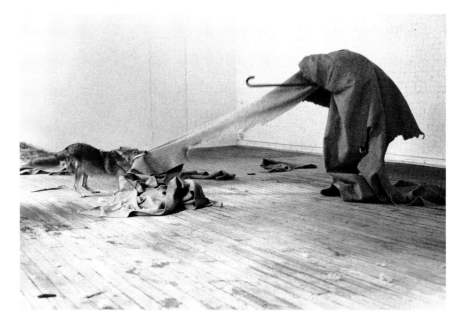

Figure 2
I Like America and America Likes Me,
Joseph Beuys and coyote, René Block
Gallery, New York, May 23–25, 1974.

Penck. The extensive catalog included essays by Evelyn Weiss, Manfred Schneckenburger, Albert Schug, Marlis Grüterich, Wulf Herzogenrath, and David A. Ross.

Artpark opened in Lewiston, New York, July 25. Rae Tyson's introduction to *Artpark: The Program in Visual Arts* noted: "Artpark is unique as a public park and as a space for art. It is 200 acres of common ground for artists and the public—a resource for developing new art and for making it accessible to a general audience. . . . Artists who come to the park reaffirm the history and the public nature of the land and work to renew its life from their own perspectives. Their contact with tens of thousands of visitors in the course of their work . . . proves to be a valuable resource for making new art and ideas freely accessible to the public" (p. 9). Among the artists invited to Artpark the first summer were Peter Campus, Nancy Holt, and Gordon Matta-Clark. Many of the concepts behind this project, including the value of land reclamation and public responsibility, reflect the influence of Robert Smithson, and the first season was dedicated to his memory.

The exhibition *Art into Society, Society into Art*, held at the Institute of Contemporary Art, London, October 30–November 24, included work by Joseph Beuys and Hans Haacke. Christos Joachimides and Norman Rosenthal organized the exhibition and wrote essays for the catalog.

In response to Robert Morris's poster, Lynda Benglis ran a two-page color advertisement of herself with dildo in the November *Artforum*; in the December issue, Lawrence Alloway, Max Kozloff, Rosalind Krauss, Joseph Masheck, and Annette Michelson published a statement denouncing the ad.

Hallwalls, an alternative space organized by artists Charles Clough, Robert Longo, and others opened in December in Buffalo, New York. Throughout the seventies Hallwalls showed work, screened films, and sponsored lectures by many contemporary artists and critics.

1975

The exhibition *Video Art*, organized by Suzanne Delehanty, was held at the Institute of Contemporary Art, University of Pennsylvania, Philadelphia, January 17–February 28. It subsequently toured to the Contemporary Arts Center, Cincinnati (March 22–May 30), the Museum of Contemporary Art, Chicago (June 28–August 31), and the Wadsworth Atheneum, Hartford (September 17–November 2). Both video artists and artists who used video, including many Europeans, were presented in the exhibition. The catalog included essays by David Antin, Lizzie Borden, Jack Burnham, and John McHale.

The *1975 Biennial Exhibition* of the Whitney Museum of American Art, New York, January 20–April 9, was the first Whitney Biennial to include video.

Publication of *The Fox* was inaugurated by the Art and Language Foundation, New York, in April, with Joseph Kosuth, Sarah Charlesworth, Michael Corris, Preston Heller, and others as editors (fig. 3). In "A Declaration of Independence," Charlesworth asserted: "At this point attempts to question or transform the nature of art beyond formalistic considerations must inevitably begin to involve a consideration not only of the presuppositions inherent in the internal structure of art models, but also a critical awareness of the social system which preconditions and drastically confines the possibility of transformation" (p. 1).

The exhibition *The Architecture of the Ecole des Beaux-Arts*, organized and with a catalog by Arthur Drexler, was held at the Museum of Modern Art, New York, October 29, 1975–January 4, 1976. Reversing the Museum of Modern Art's traditional emphasis on modern architecture as dominated by Bauhaus-derived ideals of reductive geometry and formal simplicity, this exhibition reinvestigated the nineteenth-century historical style that had been "condemned" by Modernist dogma.

The December issue of *Artforum* was devoted to political aspects of art. Writing beneath the table of contents, Max Kozloff explained: "The articles in this issue imply that certain aspects of authoritarian art are broader in scope and more effective in impact than has been supposed. Our writers here point out a chronic flaw in perception: the failure to understand the significance of most world art's alignment with the interests of the powerful. Such a phenomenon is acknowledged by our historical literature without making the essential comparison with the realities it pointedly misrepresents. But the human problems raised by art are themselves distorted whenever it is imagined that art is socially neutral."

Figure 3
First issue of *The Fox*, Spring 1975.

1976 *La Biennale di Venezia: Environment, Participation, Cultural Structures* was held July 18–October 10. The section "International Events '72–76," organized by Eduardo Arroyo, included the work of Jonathan Borofsky, Marcel Broodthaers, A. R. Penck, Hans Haacke, Helen Mayer and Newton Harrison, Jörg Immendorff, Edward Kienholz, Dennis Oppenheim, Anne and Patrick Poirier, and Paul Thek. Joseph Beuys was included in the German pavilion. Arroyo wrote in the catalog: "The idea is current everywhere, but particularly so in Italy, that a painter makes pictures and nothing but pictures. . . . He is a child who has no opinion about life or any other subject whatever. . . . This selective apparatus thus produces a history of art which has an independent existence; it is autonomous, separate from general history, as if it were the history of a species. . . . It is against this idea of separateness between the history of art and history generally that I have tried to act in organizing this '72–76' exhibition" (vol. 2, p. 290).

The inaugural issue of *October* was published in the spring. The editors— Jeremy Gilbert-Rolfe, Rosalind Krauss, and Annette Michelson—wrote: "*October* is planned as a quarterly that will be more than merely interdisciplinary; one that articulates with maximum directness the structural and social interrelationships of artistic practice in this country. . . . *October*'s structure and policy are predicated upon a dominant concern: the renewal and strengthening of critical discourse through intensive review of the methodological options now available. *October*'s strong theoretical emphasis will be mediated by its consideration of present artistic practice. It is our conviction that this is possible only within a sustained awareness of the economic and social bases of that practice, of the material conditions of its origins and processes, and of their intensely problematic nature at this particular time" (p. 4). The first issue contained Richard Howard's translation of "Ceci n'est pas une pipe," Michel Foucault's frequently quoted essay differentiating between things and the depiction or representation of things either by image or by language; John Johnston's "Gravity's Rainbow and the Spiral Jetty"; Rosalind Krauss's "Video: The Aesthetics of Narcissism"*; and articles by Richard Freeman, Hollis Frampton, and Jeremy Gilbert-Rolfe.

The exhibition *New York—Downtown Manhattan: Soho* was held at the Akademie der Künste, Berlin, September 5–October 17. Organized by René Block, Stephen Reichert, and H. Lutze, the exhibition included video and performance series as well as major works by Scott Burton, Peter Campus, Joseph Kosuth, Gordon Matta-Clark, Nam June Paik, Ned Smyth, and Joe Zucker. Essays by Block, Stephen Koch, Lawrence Alloway, Peter Frank, Lucy R. Lippard, Douglas Davis, Reichert, and Joan La Barbara were included in the catalog, which stated that the exhibition was organized to celebrate the bicentennial of the United States with its "explosive cultural developments in music, dance, theater, literature and visual arts the center point of the 1976 festival" (p. 7). The continued influence of the United States in Europe, as reflected in this exhibition, was soon to change.

The United States première of "Einstein on the Beach," an "opera" by Robert Wilson and Philip Glass, with choreography by Lucinda Childs, was

held at the Metropolitan Opera House, Lincoln Center, New York, November 21, following its debut in Avignon and subsequent European tour. This influential multimedia production was Wilson's first major collaborative project. The life of Albert Einstein served as the point of departure for a metaphysical odyssey which, as in all of Wilson's productions, depended on dislocation and visual metaphor for its emotional impact.

1977 The *1977 Biennial Exhibition* of the Whitney Museum of American Art, New York, February 19–April 3, included photography for the first time.

The exhibition *Improbable Furniture* was held at the Institute of Contemporary Art, University of Pennsylvania, Philadelphia, March 10–April 10; it toured to the La Jolla Museum of Contemporary Art, La Jolla, California, May 20–July 6. Included were works by Scott Burton, Richard Artschwager, Robert Morris, Ree Morton, and Ned Smyth. The catalog contained essays by Robert Pincus-Witten* and Suzanne Delehanty. The exhibition, and accompanying essays, focused on contemporary artists' investigations of the associational content inherent in the sculptural forms of furniture.

Documenta 6 was held at the Fridericianum, the Neue Galerie, and the Orangerie in Kassel, West Germany, June 24–October 2. Painting, sculpture, film, video, and performance were included in the exhibition. Despite an apparently formalist theme, the painting section, "Malerei als Thema der Malerei," included work by Markus Lüpertz, Malcolm Morley, A. R. Penck, and Andy Warhol. The sculpture section, "Plastik/Environment," emphasized large-scale, environmental, and site-specific works, including those of Alice Aycock, Joseph Beuys, Gordon Matta-Clark, and Robert Morris. The performance schedule included Laurie Anderson, Scott Burton, and Chris Burden, as well as a satellite collaboration with Nam June Paik, Joseph Beuys, and Douglas Davis. The sections on photography and film presented a historical overview of photography since Daguerre. The three-volume catalog included essays by Lothar Romain, Bazon Brock, Karl Oskar Blase, Klaus Honnef, Evelyn Weiss, Lothar Lang, Manfred Schneckenburger, Joachim Diederichs, Peter W. Jansen and Birgit Hun, Wulf Herzogenrath, David A. Ross, Wieland Schmied, and Rolf Dittmar.

The exhibition *Pictures* was held at Artists Space, New York, September 24–October 29. Organized by Douglas Crimp, it included work by Troy Brauntuch, Jack Goldstein, Sherrie Levine, and Robert Longo. In the catalog, Crimp wrote: "To an ever greater extent our experience is governed by pictures, pictures in newspapers and magazines, on television, and in the cinema. Next to these pictures firsthand experience begins to retreat, to seem more and more trivial. While it once seemed that pictures had the function of interpreting reality, it now seems that they have usurped it. It therefore becomes imperative to understand the picture itself, not in order to uncover a lost reality, but to determine how a picture becomes a signifying structure of its own accord" (p. 1).*

The exhibition *Probing the Earth: Contemporary Land Projects* was held at the Hirshhorn Museum and Sculpture Garden, Washington, D.C., October 27, 1977–January 2, 1978, and subsequently toured to the La Jolla (California) Museum of Contemporary Art (January 27–February 26) and the Seattle Art Museum (March 23–May 21). The catalog was prepared by John Beardsley. It was the first major exhibition entirely devoted to earth-and land-oriented artworks.

1978 The exhibition *"Bad" Painting*, held at the New Museum, New York, January 14–February 28, included work by Joan Brown, Charles Garabedian, Neil Jenney, Earl Staley, and William Wegman. In her catalog essay, Marcia Tucker wrote: "In part, this is one of the most appealing aspects of 'bad' painting—that ideas of good and bad are flexible and subject to both the immediate and the larger context in which the work is seen" (pp. 21–22).*

La Biennale de Venezia, Dalla Natura all'arte, dall'arte alla natura, held July 2–October 29, included work by Vito Acconci, Alice Aycock, Joseph Beuys, Marcel Broodthaers, Peter Campus, Gilbert and George, Hans Haacke, Richard Long, and A. R. Penck. In their collaborative catalog essay, Achille Bonito Oliva, Jean Christophe Ammen, Antonio Del Guerico, and Filberto Menno asserted the principles of the exhibition: "We are proposing a critical re-reading of modern art from the point of view of the relationship it has with the environment. To be more precise, the idea that guided us was that modern art, even with its very complex and often contradictory phenomenology, presents coherent sign systems that replace the sign system of tradition based on the linguistic codification of the Renaissance. Modern art has opened to question, above all, the principle of correspondence contained within the traditional system, and it has been concerned with a re-establishment of language by avoiding any reference to an uncritical correspondence between language and reality. Before reflecting the world, the artist is led to thinking about himself, to an examination of his capacity and methods. The passage from mind to reality is not assured *a priori* on ontological grounds, and neither is that from the language of art to the natural universe" (p. 11).

The exhibition *Architectural Analogues*, organized by Lisa Phillips, was held at the Whitney Museum of American Art, Downtown Branch, September 20–October 25. Included were drawings, models, and photodocumentation of projects by Siah Armajani, Alice Aycock, Donna Dennis, Rafael Ferrer, Thomas Lanigan-Schmidt, and Robert Morris. Coincidentally, *Dwellings* was held at the Institute of Contemporary Art, University of Pennsylvania, Philadelphia, October 20–November 25. Organized by Suzanne Delehanty, the exhibition included work by Siah Armajani, Alice Aycock, Donna Dennis, and Gordon Matta-Clark, and a catalog with an essay by Lucy R. Lippard. These two exhibitions were among the first to examine the investigation by visual artists of architectural forms for their associative content as well as for their formal structure.

The exhibition *New Image Painting*, held at the Whitney Museum of

American Art, New York, December 5–January 28, 1979, included work by Denise Green, Neil Jenney, Robert Moskowitz, Susan Rothenberg, and Joe Zucker. The exhibition acknowledged the increasingly frequent appearance of recognizable images in American painting and sculpture. The catalog included statements by the artists and an essay by Richard Marshall, who noted: "What becomes most apparent in these works is the interplay between the emotive content of the image and its formal structure and characteristics. . . . A viewer's response . . . is based on the meanings that he attaches to such images . . . meanings . . . that are defined within a cultural system and social organization and which are mediated by the use of symbols" (p. 7).

1979 The *1979 Biennial Exhibition* of the Whitney Museum of American Art, New York, February 6–April 1, included film for the first time.

Americans on the Move, a multimedia performance by Laurie Anderson, was previewed at Carnegie Recital Hall, New York, February 11, and premiered at the Kitchen, New York, April 13–14. It subsequently became part 1 of *United States I–IV*, a four-part musical, verbal, and visual collage, incorporating and commenting on American culture, the ambiguity of language, and the illegibility of signs.

European Dialogue: The Third Biennale of Sydney, at the Art Gallery of New South Wales, April 14–May 27, included film, video, and performances. This exhibition documented an international dialogue and a shift in emphasis toward extra-formal content. It included the work of such artists as Joseph Beuys, Hanne Darboven, Hamish Fulton, Jean Le Gac, Hermann Nitsch, A. R. Penck, Anne and Patrick Poirier, and Arnulf Rainer. The catalog contained essays by George Boudaille, Karl Ruhrberg, and others.

The exhibition *Directions 1979*, held at the Hirshhorn Museum and Sculpture Garden in Washington, D.C., June 14–September 23, included the work of Eleanor Antin, Donna Dennis, and Thomas Lanigan-Schmidt. The first in a series of exhibitions conceived to identify areas of common concern in contemporary art, it dealt, in part, with references to narrative structures and iconographic forms. The catalog was written by Howard N. Fox.

1980 The exhibition *Illustration and Allegory* at the Brooke Alexander gallery, New York, May 13–June 14, included the work of Robert Longo and David Salle. The catalog essay by Carter Ratcliff examined the allegorical nature—the hidden meanings—implicit in paintings that allude to the imagery and style of popular illustration.

The Times Square Show, held in New York in June 1980, was organized by Colab (Collaborative Projects, Inc.) in an unused building at Seventh Avenue and Forty-first Street. Included were works by John Ahearn, Jenny Holzer,

Tom Otterness, and many others. Writing in the September issue of *Arts Magazine*, Kim Levin noted: "The history of art in our century can be seen as an inexorable march toward abstraction and reduction, but it can also be seen as a series of efforts at incorporating the realities of modern life into art, with each new movement claiming to capture a more essential aspect of reality than the one before. Each was an effort to bridge some gap between life and art. And if we look at it this way—if the Times Square show presents the newest realism—modern art has come full circle, for new wave art exults not in progress but in its littered aftermath, and thus relegates the Modernist dreams of a utopian future to the past" (p. 89).

La Biennale di Venezia: arti visivi '80 was held June 1–September 28. The exhibition *L'arte negli anni settanta/Aperto 80*, at the Magazzini del Salle alle Zattere, Venice, included work by Jonathan Borofsky, Sandro Chia, Francesco Clemente, Enzo Cucchi, Robert Moskowitz, Susan Rothenberg, Julian Schnabel, Ned Smyth, and others, as well as a catalog with essays by Achille Bonito Oliva and Harald Szeeman. Bonito Oliva's essay noted a shift from linguistic models in the art of the sixties to the use of cultural artifacts, sometimes through quotation, as material for art in the seventies.

Architectural Sculpture, organized by Debra Burchett for the Los Angeles Institute of Contemporary Art, and held at various locations in and around Los Angeles, September 30–November 30, included photographs, drawings, models, and projects by Siah Armajani, Alice Aycock, Nancy Holt, Gordon Matta-Clark, Anne and Patrick Poirier, and Ned Smyth. This comprehensive survey explored, on a major scale, a tendency in sculptural works to refer to architectural form as a carrier of imagery, metaphorical content, and historical and cultural information. The two-volume catalog included essays by Susan C. Larsen, Lucy R. Lippard, and Melinda Wortz.

1981 The exhibition *Pictures and Promises*, organized by Barbara Kruger, was held at the Kitchen, New York, in January. In an *Art in America* article, "Subversive Signs," Hal Foster wrote: "Promiscuity of signs was the subject of [this] show ... in which ads, logos and art works were placed together and the separate status of each was cast in doubt" (p. 92).*

The exhibition *A New Spirit in Painting*, organized by Christos M. Joachimides, Norman Rosenthal, and Nicholas Serota, was held at the Royal Academy, London, January 15–March 18. The first of a number of major exhibitions to emphasize the subjectivity of the act of painting as undifferentiated from the "subject" of painting—that is, its "content"—the show included work by thirty-eight artists, among them Sandro Chia, Philip Guston, Anselm Kiefer, Jannis Kounellis, Markus Lüpertz, Mario Merz, Malcolm Morley, Mimmo Paladino, A. R. Penck, and Julian Schnabel. The catalog included the essay "A New Spirit in Painting" by Joachimides and extensive notes on the artists. Joachimides, Rosenthal, and Serota wrote in their preface: "This exhibition ... is meant both as a manifesto and as a reflection on the state of painting now. ... [Although there are] outstanding non-figurative paintings in our exhibition ... it is surely unthinkable that the

representation of human experiences, in other words people and their emotions, landscapes and still-lifes could be forever excluded from paintings. They must in the long run again return to the centre of the argument of painting. This is a central proposition of this exhibition" (pp. 11–12).

The exhibition *Directions 1981*, held at the Hirshhorn Museum and Sculpture Garden, Washington, D.C., February 12–May 3, included the work of Conrad Atkinson, Vernon Fisher, Alain Kirili, and Earl Staley, with a catalog by Miranda McClintic. The exhibition documented contemporary artists' concerns with the role of the artist as social critic and with the functions of myth and metaphor, as well as concern with the formal aspects of their work.

The exhibition *New York/New Wave*, organized by Diego Cortez, was held at P.S. 1, Long Island City, New York, February 15–April 5, and traveled to Forte di Belvedere, Florence, Italy, in September. This exhibition, which included work by Jean Michel Basquiat, Keith Haring, and hundreds of other artists and photographers, was conceived to commemorate the influence of new wave music on contemporary art.

The exhibition *Machine Works* was held at the Institute of Contemporary Art, University of Pennsylvania, Philadelphia, March 12–April 9, 1981. Organized by Janet Kardon, it included work by Vito Acconci, Alice Aycock, and Dennis Oppenheim, and a catalog with essays by Kardon and Kay Larson. The exhibition examined machine imagery as a metaphorical vehicle in the work of these three artists.

The exhibitions *Westkunst* and *Heute—Westkunst* were held at the Museen der Stadt Köln, Cologne, May 30–August 16. *Westkunst*, organized and with a catalog by Laszlo Glozer, Karl Ruhrberg, Kaspar Koenig, and others, included work by Vito Acconci, Richard Artschwager, John Baldessari, Robert Barry, Joseph Beuys, Christian Boltanski, Marcel Broodthaers, Hanne Darboven, Gilbert and George, Douglas Huebler, Jörg Immendorff, Edward Kienholz, Joseph Kosuth, Jean Le Gac, Richard Long, Mario Merz, Hermann Nitsch, A. R. Penck, Nam June Paik, Paul Thek, and Lawrence Weiner. The *Heute* section included work by thirty-seven contemporary artists, among them John Ahearn, Jonathan Borofsky, Troy Brauntuch, Sandro Chia, Francesco Clemente, Enzo Cucchi, Jenny Holzer, Anselm Kiefer, Robert Longo, Mimmo Paladino, David Salle, and Julian Schnabel. An extensive survey of Western art since 1939—the year suggests the political/historical focus—this exhibition also emphasized the representational aspects of recent art.

The exhibition *Soundings*, organized by Suzanne Delehanty, was held at the Neuberger Museum, State University of New York, Purchase, September 20–December 23. Included were installations, objects, and documentation of work by Vito Acconci, Laurie Anderson, Nam June Paik, and Robert Morris, as well as films and a series of live performances. The exhibition was a historical survey of the allusion to, and incorporation of, sound in

modern art, and touched on issues relating to artists' questioning the truth of sensory perception, sound as a mediation between the phenomenological and the spiritual worlds, the integration of all art forms, and the relationship of art to popular culture. The catalog included essays by Delehanty, Dore Ashton, Germano Celant, and Lucy Fischer.

The exhibition *Body Language: Figurative Aspects of Recent Art*, organized and with a catalog by Roberta Smith, was held at the Hayden Gallery, Massachusetts Institute of Technology, Cambridge, October 2–December 24, and subsequently toured to the Fort Worth (Texas) Art Museum (September 11–October 4), the University of South Florida Art Gallery, Tampa (November 12–December 17), and the Contemporary Arts Center, Cincinnati, Ohio (January 13–February 27). Included were works by Siah Armajani, Jonathan Borofsky, Troy Brauntuch, Scott Burton, Robert Longo, David Salle, Julian Schnabel, and Cindy Sherman.

The exhibition *Figures: Forms and Expressions*, organized by Robert Collignon, William Currie, G. Roger Denson, Biff Henrich, Charlotta Kotik, and Susan Krane, was held at the Albright-Knox Art Gallery, the CEPA Gallery, and Hallwalls, Buffalo, New York, November 20–January 3. Included were works by John Ahearn, Sandro Chia, Francesco Clemente, Leon Golub, Robert Longo, and David Salle; the catalog included essays on the artists. These exhibitions, and several the following year, focused on various aspects of imagery in contemporary art.

The exhibition *Metaphor: New Projects by Contemporary Sculptors*, organized and with a catalog by Howard N. Fox, was held at the Hirshhorn Museum and Sculpture Garden, Washington, D.C., December 17–February 28. It included work by Vito Acconci, Siah Armajani, Alice Aycock, Robert Morris, and Dennis Oppenheim. Somewhat related to the *Machine Works* exhibition earlier in the year, this exhibition examined the notion of the linguistic model—metaphor—as the shared concern of these and other contemporary artists.

1982 The exhibition *Figuration*, organized by Phyllis Plous, was held at the University Art Museum, University of California, Santa Barbara, January 6–February 7, with a catalog containing essays by Plous and Michael R. Klein. The exhibition included work by Jonathan Borofsky, Neil Jenney, Malcolm Morley, and David Salle. This was typical of an increasing number of exhibitions focusing on the re-emphasis of the figurative in contemporary art, and the figure as a vehicle to convey meanings, social commentary, associations, and references.

The February issue of *Artforum* was devoted to the avant-garde and mass culture. In their editorial, Ingrid Sischy and Germano Celant specified the aim of the issue as "to suggest a changing dynamic between the language of the avant-garde and the vulgate, both of which seem to be feeding on one another. . . . This issue seeks to confront artmaking that retains its

autonomy as it enters mass culture at the blurred boundary of art and commerce, and partakes of the wandering multiplicities of the body of popular art" (p. 34). Included were articles on Solidarity posters, fashion design, and a recording by Laurie Anderson.

Jenny Holzer's "Truisms" were beamed from a Spectacolor sign above Times Square, March 15–30 (fig. 4), as part of an ongoing project sponsored by the Public Art Fund, New York, to bring art into public places.

Figure 4
Jenny Holzer, Spectacolor signboard, Times Square, New York, March 15–30, 1982.

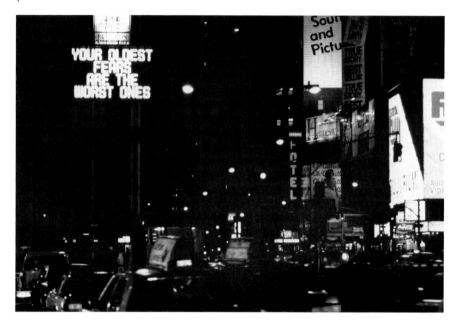

The exhibition *Avanguardia Transavanguardia*, organized by Achille Bonito Oliva, was held in Rome, April–July. Included were works by Vito Acconci, Joseph Beuys, and Anselm Kiefer. In his catalog, Bonito Oliva* argued that artists have responded to global economic and political instability—the universal failure of ideology—by employing images whose references and meanings constantly shift, and that a unified concept of the avant-garde is no longer possible.

The exhibition *Focus on the Figure: 20 Years*, organized and with a catalog by Barbara Haskell, was held at the Whitney Museum of American Art, New York, April 15–June 13. This exhibition, which attempted to connect contemporary art with an ongoing tradition of American figurative painting, included work by Jonathan Borofsky, Joan Brown, Eric Fischl, Robert Longo, Ed Paschke, Susan Rothenberg, David Salle, and Julian Schnabel.

The exhibition *Eight Artists: The Anxious Edge*, organized and with a catalog by Lisa Lyons, was held at the Walker Art Center, Minneapolis, April 25–June 13. The exhibition, which included work by Jonathan Borofsky, Chris Burden, Robert Longo, David Salle, Italo Scanga, and Cindy Sherman, projected a relationship between social and artistic developments and interpreted the work of the artists as a response to the anxiety of the contemporary world.

The May issue of *Artforum* included Joseph Kosuth's "Portraits: Necrophilia, Mon Amour," a "conversation" among Kathy Acker, Sandro Chia, Philip Glass, Joseph Kosuth, Barbara Kruger, David Salle, Richard Serra, and Lawrence Weiner. Kosuth wrote: "Artists work with meaning, not form (if such a separation were possible). . . . Since the demise of that historicist discourse called Modernism, a kind of generalized vacuum of meaning has seemed to develop" (p. 60).*

The exhibition *The Pressure to Paint*, organized and with a catalog by Diego Cortez, was held at Marlborough Gallery, New York, June 4–July 9. Works by Jean Michel Basquiat, Sandro Chia, Francesco Clemente, Enzo Cucchi, Keith Haring, Jörg Immendorff, Anselm Kiefer, Markus Lüpertz, A. R. Penck, David Salle, and Julian Schnabel were included. This comprehensive exhibition was among the first to compare the work of contemporary American, German, and Italian "expressionist" painters. In his catalog introduction, Cortez wrote: "The politics of the New Painting is direct. People want image and color, the media is interested; after the 'quasi-cybernetic hardware-software Network hook-ups' of the 70's . . . artists are again working with their hands. . . . The 'New Market/New Painting' has, underneath its layers of materialism, opportunism, and ambition, a poetry so radical, that to my eye it is clearly the most significant art of this time" (p. 5).

The exhibition *Documenta 7*, organized by Rudi Fuchs was held at the Fridericianum, Orangerie, and Neue Galerie, Kassel, West Germany, June 19–September 26. Not really a "theme show" in the usual sense, this exhibition covered many generations and varieties of work, including that of Vito Acconci, Siah Armajani, John Baldessari, Robert Barry, Jean Michel Basquiat, Joseph Beuys, Jonathan Borofsky, Scott Burton, Sandro Chia, Francesco Clemente, Enzo Cucchi, Hanne Darboven, Hans Haacke, Keith Haring, Anselm Kiefer, Barbara Kruger, Sherrie Levine, Richard Long, Robert Longo, Bruce Nauman, Hermann Nitsch, Mimmo Paladino, A. R. Penck, Arnulf Rainer, David Salle, Cindy Sherman, Andy Warhol, and Lawrence Weiner. Perceived to be both nationalistic and historicist by many critics, the exhibition emphasized Conceptual and language-oriented art and new "expressionism," but made no attempt to link them conceptually. In his introduction to the two-volume catalog, which also includes essays by Coosje van Bruggen, Germano Celant, Johannes Gachnang, and Gerhard Storck, Fuchs cites Goethe, T. S. Eliot, Jorge Luis Borges, and a letter from Friedrich Hölderlin to Böhlendorf to illuminate the continuity of the past with the present. Fuchs appears to endorse these closing lines of Eliot's "Tradition and the Individual Talent": "But very few know when there is an expression of *significant* emotion, emotion which has its life in the poem and not in the history of the poet. The emotion of art is impersonal. And the poet cannot reach this impersonality without surrendering himself wholly to the work to be done. And he is not likely to know what is to be done unless he lives in what is not merely the present, but the present moment of the past, unless he is conscious, not of what is dead, but of what is already living" (p. xx).

The first issue of *The New Criterion*, a monthly review edited by Hilton Kramer, was published in September. In his essay "Postmodern: Art and Culture in the 1980s," Kramer equated modernism with the concept of the avant-garde and revolt against the bourgeoisie, and postmodernism with revival of past bourgeois styles and camp.

The exhibition *Zeitgeist*, organized by Christos M. Joachimides and Norman Rosenthal, was held at the Martin-Gropius-Bau, Berlin, October 15–January 16. Forty-five artists were represented, among them Joseph Beuys, Jonathan Borofsky, Sandro Chia, Francesco Clemente, Enzo Cucchi, Jiři Georg Dokoupil, Gilbert and George, Anselm Kiefer, Jannis Kounellis, Markus Lüpertz, Mario Merz, Jörg Immendorff, Robert Morris, Mimmo Paladino, A. R. Penck, Susan Rothenberg, David Salle, Julian Schnabel, and Andy Warhol. Joachimides and Rosenthal had organized the 1981 *New Spirit in Painting* exhibition, of which this can be seen as a continuation. Their stated intention was to define and celebrate the "spirit of the time." As in *New Spirit in Painting*, Joachimides's catalog essay emphasized the subjectivity and sensuality of contemporary painting and urged contemporary artists to discard the myth of the avant-garde and to borrow more freely from the past. The catalog also included essays by Rosenthal, Robert Rosenblum, Hilton Kramer, Walter Bachauer, Karl-Heinz Bohrer, Paul Feyerabend, Vittorio Magnago Lampugnani, and Thomas Bernhard.

The exhibitions *Image Scavengers: Photography*, with a catalog including essays by Paula Marincola and Douglas Crimp, and *Images Scavengers: Painting*, with a catalog by Janet Kardon, were held at the Institute of Contemporary Art, University of Pennsylvania, Philadelphia, December 4–January 30. The exhibitions included work by Barbara Kruger, Sherrie Levine, Robert Longo, David Salle, and Cindy Sherman. The concurrent exhibitions isolated the issue of appropriation—both of images and of image-making strategies—from mass media and popular culture as central to the work of the artists included.

The exhibition *New Figuration in America*, organized by Russell Bowman, with a catalog including essays by Bowman and Peter Schjeldahl, was held at the Milwaukee Art Museum, December 3–January 23. One of an increasing number of exhibitions focusing on various aspects of figurative painting in the United States, it included work by John Ahearn, Jonathan Borofsky, Troy Brauntuch, Robert Longo, Malcolm Morley, Susan Rothenberg, David Salle, Julian Schnabel, Cindy Sherman, and Earl Staley.

1983 The exhibition *Champions*, with a catalog by Tony Shafrazi, was held at the Tony Shafrazi Gallery, New York, January. Included were works by John Ahearn, Jean Michel Basquiat, Keith Haring (fig. 5), and other "graffiti" artists. Shafrazi wrote: "These artists [are] no longer bound by any single rule or outmoded guideline. Nor are they oppressed by the dogma of a particular school. Instead, their approach is personal. . . . They draw upon the whole of history as freely as they use the stimuli of urban references. As a result,

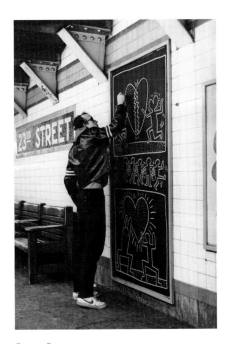

they have at their disposal the most varied of cultural sources available at at any one moment" (p. 2).

The exhibition *Directions 1983*, organized and with a catalog by Phyllis Rosenzweig, was held at the Hirshhorn Museum and Sculpture Garden, Washington, D.C., March 10–May 15. Works by Siah Armajani, Jonathan Borofsky, Scott Burton, Robert Longo, David Salle, Julian Schnabel, and Cindy Sherman were included. This exhibition focused, in part, on the various ways contemporary artists refer or allude to existing non-art objects, popular imagery, and cultural artifacts.

The exhibition *Art and Social Change, U.S.A.*, organized by Richard Olander, was held at the Allen Memorial Art Museum, Oberlin, Ohio, April 19–May 30. It included work by John Ahearn, Barbara Kruger, Jenny Holzer, and Sherrie Levine. In the catalog (published as *Allen Memorial Art Museum Bulletin* 40, no. 2, 1982–83), which also contained essays by David Deitcher, Lucy R. Lippard and Jerry Kearns, and Craig Owens, Olander wrote: "Social Aesthetics are style-less aesthetics. . . . Social Aesthetics are interpretive aesthetics. They seek not A Meaning but Discourse" (pp. 63, 66).

Siah Armajani and Scott Burton were awarded commissions to collaborate with architect Cesar Pelli and landscape architect M. Paul Friedberg on the design of Battery Park City Plaza in lower Manhattan. The commissions represented an innovative proposal allowing socially conscious artists to work with architects and planners on the development of a public site. At the unveiling of the model for Battery Park Plaza, at the Whitney Museum of American Art in November, Scott Burton stated: "We hope to find fragments or wholes of 1930s epic sculpture. In the same way that tops of buildings are designed to echo skylines and the esplanade is designed to echo New York City parks the sculptures . . . will provide some continuity with old New York. We want to reconnect with what survives and what is familiar" (*New York Times*, December 1, 1983, p. C3). Five other artists— Richard Artschwager, Nancy Graves, Patsy Norvell, Ned Smyth, and Frank Stella—were also commissioned to present proposals for other sites.

The exhibition *Der Hang zum Gesamtkunstwerk*, organized by Harald Szeeman, was held at the Kunsthaus Zürich, February 11–April 30, and toured to the Städtische Kunsthalle und Kunstverein für die Rheinlande und Westfalen, Düsseldorf (May 19–July 10), and the Museum moderner Kunst Museum des 20 Jahrhunderts, Vienna (September 10–November 13). This exhibition, which included work by Joseph Beuys, Marcel Broodthaers, Anselm Kiefer, and Hermann Nitsch, referred to the Wagnerian concept of the "total work of art"—a union of all the arts with the understanding that such a total work of art could hasten the reconstruction of an ideal society, and surveyed the historical impulse of artists to incorporate, interact with, and comment upon broad areas of their contemporary culture and history. The catalog included essays by Bazon Brock and many others.

The exhibition *Expressions: New Art From Germany: Georg Baselitz, Jörg*

Immendorff, Anselm Kiefer, Markus Lüpertz, A. R. Penck, organized by Jack Cowart with Siegfried Gohr as consultant, was held at the Saint Louis (Missouri) Art Museum, June–August, and subsequently traveled to the Institute for Art and Urban Resources (P.S. 1), New York (October–November); the Institute of Contemporary Art, University of Pennsylvania, Philadelphia (December–January); and the Corcoran Gallery of Art, Washington, D.C. (July–September 1984). This was the first major traveling exhibition in the United States of contemporary German painters. The catalog included essays by Cowart, Gohr, and Donald B. Kuspit, all of whom addressed the social and historical issues central to contemporary German art, and a critical bibliography by Renate Winkler.

The Comic Art Show, organized by John Carlin and Sheena Wagstaff, was held at the Whitney Museum of American Art, New York, Downtown Branch, July 8–August 26. An excellent exhibition linking art to popular culture, it included work by Roger Brown, Henry Chalfant, Vernon Fisher, Keith Haring, David Salle, and Andy Warhol. The catalog contained essays by Richard Marshall, Jerry Robinson, Kim Thompson, J. Hoberman, as well as Carlin and Wagstaff.

1984 "Private Symbol/Social Metaphor" is the theme of the fifth *Biennale of Sydney*, Art Gallery of New South Wales, Australia, April 10–June 17.

"Paradise Lost/Paradise Regained: American Visions of the New Decade" is the theme of the United States pavilion, *Biennale de Venezia*, June 10–October 31. The exhibition includes work by Roger Brown, Louisa Chase, Eric Fischl, Charles Garabedian, and Earl Staley. Organized by Marcia Tucker, Lynn Gumpert, and Ned Rifkin, it focuses on the reactions of American artists to the promises, kept or failed, of the "American Dream."

Bibliography

This is a selected listing of critical articles, essays, and books of a general theoretical or historical nature published since 1974 and relevant to the theme of this exhibition. As in the Chronology, the focus is thematic. Exhibition catalogs and monographs on individual artists are not included.

Alloway, Lawrence. "Artists As Writers, Part One: Inside Information." *Artforum* 12 (March 1974): 30–35. "Part Two: The Realm of Language." *Artforum* 12 (April 1974): 30–35.

Benamou, Michel, and Caramello, Charles, eds. *Performance in Postmodern Culture*. Madison, Wis.: Coda Press; Milwaukee: University of Wisconsin Center for Twentieth-Century Studies, 1977.

Bleckner, Ross. "Transcendent Anti-Fetishism." *Artforum* 17 (March 1979): 50–55.

Bonito Oliva, Achille. *Avanguardia Transavanguardia*. Milan: Electa, 1982.

———. "The Bewildered Image." *Flash Art* 96–97 (March–April 1980): 32–41.

———. "The International Trans-Avantgarde." Translated by Paul Blanchard. *Flash Art* 104 (October–November 1981): 36–43.

———. "The Italian Trans-Avantgarde." *Flash Art* 92–93 (October–November 1979): 17–20.

———. "Process, Concept and Behavior in Italian Art." *Studio International* 191 (January–February 1976): 3–10.

Borden, Lizzie. "The New Dialectic." *Artforum* 12 (March 1974): 44–51.

Brock, Bazon. "The End of the Avant-Garde? And So the End of Tradition." *Artforum* 19 (Summer 1981): 62–67.

Buchloh, Benjamin H. D. "Allegorical Procedures: Appropriation and Montage in Contemporary Art." *Artforum* 21 (September 1982): 43–56.

———. "Figures of Authority, Ciphers of Regression: Notes on the Return of Representation in European Painting," *October* 16 (Spring 1981): 39–68.

Burnham, Jack. *Great Western Salt Works: Essays on the Meaning of Post-Formalist Art*. New York: Braziller, 1974.

Crimp, Douglas. "About Pictures." *Flash Art* 88–89 (March–April 1979): 34–35.

———. "The End of Painting." *October* 16 (Spring 1981): 69–86.

———. "The Photographic Activity of Post-Modernism." *October* 15 (Winter 1980): 91–101.

———. "Pictures." In *Pictures*, pp. 3–29. Exhibition catalog. New York: Artists Space, 1977.

———. "Pictures." *October* 8 (Spring 1979): 75–88.

Davis, Douglas. *Artculture: Essays on the Post-Modern*. New York: Harper and Row, 1977.

———. "Post-Performancism." *Artforum* 20 (October 1981): 31–39.

———. "Post Post-Art." *Village Voice*, June 25, 1979, pp. 37–43.

Faust, Wolfgang Max. "'Du Hast Keine Chance Nutze Sie!' With It and Against It: Tendencies in Recent German Art." *Artforum* 20 (September 1981): 33–39.

———. "Der Hunger nach Bildern." *Kunstforum International* (December 1981–January 1982): 81–99.

———, and de Vries, Gerd. *Hunger nach Bildern, Deutsche Malerei der Gegenwart*. Cologne: DuMont, 1982.

Foote, Nancy. "The Anti-Photographers." *Artforum* 15 (September 1976): 46–54.

Foster, Hal, ed. *The Anti-Aesthetic: Essays on Postmodern Culture*. Port Townsend, Washington: Bay Press, 1983.

———. "Between Modernism and the Media." *Art in America* 70 (Summer 1982): 13–17.

———. "The Expressive Fallacy." *Art in America* 71 (January 1983): 80–83, 137.

———. "The Problem of Pluralism." *Art in America* 70 (January 1982): 9–15.

———. "Subversive Signs." *Art in America* 70 (November 1982): 88–92.

Frampton, Hollis. "The Withering Away of the State of the Art." *Artforum* 13 (December 1974): 50–55.

Gachnang, Johannes. "New German Painting." *Flash Art* 106 (February–March 1982): 33–37.

Gilbert-Rolfe, Jeremy. "Robert Morris: The Complication of Exhaustion." *Artforum* 13 (September 1974): 44–49.

Gohr, Siegfried. "The Difficulties of German Painting with Its Own Tradition." In *Expressions: New Art from Germany*, edited by Jack Cowart, pp. 27–41. Translated by J. W. Gabriel. Exhibition catalog. Saint Louis: Saint Louis Art Museum, 1983.

———. "The Situation and the Artists." *Flash Art* 106 (February–March 1982): 38–46.

Graham, Dan. "Art in Relation to Architecture, Architecture in Relation to Art." *Artforum* 17 (February 1979): 22–29.

———. "Not Post-Modernism: History as Against Historicism, European Archetypal Vernacular in Relation to American Commercial Vernacular, and the City as Opposed to the Individual Building." *Artforum* 20 (December 1981): 50–58.

———. "Signs." *Artforum* 19 (April 1981): 38–43.

Halley, Peter. "A Note on the 'New Expressionism' Phenomenon." *Arts Magazine* 57 (March 1983): 88–89.

Hills, Patricia. "Art History Textbooks: The Hidden Persuaders." *Artforum* 14 (Summer 1976): 58–61.

Huebler, Douglas. "Sabotage or Trophy? Advance or Retreat?" *Artforum* 20 (May 1982): 72–76.

Kontova, Helena. "From Performance to Painting." *Flash Art* 106 (February–March 1982): 16–21.

———, and Politi, Giancarlo. "An Interview with Achille Bonito Oliva." *Flash Art* 98–99 (Summer 1980): 8–9.

Kosuth, Joseph. "Portraits: Necrophilia, Mon Amour." *Artforum* 20 (May 1982): 59–63.

Kozloff, Max. "Pygmalion Reversed." *Artforum* 14 (November 1975): 30–37.

Krauss, Rosalind. "Notes on the Index: Seventies Art in America, Part One." *October* 3 (Spring 1977): 68–81. "Part Two." *October* 3 (Fall 1977): 58–67.

———. "The Originality of the Avant-Garde: A Postmodernist Repetition." *October* 18 (Fall 1981): 47–66.

———. "Rauschenberg and the Materialized Image." *Artforum* 13 (December 1974): 36–43.

———. "Video: The Aesthetics of Narcissism." *October* 1 (Spring 1976): 51–64.

Kuspit, Donald B. "Acts of Aggression: German Painting Today, Part One." *Art in America* 70 (September 1982): 140–51. "Part Two." *Art in America* 71 (January 1983): 90–101, 131–35.

———. "Art Criticism: Where's the Depth?" *Artforum* 16 (September 1977): 38–41.

———. "Audience and the Avant-Garde." *Artforum* 21 (December 1982): 36–39.

———. "Flack from the 'Radicals': The American Case against Current German Painting." In *Expressions: New Art from Germany*, edited by Jack Cowart, pp. 43–55. Exhibition catalog. Saint Louis: Saint Louis Art Museum; Munich: Prestel Verlag, 1983.

———. "The New (?) Expressionism: Art as Damaged Goods." *Artforum* 20 (November 1981): 47–55.

———. "A Phenomenological Approach to Artistic Intention." *Artforum* 12 (January 1974): 46–53.

————. "Postmodernism, Plurality and the Urgency of the Given." *The Idea: At the Henry* 2 (April 1981): 13–24.

————. "Stops and Starts in Seventies Art and Criticism." *Arts Magazine* 55 (March 1981): 96–99.

————. "The Unhappy Consciousness of Modernism." *Artforum* 19 (January 1981): 53–57.

Lawson, Thomas. "The Dark Side of the Bright Light." *Artforum* 21 (November 1982): 62–66.

————. "Last Exit: Painting." *Artforum* 20 (October 1981): 40–47.

————. "The Uses of Representation: Making Some Distinctions." *Flash Art* 88–89 (March–April 1979): 37–39.

Levin, Kim. "Farewell to Modernism." *Arts Magazine* 54 (October 1979): 90–92.

Lippard, Lucy R. *From the Center: Feminist Essays on Women's Art.* New York: Dutton, 1976.

Loeffler, C. E., and Tong, D., eds. *Performance Anthology: Source Book for a Decade of California Performance Art.* San Francisco: Contemporary Arts Press, 1980.

Lorber, Richard. "Epistemological T.V." *Art Journal* 34 (Winter 1974–75): 132–34.

McEvilley, Thomas. "Art in the Dark." *Artforum* 21 (Summer 1983): 62–71.

————. "Heads It's Form, Tails It's Not Content." *Artforum* 21 (November 1982): 50–61.

Michelson, Annette. "Contemporary Art and the Plight of the Public: A View from the New York Hilton, Book Review." *Artforum* 13 (September 1974): 68–70.

Morris, Robert. "Aligned with Nazca." *Artforum* 14 (October 1975): 26–39.

————. "American Quartet." *Art in America* 69 (December 1981): 92–105.

————. "The Present Tense of Space." *Art in America* 66 (January–February 1978): 70–81.

Moufarrege, Nicolas A. "Lightning Strikes (Not Once But Twice): An Interview with Graffiti Artists." *Arts Magazine* 57 (November 1982): 87–93.

O'Doherty, Brian. "Inside the White Cube: Notes on the Gallery Space, Part One." *Artforum* 14 (March 1976): 24–30. "Part Two: The Eye and the Spectator." *Artforum* 14 (April 1976): 26–34. "Part Three: Context as Content." *Artforum* 15 (November 1976): 38–44.

Owens, Craig. "The Allegorical Impulse: Toward a Theory of Postmodernism." *October* 12 (Spring 1980): 67–86. "Part Two." *October* 13 (Summer 1980): 59–80.

————. "Back to the Studio." *Art in America* 70 (January 1982): 99–107.

————. "Einstein on the Beach: The Primacy of Metaphor." *October* 4 (Fall 1977): 21–32.

————. "Robert Wilson: Tableaux." *Art in America* 68 (November 1980): 114–17.

Parks, Addison. "One Graffito, Two Graffito." *Arts Magazine* 57 (September 1982): 73.

Perreault, John. "False Objects: Duplicates, Replicas, and Types." *Artforum* 16 (February 1978): 24–27.

Perrone, Jeff. "Carl André: Art Versus Talk." *Artforum* 14 (May 1976): 32–33.

————. "The Ins and Outs of Video." *Artforum* 14 (Summer 1976): 53–57.

————. " 'Words': When Art Takes a Rest." *Artforum* 15 (Summer 1977): 34–37.

"Photography: A Special Issue." *October* 5 (Summer 1978): 3–5.

Pincus-Witten, Robert. "The Furniture Paradigm." In *Improbable Furniture*, pp. 8–16. Exhibition catalog. Philadelphia: Institute of Contemporary Art, University of Pennsylvania, 1977.

Pontbriand, Chantal, ed. *Performance: Text(e)s and Documents.* Montreal: Editions Parachute, 1982.

"Post-Modernism: A Symposium Presented by the Young Architects Circle. . . ." *Real Life Magazine* 6 (Summer 1981): 4–10.

Price, Jonathan. "Video Art: A Medium Discovering Itself." *Artnews* 76 (January 1977): 41–47.

Ratcliff, Carter. "Art and Resentment." *Art in America* 76 (Summer 1982): 9–13.

————. "On Contemporary Primitivism." *Artforum* 14 (November 1975): 57–65.

————. "On Iconography and Some Italians." *Art in America* 70 (September 1982): 152–59.

Robbins, D. A. "The 'Meaning' of 'New'—the '70s/'80s Axis: An Interview with Diego Cortez." *Arts Magazine* 57 (January 1983): 116–21.

Robins, Carrine. "Nationalism, Art, Morality and Money: Which Side Are We/They or You On?" *Arts Magazine* 56 (January 1982): 107–11.

Rosenthal, Mark. "From Primary Structures to Primary Imagery." *Arts Magazine* 53 (October 1978): 106–7.

Rosler, Martha. "The Private and the Public: Feminist Art in California." *Artforum* 16 (September 1977): 66–74.

Roth, Moira. "Toward a History of California Performance, Part One." *Arts Magazine* 52 (February 1978): 94–103. "Part Two." *Arts Magazine* 52 (June 1978): 114–23.

Salle, David. "Lawrence Weiner." *Arts Magazine* 51 (December 1976): 40.

Shore, Michael. "Punk Rocks the Art World." *Artnews* 79 (November 1980): 78–85.

Smith, Terry. "Art and Art and Language." *Artforum* 12 (February 1974): 49–52.

Sonfist, Alan, ed. *Art in the Land: A Critical Anthology of Environmental Art.* New York: Dutton, 1983.

Tucker, Marcia. "'Bad' Painting." In *"Bad" Painting.* Exhibition catalog. New York: New Museum, 1978.

"Zeitgeist: An Interview with Christos Joachimides." *Flash Art* 109 (November 1982): 26–31.

Photography Credits

Photographs were supplied by the owners of the works of art or by the artists' dealers. The following photographers are acknowledged (numbers refer to catalog entries):

Jon Abbott, New York: 16, 18, 93, 148; David Allison, New York: 77; Michael Arthur, San Diego, Calif.: 130; William H. Bengtson, Chicago: 31, 109; Tseng Kwong Chi, New York: fig. 5; Geoffrey Clements, New York: 21; Prudence Cuming Associates Ltd., London: 75; Ivan Dalla Tana, New York: 3, 65, 105; Bevan Davies, New York: 47, 70, 125, 153; D. James Dee, New York: 9, 10, 48, 60, 81, 136, 137, 139, 144; Eeva-inkeri, New York: 32, 61, 143, 147; Mark Farris, Washington, D.C.: 129; John A. Ferrari, Staten Island: 64; Peter Foe/Fotoworks: 42; Bruce C. Jones, New York: 79, 146; Al Mozell, New York: 126–28; Douglas M. Parker, Los Angeles: 20; Pelka/Noble, New York: 49; Eric Pollitzer, New York: 4, 5, 51; F. Rosenstiel, Cologne: 95; Harry Shunk, New York: 8; Lee Stalsworth, Hirshhorn Museum and Sculpture Garden: 62, 82, 92, 152, figs. 1 and 3; Caroline Tisdall, London, fig. 2; Dorothy Zeidman, New York: 122; Zindman/Fremont, New York: 28, 76, 101.